Key Monuments
of the
Baroque

also by
Laurie Schneider Adams

Giotto in Perspective, editor (1974)
Art on Trial (1976)
Art and Psychoanalysis (1993)
A History of Western Art (1993)
The Methodologies of Art (1996)
Art Across Time (1999)
Key Monuments of the Italian Renaissance (2000)

Key Monuments
of the
Baroque

Laurie Schneider Adams

Icon Editions
Westview Press
A Member of the Perseus Books Group

Published in 2000 in the United States of America by Westview Press, 5500 Central Avenue, Boulder, Colorado 80301-2877, and in the United Kingdom by Westview Press, 12 Hid's Copse Road, Cumnor Hill, Oxford OX2 9JJ

Find us on the World Wide Web at www.westviewpress.com

Library of Congress Cataloging-in-Publication Data
Adams, Laurie.
 Key monuments of the Baroque / Laurie Schneider Adams.
 p. cm.
 Includes bibliographical references and index.
 ISBN 0-8133-3427-6 (hc.)
 1. Art, Baroque. I. Title.
N6415.B3 A33 1999
709'.03'2—dc21 99-048240
 CIP

10 9 8 7 6 5 4 3 2 1

Contents

Illustrations

Numbers in italic refer to the pages on which the illustrations appear.

Preface

The title of this volume, *Key Monuments of the Baroque,* reflects the view that not all art is created equal. It is intended to affirm the existence of individual genius, identifiable styles of art, and historical periods that produced them. It implies that in any given context (time and place) some events are more significant than others; in the history of art, the significant "events" are the key monuments of art: pictures, sculptures, and buildings. They are the products made by the greatest artists and architects of their time. And although works of art may be influenced by external circumstances—for example, social, economic, and political factors; available technology and training; prevailing styles and conventions; cultural attitudes toward religion, secularism, race, gender, class, and so forth—these do not account for artistic production with the same force as the character and talent of the artist.

This bias is not intended to imply that only a single significant style emerges in a given time and place, for history is dynamic in nature. As a result, we sometimes speak of "movements" in art, which denote both the fluid nature of artistic development and the presence of more than one style at a time. Nevertheless, there is usually a "prevailing" style, which is the characteristic one, coexisting with preferences for earlier (sometimes called "old-fashioned" or "retardataire") styles as well as with newer developments (called "modern" and, more recently, "avant-garde"). Such aesthetic forces, combined with the abilities of the artists themselves, create the dynamic tensions of art history.

Nor should the external circumstances of context be ignored or underestimated. For example, under the totalitarian regimes of Nazi Germany and Stalinist Russia, avant-garde art was prohibited. Artists could leave their country (as many did), stay in their country and change style (as Malevich did), or lie low in a relatively safe zone in an occupied country (as Matisse did). As has been said many times, "Where there's life, there's hope," a sentiment that can be applied to the production of art no matter what the odds. For the old adage that "truth will out," one could say that history has also shown that "talent will out." Despite the traditional Western bias against training women to be artists, therefore, some women made careers in art. Michelangelo's father opposed his ambition to become an artist and, according to his biographers, beat him physically, abused him

emotionally, and tried to keep him from artistic training. And van Gogh persisted in making art—indeed, made some of the greatest art—even though there was no market for his work during his lifetime.

A book of this size is necessarily limited, which restricts the choices made by its author. Obviously, there are many more key monuments than those discussed here. But the advantage of focusing on a few highlights of a given historical period is that occasional forays into different methods are possible. The very selection of key works means that they can be considered from different points of view, thereby acknowledging both the primacy of individual genius and the contextual forces that interact with artistic production. Among the criteria used in selecting the monuments discussed in these pages is a conviction that their makers were the great artists of their time. As a result, the works push the envelope of stylistic innovation, while embodying significant aspects of their culture.

This text focuses on key monuments of the Baroque style, which varies in different European contexts. It begins with a chapter on the Mannerist precursors of Baroque and concludes with a brief discussion of Rococo and other eighteenth-century artistic developments. Definitions of bold face terms in the text can be found in the glossary of art-historical terms. Boxed asides provide definitions of artistic media, short biographical sketches, and other useful background information. A brief bibliography includes cited works and suggestions for further reading.

Several people have been extremely helpful in the preparation of this volume. I am grateful to Robert Baldwin for his insights on Flemish painting, to Mary Wiseman for pointers on semiotics, and to Elisabeth de Biève for translations from Dutch into English. John Adams, Paul Barolsky, Carla Lord, and Mark Zucker read the entire manuscript, ferreting out errors of fact and improving the style. The expert copyediting of Carol Flechner also contributed immeasurably to the final product. As always, the encouragement and assistance of Cass Canfield, Jr. has made the project possible.

Laurie Schneider Adams

CHAPTER ONE

Introduction
to the Baroque

The art-historical style referred to as Baroque generally designates the time period 1600 to 1750. It began in Rome in the early decades of the seventeenth century and soon spread throughout Europe. Examples of the style are found in Eastern Europe and in the Americas, especially in areas of Spanish influence, but the works illustrated in this text are products of Western Europe. Their characteristics, as we will see, vary according to time and place, function and patronage, and, above all, the style of the artist who created them. Nevertheless, there are certain formal and thematic qualities that define Baroque and that are expressed by the term itself.

Baroque is the French version of the Portuguese word *barroco,* meaning an imperfect, irregularly shaped pearl. The very term corresponds to those aspects of Baroque style that are curvilinear and **asymmetrical,** and emphasize dramatic surface movement. The animated wall surfaces of Baroque buildings, for example, can be related to the undulating surface movement of a pearl, especially an irregular one. In order to understand better the origins and meaning of Baroque, however, it is useful to consider certain significant historical developments of sixteenth-century Europe as well as aspects of the Mannerist style. Important religious and political changes—most notably the Reformation and the Counter-Reformation—had a profound influence on the arts in the sixteenth and seventeenth centuries.

The Sixteenth Century:
Religious Turmoil

The Reformation refers to the religious upheaval against growing abuses within the Catholic Church, which had controlled Western Christendom since the fall of the Roman Empire. The driving force behind this movement was the German Augustinian monk Martin Luther (1483–1546). He objected to the Church's practice of selling indulgences—letters containing papal

guarantees of salvation. He believed that faith, rather than the purchase of indulgences to gain favor with the clergy, determined the fate of one's soul. Convinced that celibacy should not be required of the clergy, he himself married a former nun. Luther also advocated a return to the simplicity of the Bible as the basic Christian text and argued for reducing the power of the Church hierarchy.

In this stance, Luther came up against the dogmatic German Dominican Johann Tetzel (1465?–1519), whom he regarded as taking money from the poor under false pretenses. Tetzel capitalized on the prevalent fear of hell, pointing out that for each mortal sin, of which many are committed daily, it was necessary to suffer seven years of penance—"endless punishment in the burning pains of Purgatory. . . . Are you not willing, then," Tetzel reasoned, "for the fourth part of a florin, to obtain these letters, by virtue of which you may bring, not your money, but your divine and immortal soul safe and sound into the land of Paradise?"[1] In fact, however, Tetzel used the funds for the personal benefit of certain clergymen and to ingratiate himself with the pope by his contributions to the rebuilding of Saint Peter's in Rome.

In 1517, Martin Luther changed the course of history when he nailed to the door of the Castle church in Wittenberg, Germany, his Ninety-Five Theses. These listed his objections to the widespread corruption in the Church. Flying in the face of Tetzel's arguments were theses 21 ("Thus those preachers of indulgences are in error who say that by the indulgences of the pope a man is freed and saved from all punishment") and 50 ("Christians should be

taught that if the pope were acquainted with the exactions of the preachers of pardons, he would prefer that the basilica of St. Peter should be burnt to ashes rather than that it should be built up with the skin, flesh, and bones of his sheep").[2]

What Luther intended as reform within the church became a groundswell of protest opposing the Church. Hence the term *Protestant.* Efforts to quell the protests failed, and by around 1600 a quarter of Western Europe had become Protestant. Protestants were concentrated in the north—in England, Scotland, Scandinavia, the Netherlands, Switzerland, and north and west Germany. Flanders, France, Italy, Spain, and southern Germany remained Catholic.

The Church's response to the Reformation—the Counter-Reformation—was an attempt at internal reform with a view to reasserting Catholic domination of Europe. A particular force in the Counter-Reformation was Ignatius Loyola (1491–1556), a Spanish soldier who was later canonized. In 1534, he founded the Society of Jesus (the Jesuits), whose role as soldiers of Christ served the pope through missionary work. In 1540, Paul III (1468–1549) approved the Society. Loyola had written the *Spiritual Exercises,* which advocated a system of spiritual and physical discipline calculated to develop a strong moral sense in his "Christian Soldiers." He recommended that his followers meditate in ways calculated to turn them from the materialism of this world to the spirituality of the next. In a section entitled "Meditation on the Agony of Death," he wrote:

Some months after your death. Contemplate this stone already blackened

by time, this inscription beginning to be effaced; and under that stone, in that coffin which is crumbling bit by bit, contemplate the sad state of your body; see how the worms devour the remains of putrid flesh; how all the limbs are separating; how the bones are eaten away by the corruption of the tomb! . . . [3]

In 1545, eleven years after Loyola founded the Jesuit order, the Council of Trent, named for the city of Trento in northern Italy, met. The council rejected any accommodation to the Protestants and reaffirmed Catholic doctrine. Heresy was to be eradicated by reforming dissenters, banning certain books by listing them on the *Index Expurgatorius,* insisting on certain themes in painting and sculpture as well as dictating architectural arrangements of churches and granting the Inquisition the right to carry out the decrees of the council. The council met three times between 1545 and 1563, and consistently demanded adherence to its views. Those who failed to comply were summarily dealt with, either by excommunication or by more corporal forms of punishment.

The Church's insistence on orthodoxy led to a conflict between religion and science that would continue into the seventeenth century. On the one hand, the sixteenth century was an age of geographic exploration, of technological advances, of scientific study (the anatomical drawings of Leonardo da Vinci), and of humanist authors (Shakespeare in England, Montaigne in France, and Cervantes in Spain). On the other hand, the mystical writings of Saint Teresa of Avila and Saint John of the Cross were gaining in influence, and the Inquisition was an omnipresent force constantly to be reckoned with.

Mannerist Precursors

From around 1520 to 1590, a new movement in art began to make inroads into the prevailing High Renaissance style in Italy. This new style is called Mannerism, after its complex and ambiguous, yet elegant and refined, character. It differs from the High Renaissance aesthetic in its asymmetry, elongated and distorted forms, provocative, serpentine poses, jarring color contrasts, unexpected spatial juxtapositions, and enigmatic **iconography.** Mannerism marked the end of Renaissance classicism and laid the groundwork for the shift to Baroque. Like the Baroque artists of the following century, the Mannerists had to navigate between the rules of the Inquisition that dominated Church patronage and the earthy, sometimes perverse tastes of their private court patrons.

A quintessential Mannerist sculpture, Benvenuto Cellini's (1500–1571) *Saltcellar* of 1543 (1.1), was completed just two years before the Council of Trent first met. Commissioned by Francis I, king of France, the *Saltcellar* exemplifies the characteristics of Mannerist art produced under court patronage. The highly polished gold surface, the colored **enamels,** and the refined, elegant details appealed to its royal patron. Its fluid forms and elusive meanings—Cellini recorded contradictory versions of the latter—are consistent with both the formal instability of the main figures and the flamboyant instability of the artist himself.

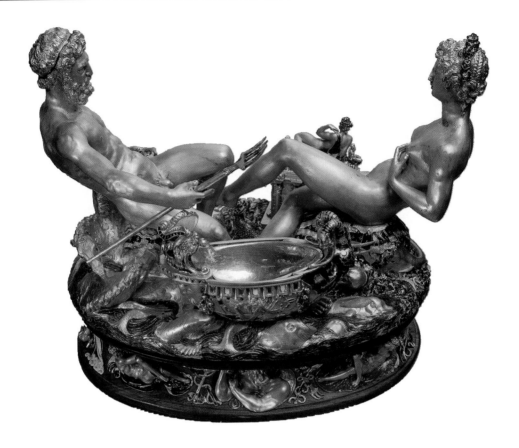

1.1 Benvenuto Cellini, *Saltcellar* for Francis I, 1543. Gold and enamel, 10 ¼ in. × 13 ⅛ in. (26 cm × 33.3 cm), Kunsthistorisches Museum, Vienna. (Scala/Art Resource)

The two main figures, rendered with typically Mannerist elongated forms, represent the Greek sea god Poseidon with his **attribute**, the trident, and the earth goddess. They recline unsteadily backward, opening up a broad space between them, and their gazes meet. Their ambiguous character is reflected in their contradictory poses. The earth goddess tweaks her left breast provocatively, as if trying to hold Poseidon's attention. She sits on a pillow supported by an elephant and decorated with *fleurs-de-lis,* emblems of French royalty. Beside her is the pepper container, which is in the form of a conflated **Ionic** triumphal arch. Above the container reclines a smaller nude female, who, like the personifications of times of day and wind gods on the base, is inspired by Michelangelo's figures in San Lorenzo's Medici Chapel. Next to the elaborate salt bowl, alluding to the salty sea, is Poseidon, surrounded by sea horses and dolphins. The swirling white and blue enamel surface on which the gods sit is intended to evoke foaming waves.

Benvenuto Cellini: Autobiography

In 1557, while under house arrest for sodomy, Cellini dictated his autobiography to his fourteen-year-old assistant. It is a remarkable picture of the artist and his times, both of which were in turmoil. Most of Cellini's sculptures, like the *Saltcellar,* were either portraits or of mythological subjects. He worked mainly for private patrons, particularly Francis I of France and Cosimo I de' Medici, duke of Florence from 1537 to 1569 and grand duke of Tuscany from 1569 to 1574.

Cellini's autobiography describes his early conflicts with his father, who tried to force him into a career in music. But at the age of fifteen Cellini defied his father and apprenticed himself to a goldsmith. His later life was turbulent; he was often in trouble with, and on the run from, the law. Actively bisexual, he finally married the mother of his illegitimate children. Cellini's description of his father provides an explanation for his own ambivalence. Despite being named *Benvenuto* ("welcome" in Italian) by his father, Cellini records two well-known early childhood memories that reveal his father's underlying hostility toward him.

In one, Cellini catches a scorpion and refuses to part with it, whereupon his father cuts off its tail and claws. In the other, Cellini sees a salamander leaping in the fire. (According to traditional animal lore, salamanders have the ability to live in fire.)[4] His father boxes his ears on the unlikely pretext of making sure he remembers that the lizard is a salamander. Then he kisses Cellini and gives him some money. Both memories (which are surely symbolic distortions known as "screens" or "screen memories") show the elder Cellini as alternately violent and loving, which is consistent with the artist's own ambivalent character. They also contain two motifs that are specifically autobiographical: the scorpion, related to Scorpio (the astrological sign under which Cellini was born), and the salamander (the emblem of Francis I) that appears on the *Saltcellar.*

Although the exact meaning of this object is difficult to determine, it is clear that it was designed to delight the French king. Along with its display of costly materials and artistic virtuosity, the *Saltcellar* is a metaphor for the realms of Francis I. A political reading of the *Saltcellar*'s iconography suggests that Francis rules a union of Earth and Ocean.

The private meaning of the *Saltcellar,* like that of many Mannerist works produced for the courts, is even more elusive than its allegorical meaning. Possibly the figure of Poseidon stood for the French king (both were bearded), whose emblem, the salamander, is one of the many iconographic details decorating the work. The gesture of Earth suggests amorous intentions toward Poseidon, which might contain references to the king's personal life. This possibility is reinforced by the connotations of *salt* and *pepper* in the French language (and elsewhere). Both terms denote wit and light satire, as well as having sexual implications. Salt can denote semen, and, in French slang, the verb "to pepper" can mean "to transmit venereal disease." The combination of wit and sexual allusion embedded in the meanings of *salt* and *pepper* conforms both to the formal character and to the iconography of Cellini's work.

Despite the elusive iconography of the *Saltcellar,* one thing is certain: the object would not have passed muster with the In-

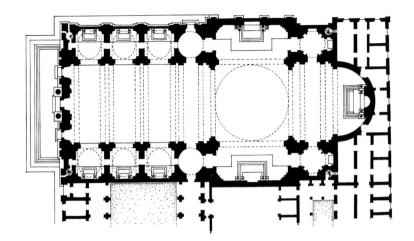

1.2 Giacomo da Vignola, plan of Il Gesù, Rome, 1568–1577. After Roth.

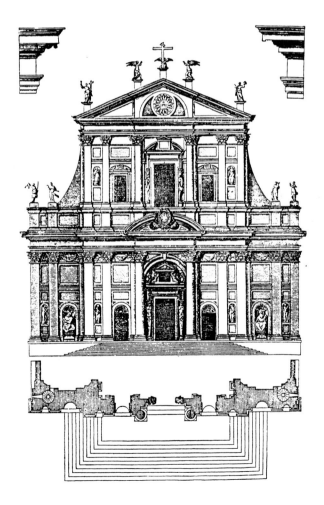

1.3 Giacomo da Vignola, design and plan of the façade of Il Gesù, Rome. Engraving, 1573.

quisition. The Council of Trent objected to mythological subject matter and nude figures as pagan and, therefore, as heretical. It decreed that art illustrate the Bible and the lives of saints, clearly identifying each figure by attributes such as **haloes** and instruments of martyrdom. Imagery, according to the Council, should evoke a mystical identification on the part of the viewer, much as Loyola's *Spiritual Exercises* were designed to do.

Such arguments were directly opposed to the humanist movement, which had characterized much of the Renaissance in the fourteenth, fifteenth, and early sixteenth centuries. Not only had the humanists revived and translated the texts of Classical antiquity, but they subscribed to the ancient Greek notion that "man is the measure of things." Humanist artists illustrated mythological as well as Christian subject matter, and treatises were written praising the dignity of man. This latter notion extended to the form of a man's body as well as to the state of his mind and soul, all of which were idealized and believed capable of achieving the highest good.

The Council of Trent also made known its views on architecture, which, it said, should create a spiritual environment for worshipers. To satisfy this requirement, there was a surge in church construction during the Counter-Reformation. The most important of these churches, Il Gesù (1.2, 1.3, 1.5), unlike Cellini's *Saltcellar,* was designed according to the dictates of the Counter-Reformation. Begun in 1568, Il Gesù was the mother church of Loyola's Society of Jesus and would become the most influential church of Baroque Rome. Its plan would also spread well beyond

Rome, disseminated by Jesuit missionaries throughout the world.

The architect Giacomo da Vignola (1507–1573) was the author of the *Regola delle Cinque Ordini d'Architettura* (The Rule of the Five Orders of Architecture), published in 1562 and eventually printed in some two hundred editions. Vignola based his **plan** of the Gesù (1.2) on the Renaissance plan of Leon Battista Alberti (1404–1472) for the church of Sant'Andrea in Mantua (1.4). Both are **Latin-cross** plans with **barrel vaults** and individual side **chapels** replacing the **side aisles**. The

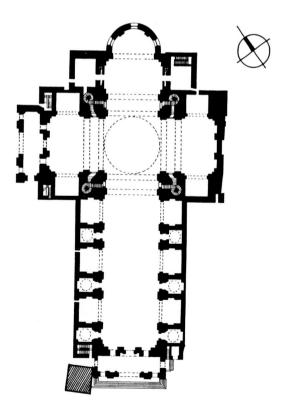

1.4 Leon Battista Alberti, plan of Sant'Andrea, Mantua, 1470–1493. After Roth.

chapels, a series of identical square modules, each with its own **altar**, allowed for the worship of individual saints and could be owned by private families. Under this arrangement, the congregation was directed architecturally toward the high altar in the **apse**, which was illuminated by light from the dome. Since the only other source of light in the Gesù was the **clerestory** of the **nave**, the **crossing** became the most illuminated space in the church. The light at the crossing thus contributed to the dramatic character of the high altar.

Also emphasizing the high altar was the distance between the apse and the **sacristy**, which meant that when the priest proceeded from the sacristy to celebrate Mass, he could be seen by the entire congregation. The dramatic effect of the priest's visibility—like an actor approaching center stage—was to build up the expectation of the worshipers as he prepared to begin the service. This sense of drama in the service of mystical spirituality, which was required by the Council of Trent, would become a characteristic of the Baroque style in the seventeenth century.

The differences between the plan of Sant' Andrea and that of the Gesù, however, reflect the new demands of the Counter-Reformation. Vignola's **transepts** are relatively shallower (and each contains an altar), his dome larger, and his nave wider than those in Alberti's church. The purpose of the wide nave and barrel vault was to provide space for a large congregation and to improve the acoustics. This enabled worshipers to identify spiritually with the text and music of the Mass, as desired by the Council of Trent. Although the congrega-

tion was encouraged to respond to the priest in the celebration of ritual, it was kept apart from the clergy by the separation of the nave from the **choir**. This reflected the Counter-Reformation view that in spiritual matters the lay public should experience a mystical union with the Church, while preserving the hierarchical structure of the Church.

Vignola's design for the **façade** of the Gesù was never executed because of his death in 1573, but his original conception is preserved in an engraving of the same year (1.3), which also includes a ground plan of the façade. It shows the emphasis on the center by the slight forward projection of the façade; the main door and the window above it on the second story are flanked by columns engaged with **pilasters**. The round **pediment** over the door is repeated twice—over the horizontal **cornice** and inside the crowning triangular pediment. The latter, in turn, repeats the small triangular pediment underneath the arc over the main door.

As one moves away from the center, the sides of the façade become flatter. **Columns** are replaced by rectangular pilasters, and the wall itself is slightly recessed at the ends of the central two-storied section. Creating a visual transition between the vertical sides of the upper center story and the horizontal elements at the top of the extended sides of the lower story are two curved elements. The upper edges of the façade at both levels are crowned with statues of saints and angels, which, like the architectural motion of the surface, create a unified, animated whole.

The present façade of the Gesù (1.5) is the work of Giacomo della Porta (c. 1537–1602),

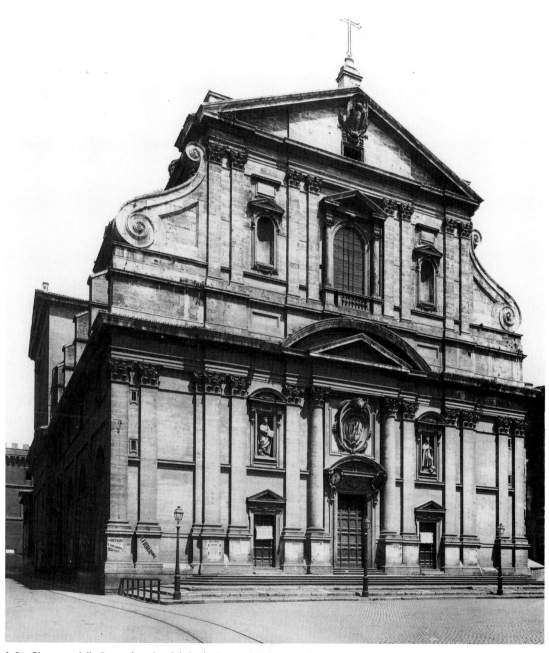

1.5 Giacomo della Porta, façade of Il Gesù, Rome, 1573–1577. (Art Resource)

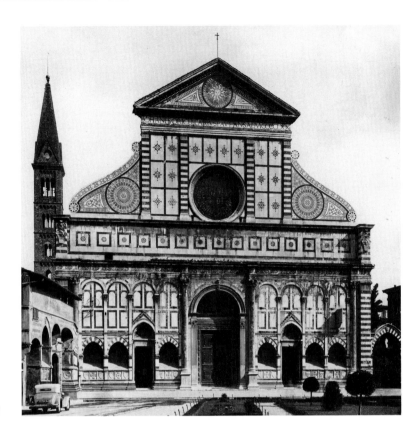

1.6 Leon Battista Alberti, façade of Santa Maria Novella, Florence, 1458–1471. (Art Resource)

the leading Roman architect working after Vignola's death. His façade is even more dependent on Alberti's façade for Santa Maria Novella in Florence (1.6) than Vignola's design had been. At the same time, however, della Porta's façade is more animated than Vignola's and thus closer to the eventual development of Baroque. Della Porta follows Alberti in the large scrolls at the sides of the upper story, although in the later version the curves are more pronounced. Compared with Vignola's conception, della Porta's façade appears heavier and more varied. It seems to push forward toward the viewer even more than Vignola's, and its heavier shadows accentuate the depth of the surface elements.

As much as the church of Il Gesù satisfied the adherents of the Council of Trent, the monumental painting *The Feast in the House of Levi* (formerly *The Last Supper*) by Paolo Veronese (1528–1588) disturbed them (1.7), even though, in large part, the iconography conformed to the council's rules. Veronese was born in Verona, as his name indicates, and in his early twenties went to Venice, where he was influenced by the rich colors and painterly textures of the High Renaissance painter Titian (c. 1485–1576). The choice of subject obeyed the rules of the Council for it represented Christ's last meal. Its original setting, in the **refectory** of Santi Giovanni e Paolo in Venice, was equally appropriate since it would inspire the monks

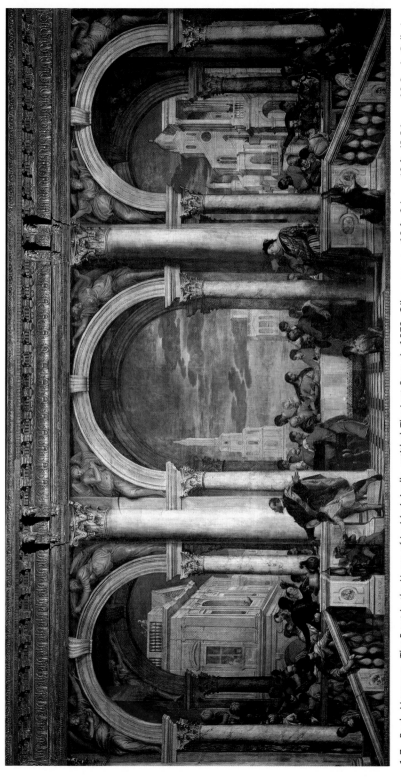

1.7 Paolo Veronese, *The Feast in the House of Levi* (originally entitled *The Last Supper*), 1573. Oil on canvas, 18 ft. 3 in. × 42 ft. (5.56 m × 12.8 m). Gallerie dell'Accademia, Venice. (Scala/Art Resource)

to identify with the Last Supper while they themselves ate.

The vast picture is set like a stage, **illusionistically** projecting through an **arcaded loggia** that opens onto a cityscape. Painted steps lead from the loggia seemingly into the refectory itself. Figures in the foreground and on the stairs increase the illusionistic effect of the architecture because they are rendered as if occupying the same space as the viewer. A second plane of space is contained under the loggia, and a third is occupied by background buildings resembling stage sets.

The most sacred space is suitably reserved for the central area of the picture. It shows Christ leaning to his left (our right) toward the young apostle John; the elderly Saint Peter is to his right (our left). The ease with which these figures are identified fulfills the requirements of the Council of Trent, as does Christ's halo. Furthermore, the prominence of the white tablecloth refers to the table of the Mass, or altar,[5] where the bread and wine are miraculously transformed into the body and blood of Christ. This miracle of transubstantiation was specifically upheld by the Council of Trent against arguments that it was a symbolic rather than a literal transformation.

Juxtaposed on either side of the central space is a building on Christ's left that resembles a pagan temple and, on Christ's right, a taller church tower. This symbolic architectural juxtaposition heralds the eventual victory of Christianity over paganism. Below the pagan building, in shadow, is a figure who is most likely Judas; his Semitic physiognomy is unmistakable, and he turns from Christ. At the left, below the church tower, sits a large illuminated figure draped in red; this is the costume and color associated with cardinals and thus with Church hierarchy. His formal alignment with the church building and his placement in light denotes the triumph of the Church. A related message is contained in the architecture of the loggia itself, for the triple arches with their winged Victories on the **spandrels** proclaim Christ's victory over death.[6]

Also in tune with the Counter-Reformation is Veronese's rendering of the sky. That darkness is in the process of descending is clear from the lighter section above Christ and his apostles. This conflates two significant events in Christ's life—the Last Supper, which takes place in the evening, and the Crucifixion. Referring to the Christian tradition that the sky grew dark when Christ died, Veronese's iconography reminds viewers of Christ's imminent arrest, trial, and death. At the same time, the lighter sky corresponds to Christ's holy nature, framing him in natural light while the mystical light of the halo emanates from his head.

Despite the iconographic elements in Veronese's *Last Supper* that conformed to the Council of Trent's rules for creating religious imagery, the artist ran afoul of the Inquisition. On July 18, 1573, he was called before the Holy Tribunal in Venice to explain certain "transgressions" in his painting. The prosecutor objected to the presence of buffoons, dwarfs, Germans, and other unsuitable figures. Clearly, it was the Germans who were particularly offensive, for they reminded Inquisitors of Martin Luther. Veronese was given three months to correct the picture, which he did by changing its title from *The Last Supper* to *The Feast in the House of Levi*.[7]

Excerpt from Veronese's trial

Questioner: In this Supper . . . what is the significance of the man whose nose is bleeding?

Answer: I intended to represent a servant whose nose was bleeding because of some accident.

Q: What is the significance of those armed men dressed as Germans, each with a halberd in his hand?

A: We painters take the same license the poets and the jesters take and I have represented these two halberdiers, one drinking and the other eating nearby on the stairs. They are placed here so that they might be of service because it seemed to me fitting, according to what I have been told, that the master of the house, who was great and rich, should have servants.

Q: And that man dressed as a buffoon with a parrot on his wrist, for what purpose did you paint him on that canvas?

A: For ornament, as is customary.

Q: Who are at the table of Our Lord?

A: The Twelve Apostles

Q: What is St. Peter, the first one, doing?

A: Carving the lamb in order to pass it to the other end of the table.

Q: What is the Apostle next to him doing?

A: He is holding a dish in order to receive what Saint Peter will give him.

Q: Tell us what the one next to this one is doing.

A: He has a toothpick and cleans his teeth. . . .

Q: Does it seem fitting at the Last Supper of the Lord to paint buffoons, drunkards, Germans, dwarfs and similar vulgarities?

A: No, milords.

Q: Do you not know that in Germany and in other places infected with heresy it is customary with various pictures full of scurrilousness and similar inventions to mock, vituperate, and scorn the things of the Holy Catholic Church in order to teach bad doctrines to foolish and ignorant people? . . .

NOTES

1. Cited by Linnea H. Wren, ed., *Perspectives on Western Art,* vol. 2 (New York, 1994), p. 104.

2. *Ibid.,* p. 105.

3. *Ibid.,* p. 78.

4. For this fact, I am grateful to Mark Zucker.

5. David Rosand, *Painting in Cinquecento Venice: Titian, Veronese, Tintoretto* (New Haven and London, 1982), p. 166.

6. *Ibid.,* p. 170.

7. From Elizabeth Gilmore Holt, ed., *Literary Sources of Art History: An Anthology of Texts from Theophilus to Goethe* (Princeton, 1975), pp. 246–248.

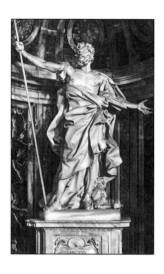

Baroque Architecture and Sculpture in Rome

The Cultural Context

The Baroque style flourished during an extended period of political and religious strife. Conflict between Catholicism and Protestantism continued to plague Europe, which, from 1618 to 1648, was devastated by the Thirty Years' War. Another conflict fraught with both religious and political undercurrents pitted the forces of orthodoxy against those of science.

In the late fifteenth century, two German clerics—Heinrich Kramer and James Sprenger—had countered the humanist trends of the Renaissance by publishing the *Malleus Maleficarum* (*Witches' Hammer*). This provided instructions for identifying witches and recommendations for torturing the accused in order to extract confessions. In the early sixteenth century, on the other hand, the Polish astronomer Nicolas Copernicus (1473–1543) took a more scientific approach to the world, declaring that the sun was the center of the universe and that the planets (including the earth) revolved around it. When Galileo Galilei (1564–1642) endorsed this heliocentric view, he was denounced as a heretic by Pope Paul V (papacy 1605–1621). At the age of seventy, Galileo was forced by the Inquisition to recant. Nevertheless, such revolutionary views, encouraged by the scientific use of the telescope, led to an expanded awareness of the universe that was consistent with the age of geographic exploration and was reflected in the vast expanses of landscape in European painting.

The new scientific discoveries, opposed as they were by more religious trends, naturally had social implications. The French philosopher René Descartes (1596–1650) linked man's ability to reason logically with the very nature of human existence—a position exemplified by his proverbial "I think, therefore I am." In England, Sir Isaac Newton (1642–1727) argued that man could dominate nature, and Francis Bacon's (1561–1626) empiricism led to the scientific observation of nature and the development of scientific experimentation.

The Style

The heyday of Baroque was marked by a surge in church building from around 1620, which was inspired by the model of the Gesù. Architecture became increasingly large-scale, with curved walls, expansive squares, and ornate fountains. Painting was no longer conceived of as a replica of nature seen through a window from a fixed viewpoint, as in the Renaissance. Although the picture plane was still thought of as depicting a space behind itself, Baroque vision is controlled by the thrusts of diagonal **planes** and dramatic—even melodramatic—variations of light, dark, and color that create visual motion. The construction of space is typically asymmetrical in contrast to the Renaissance preference for classically inspired symmetry. Baroque style continued to flourish in some areas of Europe into the eighteenth century, but most of its key monuments were created between 1620 and 1700.

National tastes, to some extent, inspired different trends within the Baroque style. In Italy, Classical influence merged with emotional drama, whereas French Baroque tended to be more austere. In Catholic Spain and France, the patronage of the courts was particularly influential, as it was in Protestant England under the Stuarts. Dutch Baroque had its greatest exponents in Rembrandt and Vermeer, whose patrons were primarily secular. In Flanders, Church patronage predominated, although Rubens and van Dyck were also employed by courts, Rubens primarily in Spain and England as well as Flanders, and van Dyck mainly in England. Despite such differences, however, the formal qualities of the style were remarkably consistent.

The content of Baroque painting and sculpture, in reaction to Mannerism, emphasizes realism and the direct study of nature. New categories of imagery, such as **landscape, genre,** and **still life,** begin to emerge. Often these are imbued with political or allegorical messages. At the same time, the interest in Classical and mythological themes persists alongside the spirituality of Christian subject matter required by the Council of Trent. In the greatest artists of the period—Bernini, Caravaggio, Velázquez, and Rubens, for example—there is a new synthesis of mysticism and dramatic psychological power that characterizes some of the most important Baroque art.

Although significant monuments of Baroque style were produced throughout Europe, the center of patronage in the early decades of the seventeenth century was the city of Rome. Saint Peter's was a key architectural monument in Baroque Rome and had been in the process of being remodeled since the early sixteenth century. In its finished state, Saint Peter's is essentially a Baroque structure. The number of architects who worked on the project and the popes who commissioned them, as well as its cost, its size, and the century and a half required for its completion, all reflected the significance of Saint Peter's as the mother church of the Catholic faith and the most important pilgrimage site in Europe.

Caput Mundi:
The Evolution of Saint Peter's

As Rome had been designated "head of the world" during the empire, so it became the central city of Western Christendom, fol-

lowing Constantine's legalization of Christianity in A.D. 313. On the traditional site of Saint Peter's burial, Constantine constructed the Early Christian **basilica**, an architectural form derived from the Roman basilica, with a large nave, side aisles, and an apse. When Julius II was elected pope in 1503, he decided to remodel the fourth-century church. In 1504, he appointed Donato Bramante (c. 1444–1514) to the task.

Bramante's plan (2.1) was based on the Greek cross, which conformed to the tradition of centralized, circular structures for **martyria.** Centralized church plans had also been the ideal since the early decades of the Renaissance in fifteenth-century Florence. His design for the façade (2.2) is shown on the foundation medal struck by Caradosso (Julius II laid the foundation stone in 1506). Bramante preferred **symmetry** in the plan as well as in the façade, and simple, regular shapes. After his death in 1514, several architects worked on the design. But political turmoil, including the sack of Rome in 1527 by the Holy Roman Emperor, halted further construction for nearly thirty years.

In 1534, Paul III (d. 1549) became pope and appointed Antonio da Sangallo the Younger (1483–1546) architect of Saint Peter's (see 2.3). Bowing to arguments—which had been advanced from early on in the sixteenth century—that a longitudinal Latin-cross plan was more suited to making the liturgy accessible to large congregations, Sangallo lengthened one transept, but did little else. It was not until Paul III hired Michelangelo, following Sangallo's death in 1546, that significant changes were made. Michelangelo remodeled Saint Peter's according to a Greek-cross plan

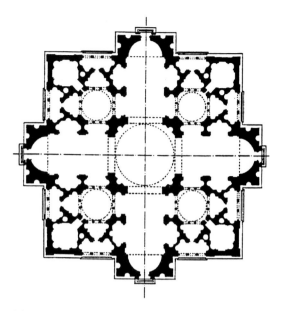

2.1 Donato Bramante, plan of Saint Peter's, Rome.

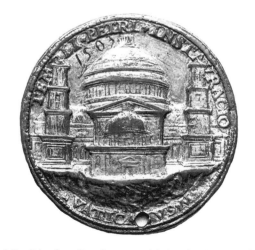

2.2 Cristoforo Caradosso, medal showing Bramante's plan of Saint Peter's, Rome. (Art Resource)

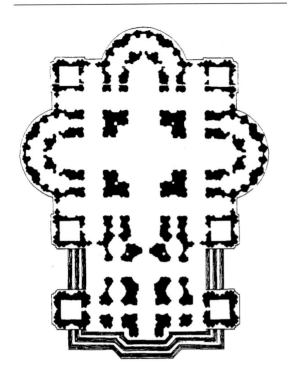

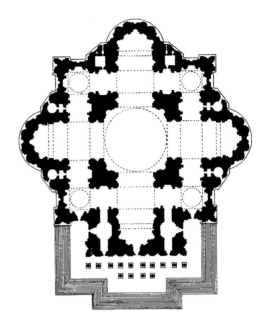

2.4 Michelangelo, plan of Saint Peter's, Rome.

2.3 Antonio de Sangallo the Younger, plan of Saint Peter's, Rome.

(2.4), with a **colonnaded** entrance and thicker walls to support the central dome.

On the exterior, he used giant **Corinthian** pilasters surmounted by a stepped **entablature.** At each corner, he modified the angle with an additional section to create a sense of dynamic motion in the wall surface. Michelangelo designed a hemispherical dome, but died in 1564 before its completion. The dome was finished by Giacomo della Porta but is slightly elliptical; the **lantern** was added from 1590 to 1593. Della Porta also designed two smaller domes, creating a transition from the curves of the dome and its **drum** to the horizontal roof of the nave (2.5).

In the seventeenth century, Saint Peter's became a Baroque monument. Pope Paul V commissioned Carlo Maderno (1556–1629) to complete the building according to a longitudinal plan. Beginning in 1605, Maderno added a long nave with **bays** and, by 1612, had finished the façade. The latter conforms generally to Michelangelo's conception. Giant **Corinthian Orders** between each **portal** support an **attic** with a central pediment. Pilasters at the ends create the sense of a frame, while the shift to columns at the center animates the wall surface. By doubling the columns below the corners of the pediment, Maderno has also "framed" and accentuated the center. In the square in front of the façade, he has placed two fountains on either side of the Egyptian **obelisk.**

The dynamic effect of Maderno's façade wall was further enhanced by Gian Lorenzo

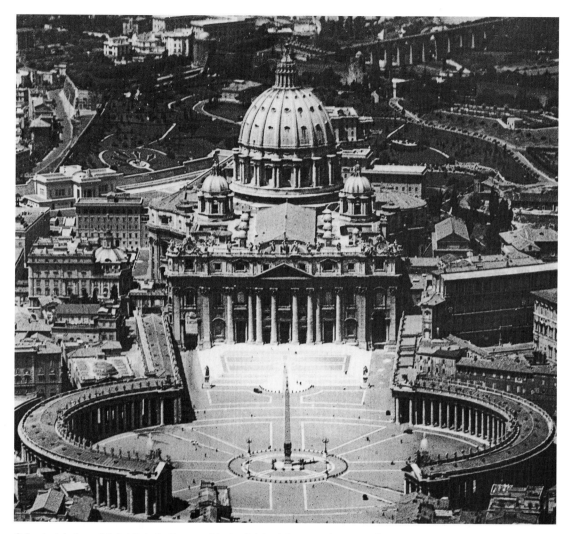

2.5 Aerial view of Saint Peter's, Rome, with the finished dome and two smaller ones. Façade by Carlo Maderno, 1605–1612. (Art Resource)

Bernini (1598–1680), who redesigned the public square (piazza). Pope Alexander VII (papacy 1655–1667) wanted a piazza that would accommodate huge crowds and enhance the visibility of the pope when addressing them. Adjusting to the presence of the Vatican Palace and Sistine Chapel to the north (see 2.6), Bernini designed a trapezoidal space that tapered eastward from the façade to a large elliptical area framed by two symmetrical colonnades defining the north and south curves of the piazza. These consist of 284 columns in the **Tuscan Order**, each 39 feet high, and were

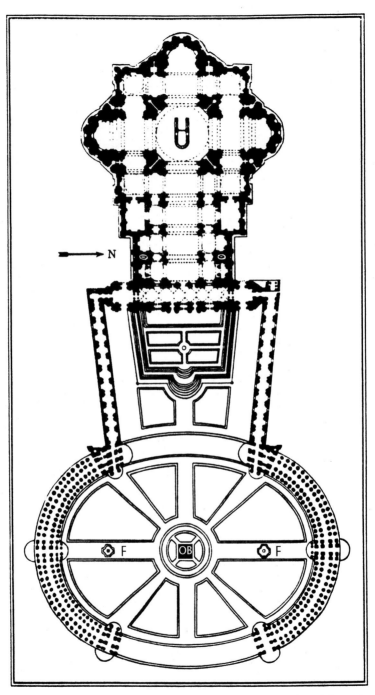

2.6 Plan of Saint Peter's, Rome, with Bernini's Piazza showing Maderno's fountains (F) and the obelisk (OB).

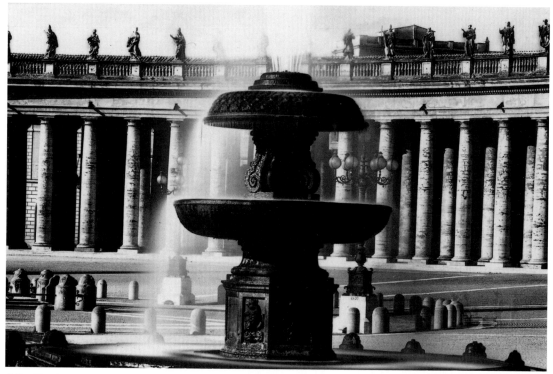

2.7 Gian Lorenzo Bernini, southern arm of the colonnade, Saint Peter's piazza, Rome. (Art Resource)

conceived of by Bernini as "arms" of the Church, embracing believers and non-believers alike (2.7).

The colonnades provide a passageway at either end of the elliptical piazza, which facilitates movement despite the volume of worshipers who gather to hear the pope's message. This accommodation of huge crowds was consistent with the decision to build a longitudinal nave and conformed to Counter-Reformation demands for serving large numbers of the faithful. Surmounting the colonnades are continuous **balustrades** interspersed with a total of 96 marble statues of saints, each 15 feet high. In both the enormous size of his additions to Saint Peter's and the animation of solids and

spaces, Bernini exemplified the Baroque taste for dynamic forms that actively engage participants in dramatic juxtapositions.

Borromini's San Carlo alle Quattro Fontane

Before Bernini had begun the piazza of Saint Peter's, which he completed in 1667, his rival architect, Francesco Borromini (1599–1667), was commissioned to design the little church of San Carlo alle Quattro Fontane (San Carlo at the Four Fountains). It was to be located at the corner of two Roman streets—the Strada Pia and the Strada Felice—which meant that Borromini

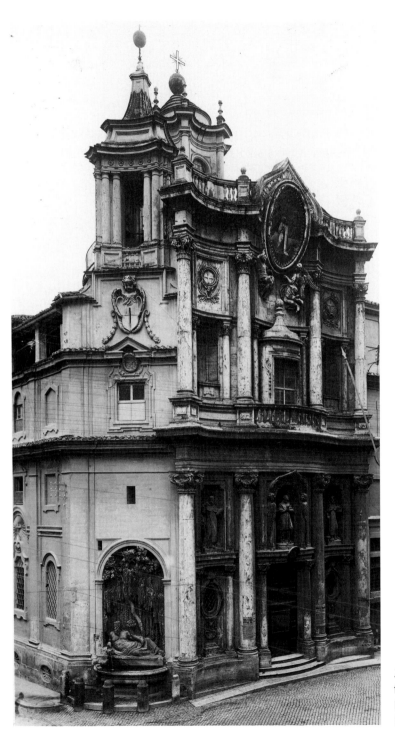

2.8 Francesco Borromini, façade of San Carlo alle Quattro Fontane, Rome, 1634–1667. (Art Resource)

had to deal with a somewhat cramped and irregular site. His patrons, members of the Discalced (Barefoot) Trinitarian Order of Spain, were charged with raising funds to free Christians who had been captured by the Islamic Moors (from Mauretania). The body of the church dates to 1634–1641, and the façade was completed later.

Compared with Bernini, who commanded the most powerful patronage in Rome, Borromini generally worked on a smaller scale. Nevertheless, his buildings were striking in their daring architectural innovations. The façade of San Carlo (2.8), for example, built from 1665 until Borromini's suicide in 1667, has more planar shifts and spatial variety than Bernini's architecture. Its wall undulates, creating a sense of organic pressure pushing in and out against the surface. The lower section is a series of three curves: concave, convex, concave. Four large columns support a curved entablature. This section, in turn, is subdivided into rectangular segments defined by **niches,** which contain sculptures and a door at the center, framed by short columns.

The upper wall is composed of three concave sections framed by a second set of large columns. Instead of the continuous cornice on the first level, this one is broken by the large medallion held aloft by angels. Above the medallion, the balustrade crowning the wall rises to a peak, carrying one's gaze skyward. On Borromini's façade, sculpture interacts with architecture, and the architecture itself is energized by the plastic variations of form, space, and plane.

San Carlo's oval plan (2.9), which also undulates rather than having a regular geo-metric shape, shows the complexity of Borromini's conception as well as his interest in the illusion of architectural movement. He combined triangles, circles, and rectangles with the basic oval. It has been suggested that he had in mind Galileo's description of the universe "as being based on geometrical, triangular relationships."[1] The plan, which is known from Borromini's drawings, is based on two equilateral triangles that share one side, a circle inscribed in each triangle, with the two circles sur-

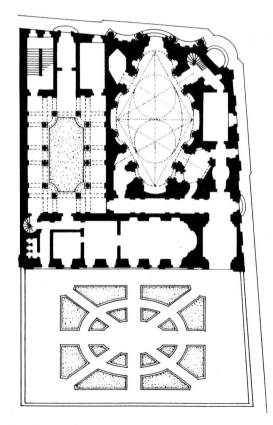

2.9 Francesco Borromini, plan of San Carlo alle Quattro Fontane, Rome, 1634–1667. After Roth.

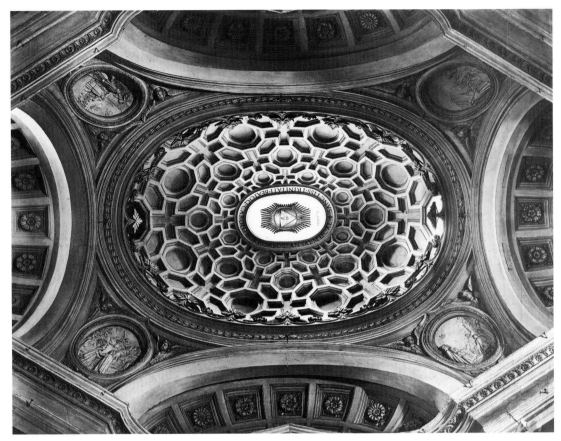

2.10 Francesco Borromini, interior of the dome of San Carlo alle Quattro Fontane, Rome, c. 1638. (Art Resource)

rounded by the oval that corresponds to the dome.

The interior of San Carlo is almost entirely of stucco, with occasional gilding. The inside of the dome, which is visible from below, is stepped and crowned by a lantern on the exterior. On the inside, it is **coffered** with hexagons, octagons, and crosses (2.10) that become smaller as they approach the dome's elliptical center. The latter is framed by an inscription identifying Borromini as the architect and the Trinitarian Order as the patron. The apex of the dome, as seen from below, is framed by eight convex curves surrounding another equilateral triangle containing the Holy Ghost inside a circle. Illuminating the circle are the upper windows of the dome, which create an illusion of light radiating from the Holy Ghost itself.

In contrast to Bernini, who excelled at sculpture as well as architecture, Borromini worked exclusively as an architect. The innovations of both artists had an enormous impact on the development of the Baroque style, which extended throughout Europe

and was adapted to other national, political, and religious contexts.

The Sculpture of Bernini

As the leading sculptor as well as the most successful architect of Baroque Rome, Bernini produced several key sculptural monuments. The evolution of his style from the Mannerist forms of his father, Pietro, who was a sculptor of lesser talent with important Vatican connections, can be seen in an early work, the *Aeneas, Anchises, and Ascanius* of 1618–1619 (2.11). This was the first of Bernini's many commissions from the influential cardinal and nephew of Pope Paul V, Scipione Borghese.

Carved in marble, Bernini's preferred medium, these three figures are arranged in spiraling poses reminiscent of Mannerist forms. In contrast to Mannerism, however, the figures are carved with the sense of an anatomical structure. Like the pulsating walls of Baroque architecture, the bones and muscles of Bernini's figures make visible their organic presence.

The textual basis of Bernini's statue is Book II of Virgil's *Aeneid,* which describes the fall of Troy and Aeneas's escape. Aeneas, in Virgil's account, places a lion skin over his shoulders and carries his aged father, Anchises, with the household gods (the Lares and Penates), from the burning city of Troy. Both gaze downward, despairing at the destruction of their civilization. The sense of resignation evinced by Anchises is consistent with his age, which is accentuated by thin proportions and a bony frame. Aeneas, on the other hand, is more robust and exudes an air of convic-

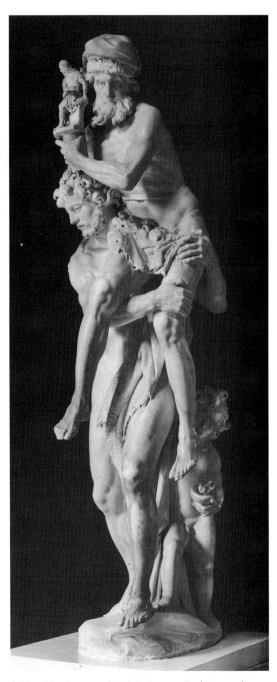

2.11 Gian Lorenzo Bernini, *Aeneas, Anchises, and Ascanius,* 1618–1619. Marble, 2.20 m high. Galleria Borghese, Rome. (Art Resource)

tion. His little son Ascanius expresses the anxiety experienced by children who are forced to leave their home. Naturalistically represented as a toddler-age child, he carries the sacred flame. Both Ascanius and his father step determinedly forward as if, despite their momentary despair, setting off on their destined mission.

In the vertical arrangement of three generations of figures, Bernini has created a totemic image, emphasizing the ancestral character of the mythic founding of Rome. Through Aeneas, whose mother was Venus, imperial Rome could trace its heritage to the gods. In the Christian era, this myth was absorbed into the notion of Christian piety by association with Virgil's *pius Aeneas*. Bernini thus alludes to the ancient view of Rome as *caput mundi* and integrates it with the role of the pope and the Vatican as embodying the centralized power of the Church.

With the marble sculpture of *David* of 1623 (2.12), also commissioned by Scipione Borghese, Bernini created a figure that commands space in a new way. In contrast to the overall verticality of the *Aeneas,* in the *David* the narrative is enhanced with diagonal planes and open spaces that actively engage the viewer. "He aims his stone," writes Wittkower, "at an imaginary Goliath who must be assumed on the central axis in space, where the beholder has to stand. Goliath is the necessary complement to the figure of David whose action would seem senseless without our postulating the existence of the giant."[2] In thus involving a space and characters beyond itself, Bernini's *David* has a theatrical quality that is characteristic of Baroque style. The *David* simultaneously projects outward

from his "stage" and also draws the viewer into the dramatic space.

The armor that David refuses in the biblical account of his battle with Goliath is visible on the ground behind him. Its presence accentuates David's decision to fight with only a stone and a slingshot, while the vigor of the body exemplifies the heroic nature of his triumph. That David's success is a victory of intelligence over brute force is shown by his intense concentration and focused gaze. His expression, which according to contemporary accounts is a mirror image of Bernini himself, reflects the artist's youthful identification with the biblical hero. Both achieved success as young men, and both had the sponsorship of powerful figures—David of King Saul and Saul's son Jonathan, and Bernini of important personages at the Vatican.[3]

David's typological role as an Old Testament precursor of Christ, as well as Goliath's association with Satan, enrich the meaning of Bernini's statue. For typology is here in the service of Counter-Reformation missionary zeal. In that light, the *David* can be seen as an allusion to the Church's battle against heretics—itself a struggle readily comparable to Christ's victory over Satan.

The year before Scipione Borghese's death at the age of fifty-seven, Bernini carved his **portrait bust** in marble (2.13). From his late adolescence, Bernini had developed a reputation as a penetrating portraitist, but with the portrait of Scipione he achieved a new kind of characterization. His belief that an artist should know his sitters was reflected in his attention to their personality and in his habit of drawing studies for their portraits.

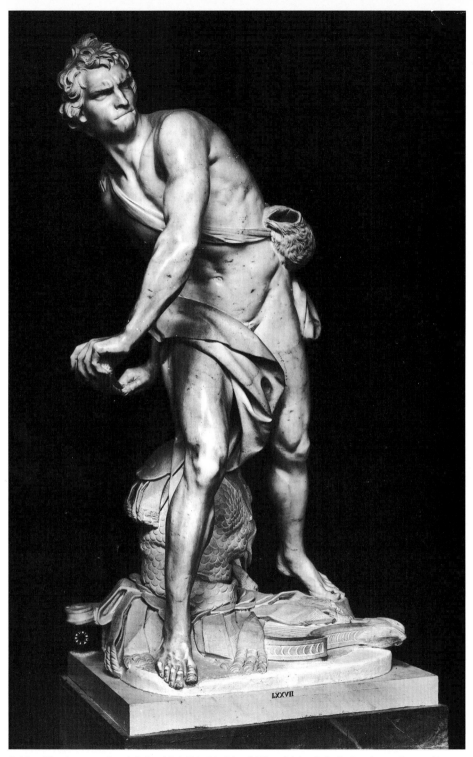

2.12 Gian Lorenzo Bernini, *David,* 1623. Marble, 1.70 m high. Galleria Borghese, Rome. (Art Resource)

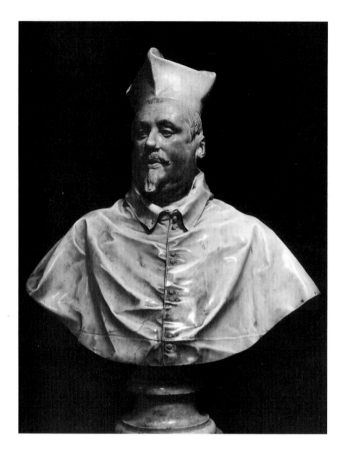

2.13 Gian Lorenzo Bernini, *Cardinal Scipione Borghese.* 1632. Marble, larger than life-size. Galleria Borghese, Rome. (Art Resource)

Despite the line indicating a crack that appeared in the course of the bust's execution (which prompted Bernini to make a second version), the portrait of Scipione is a remarkable portrayal of the cardinal's personality. He seems to turn spontaneously, as if something has just caught his attention and he is about to speak. In so doing, his ample proportions cause his neck and cheeks to bulge in waves of flesh. The eyes are penetrating and seem to reflect a lively intelligence. The asymmetry of the face and the diagonal plane of the head, which are counteracted by the slanted hat that seems barely large enough

for the massive head, create the impression of a dynamic individual engaged with the world.

The quality of engagement is characteristic of Bernini's human figures, and it elicits the viewer's empathy with them. In the *Aeneas,* we identify with the anxiety and despair of the fleeing trio as well as with the mythic sense of destiny contained in the text of the work. With the *David,* we are, as Wittkower observed, in Goliath's space and thus feel the dangerous power of the youth's intense concentration. The *Scipione* is represented as one of us, a man of some spiritual distinction whose response to an-

other's presence is nevertheless outgoing and entirely down-to-earth.

In the statue *Saint Longinus* (2.14), commissioned by the congregation of Saint Peter's for one of the niches supporting the dome, Bernini worked in his capacity as Architect of Saint Peter's. As such, he was involved with the interior decoration of the building as well as with the piazza. Located in the northeast pillar and set in an apsidal space, the subject was an appropriate one, for Saint Peter's housed the **relic** of Longinus's lance. Bernini invites the viewer to identify with the mystical ecstasy of the martyr, a circumstance promoted by the Council of Trent.

The story of the saint's martyrdom is told in the **apocryphal** Acts of Pilate as well as in the *Golden Legend* under March 15. A Roman centurion, Longinus was ordered by Pontius Pilate to stand guard at the Crucifixion, and it was he who pierced Christ's side with a lance. Two accounts of his conversion exist: in one, he recognizes Christ's divinity when the sky grows dark at his death; in the other, he is cured of an eye affliction when a drop of Christ's blood falls from the lance into his eye. Longinus resigns from the army to become a Christian monk and is martyred when he refuses to sacrifice to the pagan gods.

Bernini worked on the statue from around 1635 to 1638, carving it from four separate blocks of marble that comprise the torso, the right arm, the cloak at the right, and the cloak at the left and the back. In contrast to the *David,* whose gaze is focused on his living adversary, the *Longinus* gazes ecstatically heavenward, toward the light entering Saint Peter's from the dome. This is the moment of his conversion and, therefore, a kind of mystical recognition scene. As Longinus extends his arms in a broad diagonal plane that echoes the pose of Christ on the Cross, so the Counter-Reformation viewer is understood to identify with the saint and embrace his suffering. The deeply carved curvilinear folds of Longinus's drapery and the energized hair and beard impart a sense of inner turmoil as the saint is transformed from a pagan to a Christian. Whereas Bernini's David fights an external enemy, involving the viewer in the space of an unseen Goliath, Longinus changes within himself and evokes the viewer's empathy.

The potential instability of the statue is anchored by the diagonal of the lance, which serves an ambivalent function in one account of Longinus' conversion. It is both the instrument by which Christ is made to suffer and the link between Christ's blood and the centurion's healing. Longinus wears Roman armor under the drapery that signifies the turmoil of his recognition, while the helmet and sword that he has renounced lie at his feet. With Longinus' insight comes his rebirth as a Christian, which is alluded to in the scallop shell, itself denoting rebirth, on the base of the statue.

Another, more erotic form of mysticism is conveyed in Bernini's well-known *Ecstasy of Saint Teresa* in the chapel of the Cornaro family in Santa Maria della Vittoria in Rome (2.15). Because it is virtually impossible to include the entire space of the chapel in a photograph, an oil painting of it is illustrated here. It shows the entire altar wall, the two side walls with members of the family represented reading and conversing as if in theater boxes (but actually behind *prie-dieux*), and the ceiling space above the main scene. In this commission, which Bernini re-

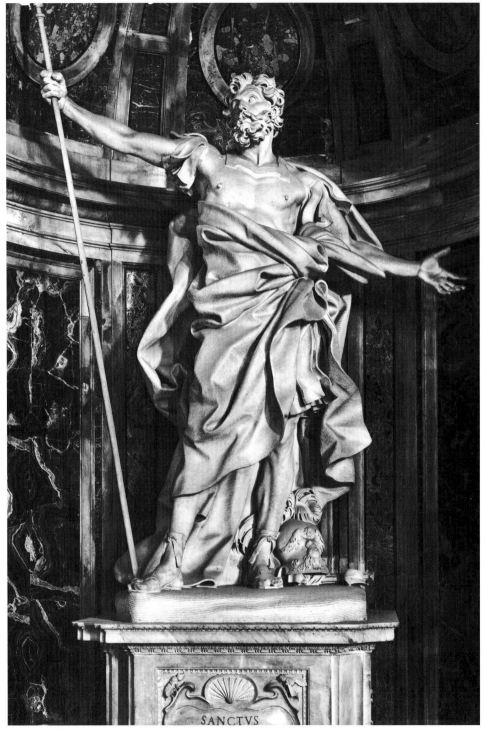

2.14 Gian Lorenzo Bernini, *Saint Longinus,* 1635–1638. Marble, c. 14 ½ ft. (4.40 m) high. Saint Peter's, Rome. (Art Resource)

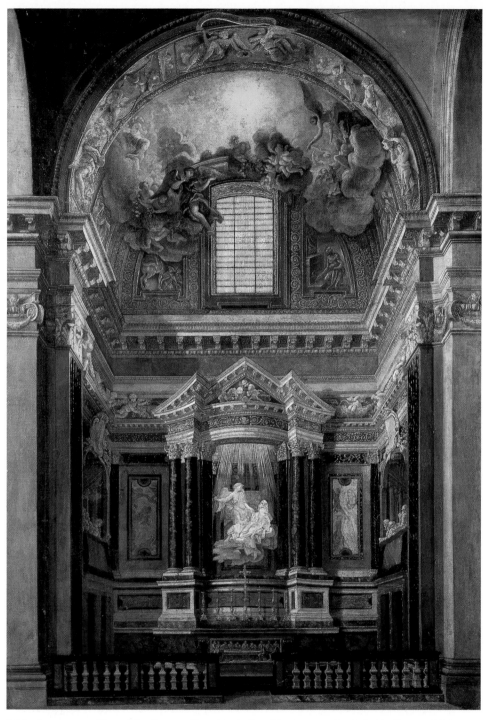

2.15 Anonymous, *View of the Cornaro Chapel,* including Gian Lorenzo Bernini's *The Ecstasy of Saint Teresa,* Santa Maria della Vittoria, Rome, 1645–1652. Oil on canvas, 5 ft. 6 ¹/₄ in. × 3 ft. 11 ¹/₄ in. (1.68 m × 1.2 m). Staatliches Museum, Schwerin, Germany. (Photo: E. Walford, Hamburg, Art Resource)

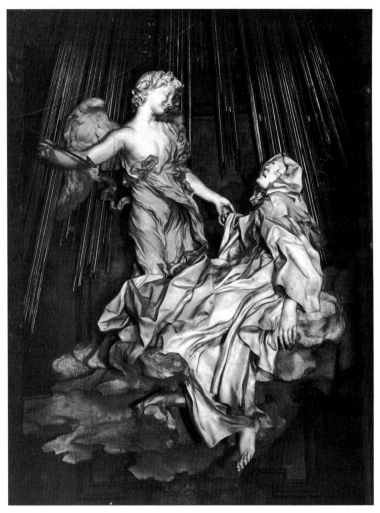

2.16 Gian Lorenzo Bernini, *The Ecstasy of Saint Teresa,* 1645–1652. Marble, life-size. Cornaro Chapel, Santa Maria della Vittoria, Rome. (Art Resource)

ceived from Cardinal Federico Cornaro shortly after 1644, the artist had a total environment in which to exercise his genius for combining emotional realism with Counter-Reformation spirituality.

The main scene (2.16), directly behind the altar, represents a mystical vision described by the Spanish Carmelite nun Saint Teresa of Avila (1515–1582) in her *Life.* Although Saint Teresa often saw angels, one vision made a particularly striking impression on her: an angel appeared, holding "a long golden arrow" with a "point of fire" at its iron tip. "With this," she wrote, "he seemed to pierce my heart several times so that it penetrated to my entrails. When he

drew it out, I thought he was drawing them out with it and he left me completely afire with a great love for God. . . . so excessive was the sweetness caused me by this intense pain that one can never wish to lose it. . . . It is not bodily pain, but spiritual, though the body has a share in it—indeed a great share."[4]

Bernini, like Teresa, was a devout Catholic and practiced the *Spiritual Exercises* of Saint Ignatius Loyola. He thus had first-hand experience of the meditations that evoke identification with the combined pleasure and pain of spiritual and physical suffering. At the same time, however, through his essential humanism and admiration of the Classical world, Bernini imbued even his most mystical works with psychological truth. As a result, his version of Saint Teresa's ecstasy shows her simultaneously swooning and levitating as a youthful angel draws back her dress and readies his arrow. She, herself, is in a state of physical relaxation as she yields to the angel, but the tension of her erotic excitement is displaced onto the agitated draperies and cloud formations.

The interplay of diagonal planes in the two figures is repeated by the gilded wooden diagonals representing divine light. As a group, the saint and the angel form a V-shape that opens up to receive the rays, themselves forming an inverted V. Their source appears to be the intense circle of light surrounding the Holy Ghost in the ceiling, which is aligned with the natural light of the window. Painted according to Bernini's design by one of his regular employees, Guidobaldo Abbatini, the ceiling appears to part in a blaze of light, leaving the illusionistic clouds and angels in rela-

tive shadow. The most intense illumination is on the gleaming white marble of the central group and on its fictive source, thus accentuating their divine correspondence.

The dynamic tension that pervades both the sculptures and the painting also characterizes the architectural setting. Accents of white and gold are repeated in the cornices and in the stucco figures of angels in the **frieze** and pediment. The niche containing the main event is framed by Corinthian columns with variegated shafts, and the curve of the broken pediment seems, like the walls of Borromini's buildings, to pulsate from within. [The notion of victory expressed in the triumphal arches of imperial Rome] is implied in the combination of rectangular **podia** supporting the columns with the curved entablature and pediment. Here, however, triumph refers to the triumph of faith in Christ.

Bernini completed the chapel in 1652. Four years earlier, he had begun work on one of several fountains he created for Roman piazzas. These are key Baroque works, for they contributed a new richness of form and spirit to the public squares of the city. Fountains generally can be seen as a Baroque development, especially in Rome, where they proliferated during the seventeenth century. They reflect the dynamic approach of the style to the urban environment as well as to interior sacred spaces.

The Pamphili pope Innocent X (papacy 1644–1655), had originally wanted Borromini to execute the Fountain of the Four Rivers in Piazza Navona (2.17), but changed his mind when he saw sketches by Bernini. This was Bernini's most monumental fountain, for which he was paid 3,000 scudi. It consisted of a travertine rock in the middle

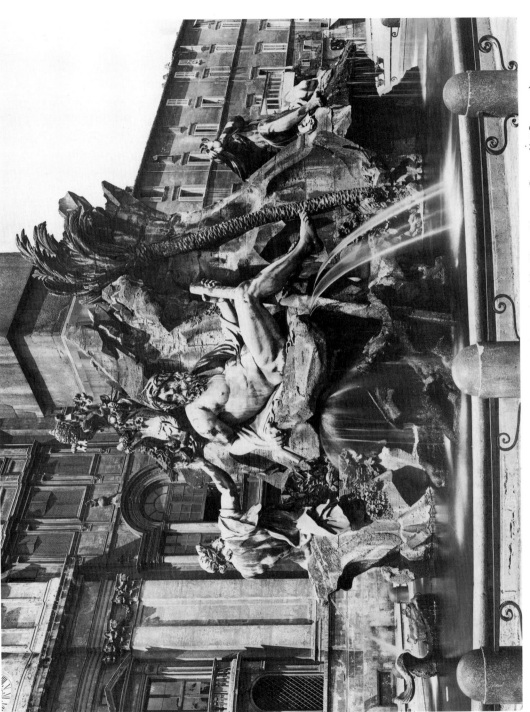

2.17 Gian Lorenzo Bernini, Fountain of the Four Rivers, 1648–1661. Travertine and marble. Piazza Navona, Rome. (Art Resource)

of the rectangular piazza with curved ends, from which water gushed forth. Four marble figures in strong, reclining **contrapposto** poses personify four rivers—the Danube, the Nile, the Ganges, and the Plata—signifying the pope's dominion over Europe, Africa, Asia, and America, respectively. Two coats of arms, between the Plata and the Nile and between the Ganges and the Danube proclaim both his patronage of the fountain and his sway over Christendom. The family insignia—lilies and a dove—correspond to standard Christian iconographic motifs denoting the purity of the Virgin and the Holy Ghost.

The Egyptian obelisk surmounting the rock serves several functions. Formally, it elevates the viewer's gaze heavenward and also confronts Borromini's Baroque church of Saint Agnese opposite. At the top of the obelisk are a dove and an olive branch, signifying the symbolic "conversion" of the pagan Egyptian structure to a Christian one, as well as being elements on the Pamphili coat of arms. It has been suggested that the arrangement of the obelisk with four rivers replicates the medieval motif of the Four Rivers of Paradise at the foot of Calvary—in which case the plane of the obelisk refers to the vertical of the Cross.

The fusion of the Classical river gods with the Christian implications of the fountain reflects Bernini's ability to negotiate the requirements of the Council of Trent while maintaining a humanist outlook. As with his other works, whether manifestly Classical—such as the *Aeneas*—or purely Christian—the *Longinus*—Bernini captures dramatic moments of spiritual and psychological transition and conveys them through form and space. The son of a lesser artist willing, like Picasso's father, to subordinate his own talent, Bernini exemplifies in his life and work the felicitous combination of discerning patronage and artistic genius. To a great extent, Bernini's **oeuvre** defines Baroque sculpture, which is reflected in the influence he exerted throughout the seventeenth century.

NOTES

1. Leland M. Roth, *Understanding Architecture* (New York, 1993), p. 370.

2. Rudolf Wittkower, *Sculpture: Processes and Principles* (New York, 1977), p. 169.

3. Bernini's biographer, Filippo Baldinucci, reported that Cardinal Maffeo Barberini—the future Pope Urban VIII—held up a mirror so that the artist could draw his own features. See F. Baldinucci, *Vita di Bernini,* trans. Catherine Enggass (University Park, Pa., and London, 1966), p. 78.

4. Cited in Linnea H. Wren, ed., *Perspectives on Western Art,* vol. 2 (New York, 1994), p. 126.

Baroque Painting in Rome

In Rome, the Baroque painters active from the late sixteenth century through about 1670 generally fall into two categories. The first, exemplified by Caravaggio, either decorated chapel walls or produced individual pictures for private patrons, or did both. The other, of which Giovanni Battista Gaulli (known as Baciccio) is a prime example, created dazzling church ceilings intended to glorify the Christian message.

Caravaggio

Michelangelo Merisi (1571–1610), who painted at the turn of the sixteenth century, is known by the name of his native town of Caravaggio in northern Italy. In 1593, around the age of twenty-two, Caravaggio arrived in Rome. From 1593 to 1595, he painted a series of boys in various erotic guises for the pleasure of a male viewer. These works constitute the artist's earliest distinctive statement of his revolutionary approach to realism.

The *Boy with a Basket of Fruit* (3.1) exemplifies Caravaggio's new approach, which achieves its powerful effect through a combination of pictorial and psychological truth. The boy himself is overtly flirtatious as he proffers himself to the viewer. Not only was the arrangement of the shirt—leaving one shoulder bare—a conventional sign of seductive intent, but the fruit plays the role of procurer between the boy and the viewer. The boy's rouged cheeks and reddish, slightly parted lips accentuate his homoerotic purpose. Clutching the fruit basket close to his chest, he enhances its meaning as a displaced self-image. This is made explicit in the highlighted yellow peach at the left, which is tinged with pink like the boy's cheeks and shaped and cleft like his bare shoulder. Both the boy and the fruit, Caravaggio implies, are ripe, succulent, and available for consumption.

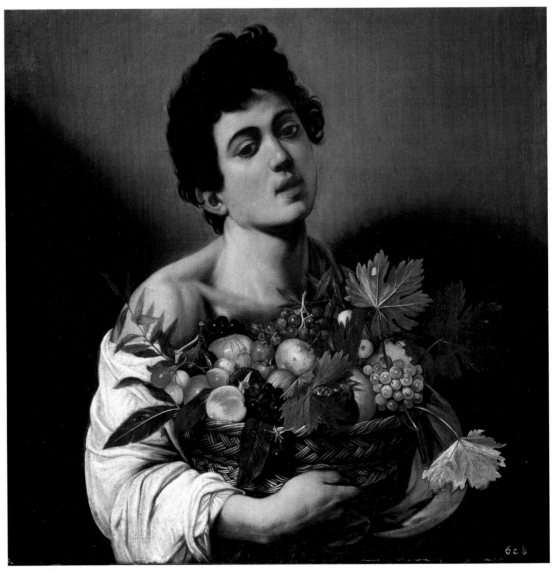

3.1 Caravaggio, *Boy with a Basket of Fruit,* c. 1594. Oil on canvas, 27 $^5/_8$ in. × 26 $^3/_8$ in. (70 cm × 67 cm). Galleria Borghese, Rome. (Scala/Art Resource)

Seventeenth-Century Biographers of Artists

Following the Renaissance revival of artists' biography, particularly Giorgio Vasari's *Lives,* several seventeenth-century authors wrote about artists. Filippo Baldinucci, author of *Notizie dei professori del disegno da Cimabue in qua . . .* , first published in 1681, wrote extensively on Bernini and emphasized the realism of both Caravaggio and Artemisia Gentileschi. He claimed that Gentileschi was particularly known for the realism of her portraits and still lifes. Giulio Mancini (*Considerazioni sulla pittura*), a medical doctor, and Giovanni Baglione (*Le vite de' pittori, scultori, e architetti*), a painter, noted Caravaggio's difficult temperament.

The leading contemporary art critic, Giovanni Pietro Bellori (*Le vite de' pittori, scultori e architetti moderni*) also wrote on archaeology. He considered Caravaggio too realistic and compared him with the Greek artist Demetrios, whose reputation in antiquity suffered from excessive realism. That is, he did not follow the platonic notion, also espoused by Raphael, of selecting the most beautiful elements from nature in order to create ideal beauty. As a result, Bellori preferred the more classicizing style of the Carracci.

In the north of Europe, Karel van Mander (1548–1606), author of *Het Schilderboeck,* emphasized Caravaggio's close study of nature. He noted the artist's argumentative personality and its interference with his art, observing in an often-cited metaphor that Mars and Minerva had never been friends. For the most part, Joachim von Sandrart (*Academie der Bau-, Bilde- und Mahlerei-Künste von 1675*) followed van Mander.

The convincing illusionistic character of the fruit justifies Caravaggio's reputation as the advocate of a new kind of realism. Determined to liberate painting from the affectations of Mannerism as well as from High Renaissance classicism, Caravaggio often produced difficult, controversial works. Some that had been painted for public display in churches were rejected by their ecclesiastical patrons. The *Boy with a Basket of Fruit,* however, was apparently created with a homosexual viewer in mind. The power of its realism resides not only in the illusionistically painted fruit, but also in the characterization of the figure. Its combination of seductive allure with a slightly wistful air—denoted by the crease in his forehead and downcast gaze—reveals the ambivalence of the boy's position as an object of male desire.

A significant subtext of the image is the ***vanitas*** theme, which deals with the passage of time. The fruit, like the boy, is ripe; the boy's pensiveness suggests his sense that he, too, becomes less appetizing as he grows old—a theme that Caravaggio takes up again in later paintings. Here, however, the boy, the fruit, and the artist himself are in their prime. Caravaggio has thus taken the traditional meaning of *vanitas*—that is, the transience of worldly concerns—out of its Christian moralizing context and has endowed it with a new psychological reality.

To further enhance the impact of his image, Caravaggio's use of Baroque lighting accentuates the directness of its confrontation with the viewer. The dramatic shift from light to dark in the background serves to "push" the boy forward—his dark hair is **silhouetted** against light and, at the same

time, frames his lighter face. Likewise, his white shirt is set against a dark background, while the fruit seems to be extended forward, nearly out of the picture plane, into the space of the viewer.

Caravaggio's dramatic use of light also characterizes his Christian paintings. In 1600, he was commissioned by the treasurer general of Pope Clement VIII, Monsignor Tiberio Cerasi, to paint two pictures—*The Conversion of Saint Paul* (3.2) and *The Crucifixion of Saint Peter*—for his funerary chapel in Santa Maria del Popolo in Rome. Here, too, the use of light and color as well as the force of the diagonal planes create strong juxtapositions that enhance the impact of the image. Like Bernini's *Saint Longinus,* Caravaggio's *Saint Paul* is shown at a moment of spiritual recognition and psychological transformation. In each case, the artist conforms to the rules of the Council of Trent, according to which imagery should evoke identification and empathy with the suffering martyr.

Caravaggio's picture is based on the text of Acts 9:3–9. Saul of Tarsus was a Jew traveling to Damascus on a mission to persecute Christians. At noon, on the road near Damascus, a bright light suddenly lit up the sky, and Saul fell to the ground, blinded. He heard a voice repeating his name and asking, "Why persecutest thou me?" When Saul asked who was speaking, the voice replied, "I am Jesus of Nazareth," and instructed him to continue to Damascus, where he would be told what to do.

Saul was led to Damascus and remained blind for three days until one of Christ's disciples touched him and restored his sight. Then he was baptized a Christian and became the apostle Paul. Paul's account thus makes use of the typological convention of a three-day time period—the same time that Jonah spent in the whale and that Christ spent in the tomb. Both, like Paul's blindness, entail being enclosed in darkness, followed by rebirth into light. In this metaphor, Paul follows the example of Christ and identifies with him. He also becomes Christ's most loyal apostle, who will eventually define, in large part, the future character of the Early Christian Church.

Paul's account of his blindness, like the story of Longinus' conversion, juxtaposes inner with outer light. The exterior light that makes vision possible is replaced in Saul's transformation by divine light. When Saul achieves true insight, he becomes a new person, symbolized by his change of name and baptism as a Christian. In Caravaggio's picture, consistent with iconographic tradition, the light knocks Saul from his horse, and he falls toward the picture plane. Saul's outstretched arms allude visually to the Crucifixion, accentuating the identification with Christ and seeming to welcome the divine light. Caravaggio translates the suddenness of the light in the text into harsh shifts from dark to light.

The sense of realism is also accentuated by Saul's abrupt **foreshortening** and the low viewpoint that corresponds to the position of actual viewers in the church. Highlights of light illuminate the red cloak that sprawls across the ground—possibly a chromatic echo of the blood of Christ. The horse lifts its right foreleg as the groom pulls on its bridle to prevent it from stamping on the fallen rider. The massiveness of the animal, still standing and reacting, like the groom, without understanding the significance of the event, creates a foil for the fallen figure.

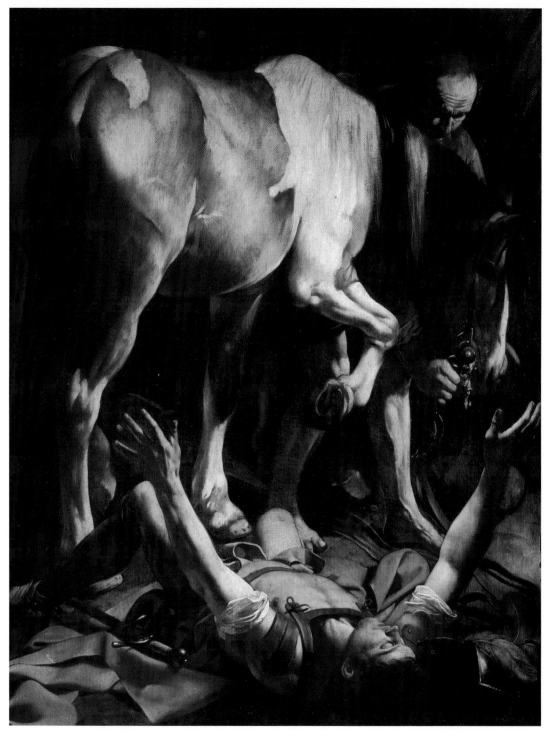

3.2 Caravaggio, *The Conversion of Saint Paul,* 1601. Oil on canvas, 90 $^5/_8$ in. × 68 $^7/_8$ in. (230 cm × 175 cm).
Cerasi Chapel, Santa Maria del Popolo, Rome. (Scala/Art Resource)

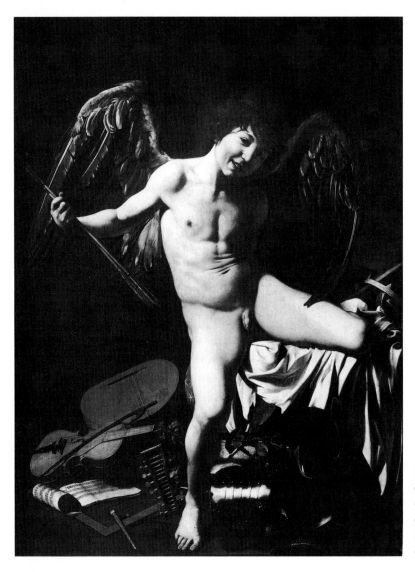

3.3 Caravaggio, *Amor,*
c. 1601–1602. Oil on canvas,
60 $^5/_8$ in. × 43 $^1/_4$ in.
(154 cm × 110 cm).
Staatliche Museen, Berlin.
(Art Resource)

Diagonal planes enhance these juxtapositions and engage the viewer spatially as well as emotionally in Saul's experience.

In both the *Boy with a Basket of Fruit* and *The Conversion of Saint Paul,* Caravaggio depicts naturalistic textures—the fruit with its illusion of glistening moisture and the horse's hair. Similar effects are found in the remarkable *Amor* (3.3). Caravaggio was reputed to have kept various props, including real birds' wings, in his studio. In the *Amor,* the realistic texture of the wings forms a striking contrast to the Classical idealization of High Renaissance painting. Their juxtaposition with the soft human flesh of Cupid has a dreamlike, surreal quality, consciously constructed to resemble an unconscious fantasy.

Also striking is the vividness of the illuminated boy and his homoerotic invitation to the viewer. Gone is the wistful pensiveness of the boy holding the fruit basket and the suggestion that time will have its day. Instead, *Amor* is triumphant, and his triumph is explicitly sexual. Strewn on the floor are an open music book, instruments of both music and geometry, and pieces of armor. On the rumpled bed are the accoutrements of kingship. Cupid's arrow and the tip of his left wing flagrantly focus attention on the boy's phallus, while the lighthearted facial expression indicates that he is enjoying his own erotic playfulness.

The relationship of Caravaggio's iconography with the painting's patron is not certain. Vincenzo Giustiniani, a Roman nobleman, "hung it in a place of honor and considered it priceless."[1] He also hid it behind a green silk curtain. Nevertheless, the *Amor* makes a scandalous impression even today and does not fail to arrest the gaze of those who catch sight of it, whether reproduced in a book or on display in a museum. One can only assume that the painting produced a similar effect on the artist's contemporaries.

Whereas Bernini was able to combine eroticism with spirituality—most evident in the *Saint Teresa*—Caravaggio often merged erotic content with violence. There are intimations of that combination in the three paintings discussed so far, but it is explicit in his works dealing with the theme of decapitation. *David with the Head of Goliath* (3.4) is generally dated toward the end of the artist's career—that is, around 1609–1610. It depicts a wistful David, one shoulder bare like the boy with the fruit basket; but instead of proffering fruit, he holds Goliath's head. Nor is the David offering himself to the viewer. Rather than gaze out of the picture, David looks at the defeated Philistine, who, in turn, gazes down at something unseen by the viewer. By a play of typically Baroque diagonals and dramatic highlights of light piercing through darkness—the sword; the tilted head, torso, and left arm of David; and Goliath's head—the viewer's gaze is also directed downward. It seems likely, given the biblical text, that what is not seen is Goliath's decapitated body and that Goliath's head expresses horror at the sight of it.

According to a seventeenth-century source, the Goliath is Caravaggio's self-portrait and the David is that of his young lover.[2] As such, this painting reflects the artist's insistence on a new type of realism that is at once anti-Classical, free of Mannerist artifice, and psychologically truthful. An important aspect of the latter is the autobiographical character of the iconography, which reveals Caravaggio's identification with beheaded figures. The fact that Goliath's head is simultaneously dead and alive is as much a psychological self-image as a literal self-portrait, perhaps more so.

Caravaggio's realism inspired a considerable following both in Italy and in northern Europe. Known as the *Caravaggisti*, the followers were drawn to his dramatic contrasts of light and dark as well as to his **tenebrism**—the use of strong darks on extended areas of the picture plane.

Artemisia Gentileschi

The artist who perhaps most shared Caravaggio's penchant for violent themes colored by erotic subtexts was Artemisia Gen-

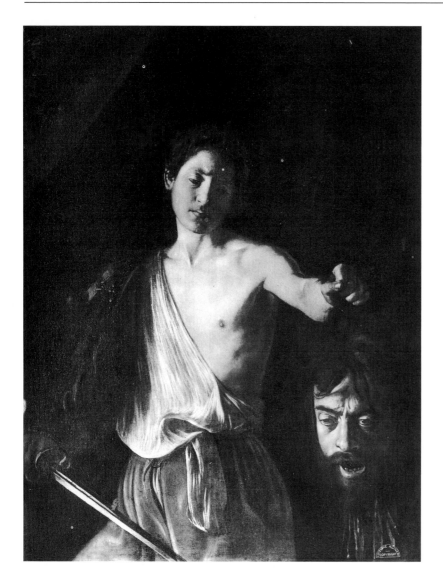

3.4 Caravaggio, *David with the Head of Goliath*, c. 1609–1610. Oil on canvas, 49 1/4 in. × 39 3/8 in. (125 cm × 100 cm). Galleria Borghese, Rome. (Art Resource)

tileschi (1593–c. 1653). Her success as a painter was unusual for a woman in the first half of the seventeenth century. In 1616, at the age of twenty-three, she was elected to the Academy of Design in Florence, where she worked for the grand duke of Tuscany. She resided primarily in Rome in the 1620s, although she also worked in Genoa and Venice, and moved to Naples in the 1630s.

From 1638, Artemisia spent about three years at the English court of Charles I, where her father had worked since the 1620s; she then moved back to Naples, where she spent the remainder of her life.[3]

In his iconography, Caravaggio identified with the victims of violence—although in reality he was himself convicted of murder and was frequently arrested for violence.

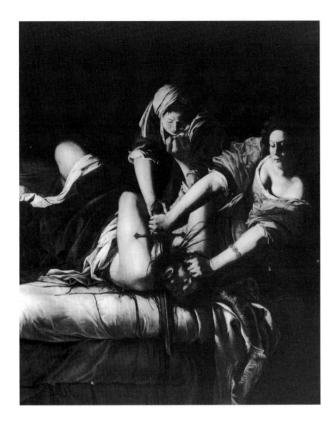

3.5 Artemisia Gentileschi, *Judith and Holofernes,* c. 1620. Galleria degli Uffizi, Florence. (Art Resource)

Artemisia had been a victim of rape but, in her art, identified with active, heroic women. She painted, for example, several versions of *Judith and Holofernes,* in which a woman destroys a male oppressor. According to the Old Testament Apocrypha, Judith, a Hebrew widow from Bethulia, goes with her servant Abra to the camp of the invading Assyrian general, Holofernes. He invites Judith to dinner and becomes inebriated. Upon returning with her to his tent, he falls onto his bed; she takes up his scimitar and decapitates him. With the assistance of Abra, Judith places Holofernes' head in a food bag and returns to Bethulia. The head is displayed from the city walls, and the Assyrian army disperses.

Artemisia's *Judith and Holofernes* of around 1620 (3.5), now in the Uffizi, shows the killing in progress. Judith and Abra hold down their struggling victim, who tries vainly to repel them with his powerful right hand. His eyes are still open, their whites an echo of the teeth visible between parted lips, indicating that he, like Caravaggio's Goliath, is aware of his own death. Here, however, the eyes are averted from the body—or, in the case of Goliath, the implied body—as Judith grasps the head and twists it.

The sense of struggle is enhanced by the dynamic crossing of diagonal planes and the alternation of bare flesh with drapery. The red-velvet covering on Holofernes re-

peats the reds on the women's sleeves and the blood spurting from his neck. Judith pulls the sword toward herself as Abra pushes down on Holofernes, creating thrusting countermovements that converge on the head that is being severed. Motion is also conveyed by the rivulets of blood running along the folds of the sheets, indicating that it has not yet congealed and emphasizing that Holofernes is still alive. The detail of the sword hilt pressing into the flesh of the Assyrian general exemplifies the artist's attention to the physical reality of Judith's deed.

Artemisia's identification with Judith, which would be consistent with the circumstances of her trial (see the box),[4] is confirmed by the bracelet on Judith's upper arm. Contained within the two visible sections are images of a woman, one with a bow and the other with a raised arm and what might be an animal. This conforms to the traditional iconography of Artemis, the Greek goddess of the moon and the hunt.[5] As such, the image is both the artist's "signature" and the "sign" of her identification with the virgin goddess,[6] who, as in the myth of Actaeon, destroys men who transgress the bounds of propriety.

Artemisia's *Judith and Her Maidservant with the Head of Holofernes* of around 1625 (3.6) has been called both her masterpiece and the epitome of her Caravaggism.[7] As in the *Judith and Holofernes,* the two women are thrown into relief against a nearly black background by their illumination; but the presence of the candle creates new, more subtle variations in shading and sharpens the oppositions of light and dark. The richness of color and texture has also been enhanced—the light on the drapery covering Judith's right leg is nearly white, while the tops of her arms and part of her face are darkly shaded.[8]

Whereas the *Judith and Holofernes* creates a play of thrusting diagonals, *Judith and Her Maidservant* is animated by a series of rhythmic curves. Their opposing directions are consistent with the fact that the moment represented has caught Judith and Abra at a point of arrested action. The curve of the nearly silhouetted sword leads the viewer's gaze back toward the blackness of the tent from which the women are about to emerge. At the same time, the forward curve of Judith's left arm, echoing the curtain, advances the narrative and simultaneously suspends it. The women appear to have been interrupted by the sight or sound of something—Abra pauses in the act of stuffing Holofernes' head into the bag as Judith raises a cautionary hand. Abra, her left arm, which presses the bloodied material around the decapitated head, forming a third curve—repeating that of Judith's left arm and the sword—momentarily pauses to look up from her grisly task.

In addition to the planar movement and countermovement, Gentileschi has created a progression of color that unifies the composition chromatically. The yellow of Judith's dress is related both to her own red lips and to the red curtain, edged with gold threads, by the orange tone of the drapery over her right shoulder. Picking up the red is the lace on Abra's left shoulder, which creates a transition to her purple sleeves. These, in turn, are related to the blue dress. Finally, the head of Holofernes, tinged with the green pallor of death, links the yellow of Judith's dress with the blue of Abra's.

The head thus forms a chromatic connection between the two women, in which the viewer also becomes engaged. Judith

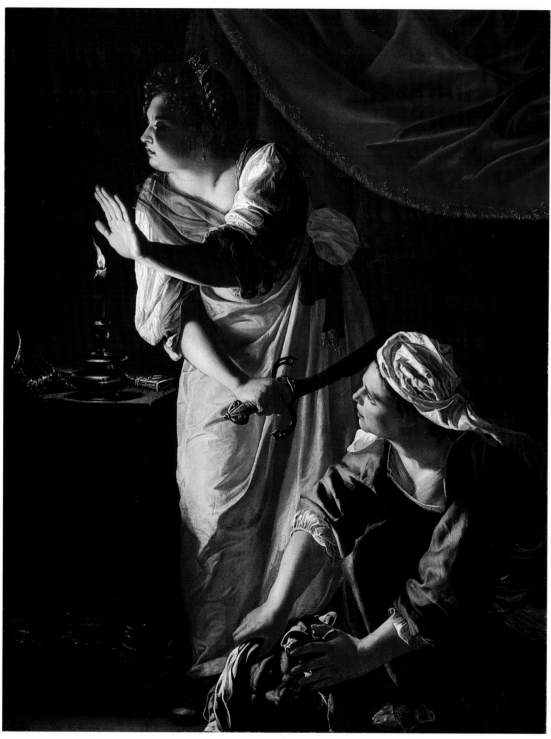

3.6 Artemisia Gentileschi, *Judith and Her Maidservant with the Head of Holofernes,* c. 1625. Oil on canvas, 72 ¹/₂ in. × 55 ³/₄ in. (184.1 cm × 141.6 cm). Detroit Institute of Arts, gift of Leslie H. Green.

Artemisia Gentileschi: The Trial

Artemisia, the only daughter among four children, was trained as a painter by her father, Orazio Gentileschi, who was himself a proponent of Caravaggio's realism. Orazio hired another painter, Agostino Tassi, to teach Artemisia perspective. Assisted by one Tuzia, a woman who lived in the Gentileschi household, Tassi had several romantic encounters with Artemisia; he raped her and then refused to marry her. In 1612, Orazio sued Tassi, and the resulting seven-month trial provides a window onto the *mores* of the time. Artemisia was betrayed by Tuzia, who testified against her, a circumstance that has been related to the artist's depiction of female unity in the *Judith and Holofernes* paintings. During the trial, Artemisia convincingly described her resistance to Tassi; but it was she, rather than the accused, who was tortured to ascertain the truth of her testimony. After the trial, Artemisia married another man, apparently a relative of one of the witnesses who had testified on her behalf.

and Abra look warily at a perceived potential danger, but Holofernes is sightless as well as headless. His face, and particularly his eyes, seems to recede into blackness. The contrast of his bloodless, unseeing severed head with the alert gazes and formal illumination of the women accentuates his role as the trophy that inspired their heroic unity of purpose.

The Baroque Ceiling

In individual canvases and sculptures, Baroque artists use various means to draw viewers into a constructed space. Baroque ceilings, however, are located directly above the viewer but at a considerable distance. In the most dramatic instances, they transform the traditional associations of ceilings with the heavens into images that satisfy the requirements of the Counter-Reformation by glorifying the Church.

The Ceiling of the Farnese Gallery

With the precedent of the Sistine Ceiling, the Baroque ceiling painters of Rome extended Michelangelo's High Renaissance illusionism. Early in the Baroque period, from 1597 to 1601, Annibale Carracci (1560–1609), briefly assisted by his brother Agostino (1557–1602), decorated the ceiling of the Farnese Palace gallery with scenes of the loves of the gods (3.7). The work exemplifies a Classical trend in the Baroque style that also reflects the tastes of the Carracci family.

Originally from Bologna, the Carracci founded an academy to teach the practice and study of art. They encouraged art students to learn ancient and Renaissance styles as well as anatomy, which is apparent in the Farnese ceiling. Both in terms of style and content, the decoration forms a transition between the classicizing High Renaissance works of Raphael, Michelangelo, and Titian, and Baroque exuberance. As with the works of Caravaggio, the figures are lifelike, but the eroticism comes from Ovid's *Metamorphoses* and other ancient sources. As a result, in contrast to the erotic dialogue constructed, for example, between Caravaggio's *Amor* and the viewer, the visitor to the Farnese Gallery gazes at Carracci's characters

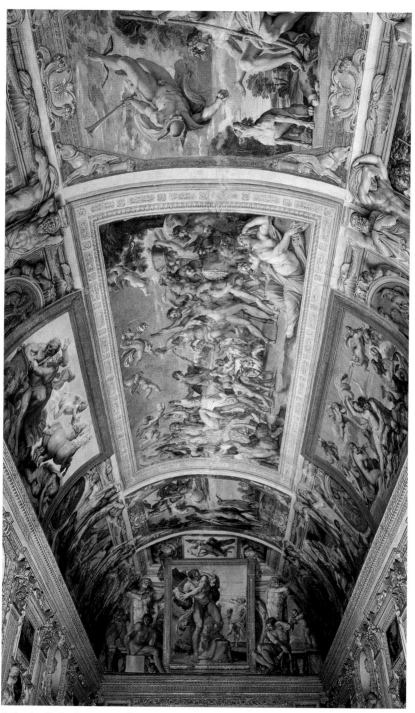

3.7 Annibale Carracci, gallery ceiling, Farnese Palace, Rome, 1597–1601. Fresco.
(Scala/Art Resource)

enacting mythological narratives. The relative distance, both physical and psychological, between viewers and the ceiling images is consistent with the Carracci preference for Classical restraint.

The Farnese ceiling is a barrel vault filled with vigorous, heroic nudes that reflect Annibale's attempt to renounce Mannerist affectation. The center scene depicting a *Triumph of Bacchus and Ariadne* is the largest. Flesh-colored nude males, **caryatid** giants in **grisaille** (imitation stone), and medallions are derived from prototypes on Michelangelo's Sistine Ceiling. These figures flank the narrative scenes and occasionally seem to turn and gaze at them. In so doing, they invite the visitor to twist and turn as they do in order to observe the gods' amorous pursuits.

The multiple formal light sources enhance the energetic figural movement. Individual panels have their own light source, while the figures outside the frames are illuminated as if from below. This facilitates the viewer's identification with the exterior figures observing the narrative scenes. Compared with the Renaissance perspective system in which the eye of the viewer is controlled by linear perspective, Carracci's frescoes involve the viewer with dynamic shifts in lighting and space.

The amorous iconography of the ceiling is consistent with the commission. Painted for the marriage of Ranuccio Farnese, Duke of Parma, the loves of the gods were intended to inspire romance in the newlyweds. In addition to the *Triumph of Bacchus and Ariadne* at the center of the ceiling, the *Wrath of Polyphemus* is visible at the far end of Figure 3.7. Bellori, the biographer of the Carracci, describes the Polyphemus in vivid terms: "The formidable giant turns and hurls a rock

. . . and his motion is most furious. He has one foot on the boulder, pressing down with his toes, as he draws the rock back in order to hurl it with greater force."[9] Bellori points out that in creating a convincing image of destructive rage, Annibale followed the advice of Leonardo da Vinci for depicting movement in the use of force: "He who wishes to hurl spears or rocks, having turned his feet toward the desired target, turns and twists and moves in the opposite direction where he prepares the disposition of his strength and turns swiftly and advantageously to the place and lets the weight fly from his hands."[10]

The motive for the Farnese iconography was not only amorous; it was also intended to evoke the divine origins of the city of Rome. In the scene of *Venus and Anchises* (3.8), Cupid encourages the romance between his mother, goddess of love and beauty, and the mortal Trojan hero Anchises. On Venus's footstool, a phrase from Virgil's *Aeneid* is visible: "GENUS UNDE LATINUM" [Whence the Latin race]. This alludes to the role of Venus and Anchises as the parents of Aeneas, the legendary founder of Rome and an ancestor of the Farnese family. The choice of this scene, therefore, identifies the progenitors of the Roman people with the Duke of Parma and his bride, and reinforces the Farnese connection to Rome itself.

The Ceiling of the Gesù

By the late 1670s, the Baroque ceiling had reached its height with Giovanni Battista Gaulli's (1639–1709) *Triumph of the Name of Jesus* (3.9) in the church of the Gesù. Born in Genoa, Gaulli had worked as Bernini's assis-

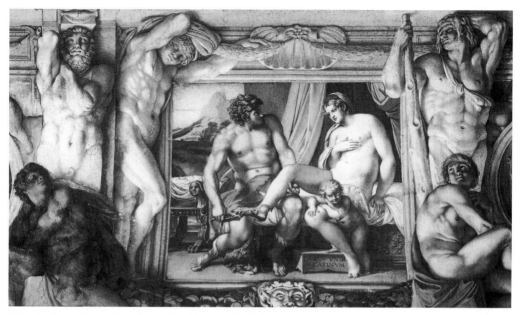

3.8 Annibale Carracci, *Venus and Anchises,* detail of the Farnese Gallery ceiling, Rome, 1597–1601. Fresco. (Art Resource)

tant in Rome. Like Bernini's dramatic environment in the Cornaro Chapel, Gaulli's fresco is a synthesis of physical and emotional exuberance with mystical spirituality. In contrast to the much earlier, classicizing decoration of the Farnese Gallery ceiling, which relates the pagan gods to human life and Roman history, the ceiling of the Gesù depicts a vision of the future. Gaulli does not invite viewers to identify with narrative scenes or with individual personalities, as Carracci does. He depicts, instead, a kind of abstract Last Judgment in which the saved and the damned are separated by light and dark, respectively.

The highest light is the yellow-white of the IHS, the first three letters of Jesus' name in Greek, which seems to draw the saved upward, through an opening in the ceiling, toward itself. Pulled downward by the weight of their sin, on the other hand, the damned (who include personifications of the religious heresies) tumble in darkness toward the earthly viewers. The damned form clusters of disordered, panicked confusion as they are forever denied the sight of God. The dark undersides of the illusionistic clouds make clear that the source of light is the heavens, indicating that the pyramidal group farthest from the IHS is destined for eternal damnation.

As the ceiling seems to open up and become sky, so Gaulli merges painting and sculpture with architecture, thus illusionistically unifying the arts in the service of Christian triumph. The solid vault of the nave dissolves into sky, which emphasizes the role of the Church as intermediary between the material, earthly world and the immateriality of eternal salvation. In drawing the saved into the spiritual realms, Gaulli reverses Bernini's arrangement in

3.9 Giovanni Battista Gaulli (Baciccio), *Triumph of the Name of Jesus,* 1676–1679. Ceiling fresco. Il Gesù, Rome. (Scala/Art Resource)

the Cornaro Chapel, where divine light is rendered concretely as gilded rays descending from heaven into the church.

Gaulli's iconography is an innovative portrayal of the biblical relationship of illumination and the power of the word to the person of Christ. In the Bible, Christ is both the "Light of the world" (John 9:5) and "the Word made flesh" (John 1:14). He is born of God's Word, from which the universe was created—"In the beginning was the Word, and the Word was with God, and the Word was God" (John 1:1). In the Gospel of Saint John (1:8), the Word and the Light are associated, although they are not the same—"He was not that Light, but was sent to bear witness of that Light."

In Gaulli's fresco, the name of Christ and divine light are represented as one and the same. The artist essentially depicts the undoing, or reversal—like a cinematic rewind—of the process of creation. God created the universe with his Word—that is, by speech: "Let there be light" made light, and "Let there be dark" made dark. Similarly, since Christ himself was made flesh by the Word of God, artists evolved the iconographic convention of certain Annunciation scenes in which Gabriel's words, printed across the picture plane, extend from the archangel's mouth to Mary's ear. Also portrayed in the Annunciation is the notion that God the Father is the ultimate source of light. Hence the need for the two elements that impregnate Mary and transform a concept into a conception: God's light entering either Mary herself or her architectural enclosure, and the verbal announcement made by Gabriel.[11]

The *Triumph of the Name of Jesus* rewinds time, absorbing the saved into the immaterial abstraction of pure light and the Word, IHS. The former signifies the idea of Christ as the "Light of the world" with all its implications, and the latter names him. In both Matthew (1:20–21) and Luke (1:31), the emphasis on the name of Christ is made explicit, when Joseph, God's earthly counterpart, dreams the angel's instruction "Thou shalt call his name Jesus." On the ceiling of the Gesù, what had been flesh is shown in the process of becoming again the Word and the Light, of returning to the time before creation—that is, before the spoken Word, when creation was still an idea (the Light). In so doing, the saved enter a preverbal realm of eternal timelessness.

In a culmination of the Baroque church ceiling, Gaulli has given visual form to the logocentric character of the Judeo-Christian tradition. He has combined creation and uncreation in a monumental image of the world being unborn, or reborn, into the light of an idea. It is no coincidence that the saved are drawn inside the framed image and the damned are ejected from it, and that the frame is in the shape of a **cartouche**. Ever since the Renaissance, Italian artists had been conversant with Egyptian forms, and they well knew that the purpose of a cartouche, a rectangle with curved short sides, was to frame the name of a king.[12] Here the king is Christ, rendered as God's Word, the IHS, merged with light. As such, Gaulli's monumental image epitomized Counter-Reformation fervor, glorifying the Christian spirit in the Church named Jesus.

NOTES

1. Howard Hibbard, *Caravaggio* (New York, 1983), p. 155.

2. *Ibid.*, pp. 331–332. For a psychoanalytic reading of this work, see Laurie Schneider, "Donatello and Caravaggio: The Iconography of Decapitation," *American Imago* 33, no. 1 (Spring 1976): 76–91.

3. Mary D. Garrard, *Artemisia Gentileschi* (Princeton, 1989), p. 21 interprets Artemisia's representation of the "solidarity and unity between women" as a "compensatory fantasy in her art."

4. For the trial transcript, see *ibid.*, app. B.

5. *Ibid.*, pp. 326–327.

6. *Ibid.*

7. *Ibid.*, p. 328.

8. Garrard (*ibid.*, pp. 334–335) relates the curved shadow on Judith's face to **chiaroscuro** drawings of the moon of around 1610 by Galileo, whom Artemisia had known in Florence. Garrard argues that, like the images on the bracelet, the shadow is an allusion to Artemis and hence to the artist's identification with her.

9. Giovanni Pietro Bellori, *The Lives of Annibale and Agostino Carracci,* trans. Catherine Enggass (University Park, Pa., and London, 1968), p. 45.

10. *Ibid.*, p. 46.

11. See Ernest Jones, "The Madonna's Conception through the Ear," in *Essays in Applied Psychoanalysis*, vol. 1 (New York, 1964), pp. 266–357.

12. For additional, but related, implications of the cartouche, see Jacques Derrida, "Cartouches," in *The Truth in Painting*, trans. Geoff Bennington and Ian McLeod (Chicago and London, 1987), pp. 183–247.

Velázquez and
the Court of Philip IV

Seventeenth-century Baroque painting in Spain was dominated by the prodigious genius of Diego Rodríguez de Silva y Velázquez (1599–1660). Velázquez was born in Seville, where he joined the painter's guild in 1617 and produced his first paintings, consisting mainly of genre scenes, portraits, and Christian subjects. These are characterized by a dark palette, especially browns and blacks. Even in these early scenes, Velázquez's figures have a quality of immediate presence accentuated by abrupt illumination that throws them into relief against dark backgrounds. In his use of blacks juxtaposed with dramatic highlighting, Velázquez's style is reminiscent of Caravaggio's tenebrism. In his methods of conveying character and the illusion of surface textures, Velázquez also has affinities with the realism of Caravaggio. But scholars disagree on both the nature and likelihood of Caravaggio's influence on the Spanish artist.

The first of seven children, Velázquez came from a middle-class family, and in 1610 his father apprenticed him to the humanist painter Francisco Pacheco. As a result, Velázquez combined artistic genius with an intellectual training based on the humanist traditions of the Renaissance. He differed from contemporary Spanish painters not only in his superior education, but also in having traveled to Italy, where he studied High Renaissance works, particularly those of Raphael and Titian. The rich, painterly textures of Titian and other High Renaissance Venetian artists, however, appealed to Velázquez's inclinations more than the restrained classicism of Raphael and the Florentine painters.

From a political standpoint, seventeenth-century Spain was an international crossroads. It ruled parts of Europe and the Americas, from both of which diplomatic envoys regularly visited the Spanish court. Artistically, however, Spain was provincial

Francisco Pacheco

Pacheco belonged to an academy that had been founded on the same principles as the Renaissance humanist academies. Composed of artists and writers, the academy was inspired by the ideas of the Dutch humanist Erasmus of Rotterdam as well as the Classical revival. From 1600, Pacheco worked on his treatise on the arts, *Arte de la pintura,* which defended the view that painting should be elevated to the status of a liberal art in Spain, as it had in Italy during the Renaissance. Pacheco's affinity for the Classical revival is evident in his assertion that only Velázquez was permitted to paint the king's portrait. In that account, he had recourse to the Classical model of the anecdotal tradition according to which Alexander the Great would allow only Apelles to paint *his* portrait.

In 1618, Pacheco's daughter married Velázquez.

in comparison to other Western European countries. Painting was still considered a handicraft, and the medieval guild system persisted. To a large extent, iconography reflected Counter-Reformation requirements.

The center of Spanish patronage was the court, ruled from 1621 to 1665 by the Habsburg monarch Philip IV. His grandfather, Philip II, had moved the court to Madrid in 1561 and amassed an impressive collection of Italian and Flemish paintings. In 1623, the twenty-four-year-old Velázquez was introduced to Philip IV through the good offices of the count-duke of Olivares, Gaspar de Guzmán y Pimental, the king's adviser, who had connections in Seville. In October of that year, thanks to a portrait he painted of the king, Velázquez was appointed Royal Painter.

Once established at court, Velázquez's career turned in the direction that it would follow for the remainder of his life. He combined the political skills necessary to negotiate the intricacies of court protocol with his remarkable genius as a painter. In addition, he encountered the continual envy of lesser artists at court. Fortunately, Philip IV, who was raised with the art collections of his grandfather and great-grandfather as examples, proved to be a discerning patron.

At the Spanish court, Velázquez's development as a painter benefited from the influence of Anthony van Dyck (see Chapter 6), court painter to Charles I of England, and of Peter Paul Rubens (see Chapter 6), who traveled to Madrid on various diplomatic missions. Rubens's enormous success as an artist spurred Velázquez's emulation of his painterly style. Partly at the urging of Rubens, Velázquez visited Italy, which inspired significant developments in his approach to painting. From the beginning, Velázquez's career was marked by his wish not only for the elevation of the status of painting from a handicraft to a liberal art, but also for his own elevation to the nobility. This is a theme that recurs in the iconography of certain of his works and that determined his ambition to succeed within the court hierarchy.

In March 1627, Velázquez was appointed Usher of the Privy Chamber and, two years later, made his first trip to Italy. His early full-length portraits in particular reveal his efforts to loosen the tighter brushwork of his earliest pictures in Seville. In formally elevating his sitters by tilting upward the

Philip II

Philip II of Spain was a discerning art patron who commissioned work from leading High Renaissance painters, especially the Venetians. His own father, Charles V, had been painted by Titian. After moving his court to Madrid, Philip II undertook an extensive building program, little of which was ever realized. He built El Escorial to the north of Madrid as a royal family tomb, palace, and monastery. In Madrid itself, Philip converted the Alcázar, a medieval palace, to a royal residence, while the Pardo, a few miles north of the Escorial, served as a retreat for the king during hunting trips. Philip's collection, combined with that of Charles V, provided subsequent monarchs with a model of magnificent patronage and the inhabitants of the court with an artistic environment of exceptional quality.

floors on which they stand, Velázquez symbolically ennobled them vis-à-vis the viewer. He also implicitly paid homage to their superior status, compared with his own. In the long run, Velázquez's diplomatic and political skills would accrue to his advantage.

Christ After the Flagellation

Although there are problems dating Velázquez's pictures, some of which he himself repainted, two key monuments that are not portraits have been dated to his first period at court.[1] Both retain the relatively smooth paint surfaces and areas of darkness that characterize his early style.

Christ After the Flagellation, Contemplated by the Christian Soul (4.1) was an unusual subject in Spain and unknown elsewhere in Europe.[2] It does not conform to the biblical text, but does satisfy Counter-Reformation taste for mystical imagery that evokes the viewer's identification with Christian suffering. A wearied and beaten Christ is tied to the column of the Flagellation as he gazes sadly at the personification of the Christian Soul behind him. The weight of his arms vainly pulling on the rope is indicated by its tautness, which is juxtaposed with the other end of the rope dangling from the knot. The dark tone of Christ's limp hands signifies the reality that the tightened rope would have cut off his circulation.

Prominently displayed in the center foreground is the whip used by Christ's torturers. Like Christ himself, it seems to emerge into light from the shadows. The discrete touches of red around Christ's shoulders and loincloth indicate that the whip has done its work. Furthermore, the strands that have come loose from the whip lie about Christ on the floor, reinforcing the impression that Velázquez has represented the aftermath of the Flagellation. The mystical character of Christ's suffering is accentuated by the glow of light around his head and the diagonal ray connecting it with the Christian Soul. The angel, whose softly textured wings recall those of Caravaggio's *Amor* (3.3), gazes down at the Soul while gesturing toward Christ. Combining the iconography of light with formal light, Velázquez depicts Christ literally and figuratively as the "Light of the world."

4.1 Diego Velázquez, *Christ After the Flagellation, Contemplated by the Christian Soul*. Oil on canvas, 5 ft. 5 in. × 6 ft. 9 in. (1.65 m × 2.06 m). National Gallery, London. (Art Resource)

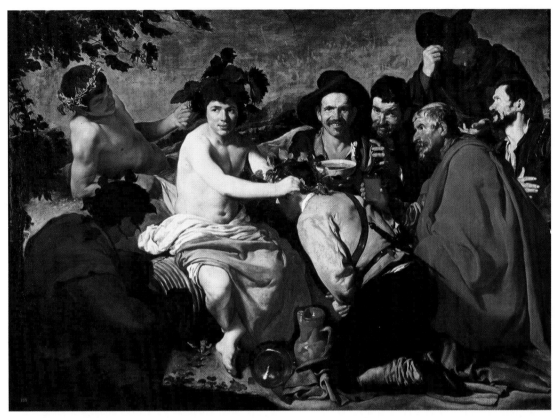

4.2 Diego Valázquez, *The Feast of Bacchus* (*Los Borrachos*), 1628, Oil on canvas, 5 ft. 6 in. × 7 ft. 6 in. (1.65 m × 2.27 m). Museo del Prado, Madrid. (Scala/Art Resource)

The Feast of Bacchus

The elusive meaning of the so-called *Feast of Bacchus* (4.2) has given rise to several interpretations. It is Velázquez's first picture with mythological content. The scene shows Bacchus, the Roman god of wine, identified by the grape leaves in his hair and his classicizing costume, crowning a soldier who kneels before him. To Bacchus's right are two figures who appear from their costumes to be his companions. One raises a wine glass and, like Bacchus, is partially nude. Gathered to Bacchus's left is a group of Spanish peasants, whose ruddy complexions identify them as drinkers. The scene has thus been read as Bacchus bringing solace to the working classes through the gift of wine.[3]

A related reading that ties the picture both to Spanish tradition and to Velázquez's ambitions has been convincingly argued by Steven Orso.[4] This view cites the legends of Bacchus's visit to Spain in antiquity, according to which the wine god conquered Iberia and ruled benevolently. On the one hand, the notion of Bacchus in Iberia appealed to the humanists as a metaphor for a Classical revival. And on

the other hand, Bacchus, enthroned on a wine cask, is implicitly identified with Philip IV as "a paradigm of good kingship for the edification of his Habsburg successor."[5] Philip himself, like the Classical gods, was associated with the stars—he was called the Planet King after the sun, which was fourth in the hierarchy of planets.[6]

Orso also argues that the *Bacchus* contains autobiographical meaning and is a response "to the opposition he [Velázquez] encountered in his efforts to advance himself at the Spanish court."[7] Rival artists had accused Velázquez of having an iconographic repertoire limited to portraiture. In a contest held at court in March 1627, Velázquez emerged the winner, although it is suspected that his connections may have influenced the outcome. As a result, Orso dates the *Bacchus* to the two-year period between March 1627 and, based on a payment record, July 1629.[8]

According to Orso, the *Bacchus* reflects an important step in Velázquez's iconographic evolution, since it takes him beyond the early genre scenes and portraits to history and myth. But it is also the artist's first painting that manifestly reflects his identification with the Classical revival and its implications for both the status of painting in Spain and his own status at court. If we read the painting from that point of view, an additional level of meaning emerges. It is clear that Velázquez has divided the picture into two sections—the Classical figures to the left and the contemporary Spaniards to the right. The latter seem to be jockeying for position, as if posing for a photograph. The leering seated figure who faces the viewer and wears a hat appears to be in the best position. He is next to the god, although slightly behind

him. Another, at the far right, has just arrived and removes his hat as if in deference to his king.

Extending across the picture plane is a long diagonal formed by Bacchus's arms and the kneeling Spanish soldier. Bacchus crowns the soldier with a wreath, symbolically "knighting" him as a member of his "Classical court." Velázquez was certainly aware of the Italian Renaissance revival of the ancient practice of crowning poets with laurel wreaths. In 1341, for the first time since antiquity, Petrarch had been crowned poet laureate in Rome. When Velázquez painted the *Bacchus,* it seems that he depicted his wished-for self-image as the chosen courtier and "painter laureate" to the Spanish king. As such, he is shown in a moment of transition, singled out by the god because of his superior talent, yet still one among mortals at court. If this reading is correct, Velázquez effectively brings Classical imagery and the Classical tradition to Spain, allying himself with Raphael and Titian in Renaissance Italy and with Rubens in seventeenth-century Flanders. Just as he elevates himself, so he raises the the art of painting above its medieval status as a handicraft to the equal of poetry, which in Spain *was* considered a liberal art.[9]

In June 1629, on the recommendation of Rubens, Velázquez left Spain and traveled for eighteen months in Italy. His subsequent mythological scenes reflect his ongoing interest in bringing the Classical world to Spain and merging its iconography with the contemporary context. At the same time, however, he continued to paint royal portraits and political subjects calculated to project the image of good government under the Habsburgs.

Equestrian Portraits:
Philip IV and *Balthasar Carlos*

For the Hall of Realms in the Buen Retiro Palace, Velázquez produced two works that combined these interests. Both *Philip IV on Horseback* (4.3) and *Balthasar Carlos on Horseback* (4.4) are in the tradition of ancient Roman and Renaissance equestrian portraits, and are statements about contemporary kingship in Spain. They are also characteristic of the Baroque style in their predominant diagonal planes, abrupt spatial shifts, and juxtapositions of light highlights with broad areas of dark. Philip's portrait was inspired by Titian's equestrian portrait of his great-grandfather, Charles V, which was then in the royal collection. Both are images of power. Titian, however, emphasizes the military character of the Holy Roman Emperor, who is armed and helmeted and carries a lance that traverses nearly the entire width of the picture plane. His horse wears the trappings of battle and paws the ground as if impatient to begin a charge.

As in the Titian, Velázquez's king is set in a landscape, with a painterly sky and trees at the left. Velázquez is also influenced by Titian in his taste for conveying material textures, such as Philip's silk sash, velvet hat, shiny armor, tassels, and lace, and the surface sheen of the horse. Both riders face the viewer's right and gaze into a vast space, denoting their extensive domains. Although Philip IV, like Charles V, is armed, his character is less bellicose. He holds a short baton of rule and wears a feathered hat instead of a helmet. The horse rears as Philip executes the *levade,* a Spanish riding-school maneuver in which the rider controls a rearing horse with one hand. Philip's military persona, although certainly evident, is thus subordinated to his equestrian skill. In this iconography, Velázquez merges the equestrian theme characteristic of the Renaissance Classical revival with a humanist image of the Habsburg king using training and intelligence to dominate an unruly horse. The political implications of such an image would have been obvious to seventeenth-century viewers of the painting.

In *Balthasar Carlos on Horseback* (Fig. 4.4), as in the portrait of his father, the setting is a cool day, with snow-capped mountains in the distance. There is also a similar synchronization of horse and rider, but the horse rears in the opposite direction and is radically foreshortened. This, in turn, increases the monumental character of the powerful horse, which is contrasted with the boy's youthful softness and the delicate gold embroidery on his costume. The horse's tail and the prince's sash fly out in unison, suggesting that horse and rider are galloping forward at great speed.

The energetic character of Balthasar Carlos, compared with the calm control of Philip, is enhanced by his diagonal movement through space. Like Philip, the prince carries the baton of rule, but here it denotes the future rather than the present. Velázquez has positioned the prince in a way that accentuates his role as the future king and implies that he is in the process of moving toward his goal. Philip, on the other hand, *is* the king; he clearly shows his right side and upright posture to the viewer—a traditional metaphor for the moral rectitude of a ruler and the legitimacy and nobility of his reign.

In the position of Balthasar Carlos, Velázquez constructs a related temporal metaphor. The prince rides forward in space as well as in time, denoting his ambition to attain his father's status. This read-

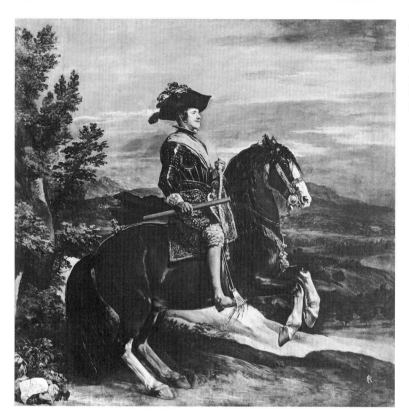

4.3 Diego Velázquez, *Philip IV on Horseback.* Oil on canvas, 9 ft. 10 ½ in. × 10 ft. 5 in. (3.01 m × 3.18 m). Museo del Prado, Madrid. (Art Resource)

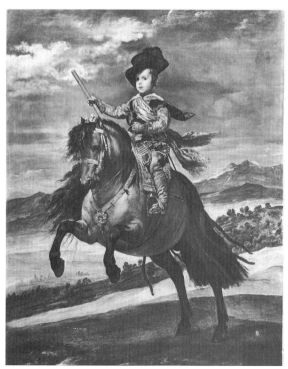

4.4 Diego Velázquez, *Balthasar Carlos on Horseback.* Oil on canvas, 6 ft. 10 ⁵/₈ in. × 5 ft. 9 in. (2.10 m × 1.75 m). Museo del Prado, Madrid. (Art Resource)

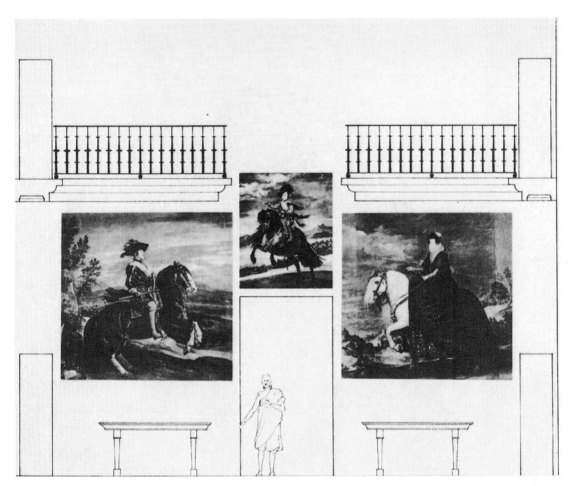

4.5 View of 4.3 and 4.4 as reconstructed in Jonathan Brown, *Velázquez* (Yale University Press, New Haven and London, 1986).

ing is enhanced by the reconstructed disposition of the paintings in the Hall of Realms (4.5).[10] Philip and his queen, Isabella, are arranged as a pair; they face each other across a space containing a doorway, above which is the smaller picture of their son. The latter is positioned so that he appears to be riding away from his mother toward the king, an image that reflects developmental reality and reinforces the Habsburg lineage. Such imagery was particularly appropriate for the Hall of Realms, which was named for the coats of arms of

Spain's twenty-four kingdoms that adorned the ceiling. Velázquez's metaphor was, however, never realized, for Balthasar Carlos died in 1646, two years after Isabella.

Sometime between 1640 and 1648, Velázquez traveled again to Italy, this time for about two years. On his return, he produced fewer portraits of the royal family, which had suffered significant losses. Of Philip's children by his first wife, only his daughter María Teresa (b. 1638) remained alive, and he had married his fourteen-year-old niece, Mariana of Austria.

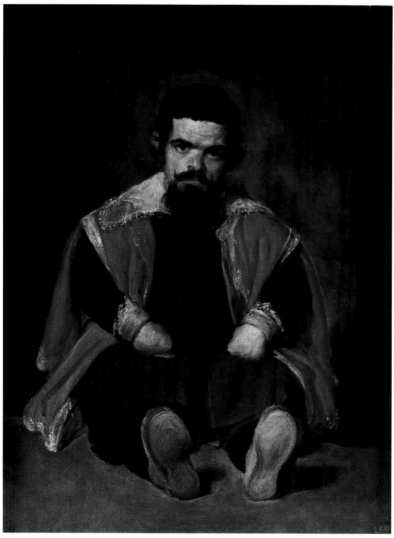

4.6 Diego Velázquez, *Sebastiàn de Morra,* 1644. Oil on canvas, 3 ft. 6 in. × 2 ft. 8 $^1/_4$ in. (1.07 m × 0.82 m). Museo del Prado, Madrid. (Scala/Art Resource)

Sebastiàn de Morra

After this trip, Velázquez spent more time on administrative duties, which limited his artistic production. A key iconographic theme throughout his career consisted of portraits of dwarfs, some of whom were im-portant members of Philip's court. In the 1640s, Velázquez painted one of his most re-markable dwarf portraits—that of *Sebastiàn de Morra* (4.6). The figure emerges from a dark background, his predominantly black costume enhanced by the rich red cloak. The gold trim and lace sleeves and collar de-

fined by loose brushwork, as well as the use of a rich red, are reminiscent of Titian. In this portrait, as in others of the same theme, Velázquez captures the uncanny quality of a fully grown adult who is childlike in size.

Sebastiàn is portrayed as a discerning, forceful figure, accentuated by the light highlight on his forehead and piercing black eyes. His foreshortened legs and clenched fists convey a sense of matter-of-fact self-assertion. The blocklike form, with legs at right angles to the torso, is softened by the diagonals of red and slight tilt of the head. Sebastiàn stares out of the picture, his intense gaze directly confronting the viewer.

Fable of Arachne (*Las Hilanderas*)

In two key monuments of the 1650s, Velázquez's late period at court, he combines mythological themes with a contemporary context, as he had done earlier in the *Feast of Bacchus*. The so-called *Fable of Arachne* (4.7), also known as *The Spinners*, has given rise to various readings.[11] Represented in the foreground is a group of five seventeenth-century Spanish women engaged in transforming balls of yarn into woven material. Two at the left are by a spinning wheel, and one in the center gathers up wool from the floor. Of the two at the right, one draws her hand across the easel-like loom, winding the spun wool into a ball. The prominence of her hand alludes to the prevailing prejudice against painting being a liberal art because it is a handicraft.

Removed from the foreground figures and set in a stagelike space, another five women enact the mythological weaving contest between Athena and Arachne. The textual basis for the narrative is Ovid's *Metamorphoses*. Arachne was the most renowned weaver in Lydia and refused to acknowledge Athena, goddess of weaving, as the source of her talent. Instead, Arachne boasted that she could weave more beautiful images than the goddess. The contest proceeded, and Arachne wove the stories of the loves between gods and mortals. Among others, she wove Zeus's abduction of Europa, which is illustrated in the tapestry on the back wall.

Athena is the helmeted figure (she was also the goddess of war and wisdom) seated on the left side of the stage. She has become enraged at the evidence of Arachne's skill and brandishes her spindle at the mortal girl standing with her back to the tapestry. In Ovid's text, Arachne tries to hang herself in despair, but Athena prevents the suicide and turns her into a spider for her hubris. As such, Arachne is destined to hang and weave webs, abstract designs that "tell no tales" and, therefore, are not a threat to gods and goddesses.[12] Velázquez has stopped the narrative just before Arachne becomes a spider, thereby emphasizing the moment of the goddess's anger and Arachne's awareness of her inevitable defeat.[13]

The scene in Arachne's tapestry is a direct quotation of Titian's *Rape of Europa* (4.8), which had been painted for Philip II. Titian had been made a Knight of the Golden Spur by Charles V and was awarded a pension by Philip II for his services.[14] He thus "provided," writes Jonathan Brown, "an artistic and social paradigm for the elevated status of painting at the court of Spain. By paying tribute to this distinguished predecessor in a style that is profoundly Titianesque, Velázquez claimed a place in

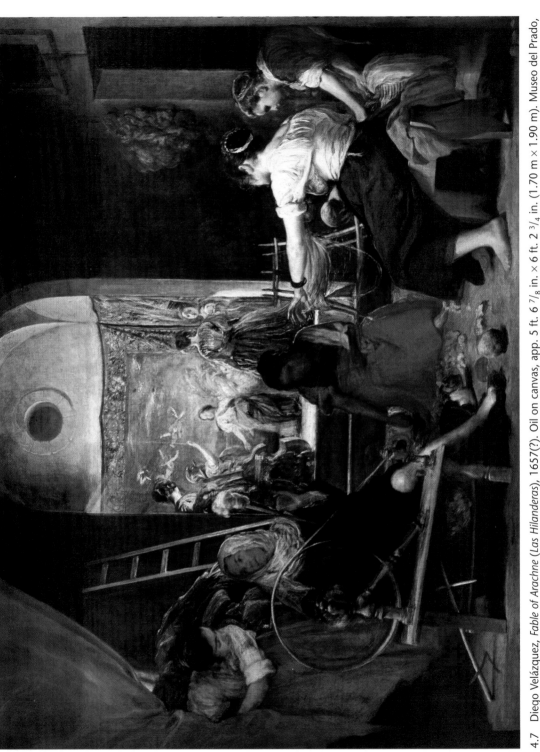

4.7 Diego Velázquez, *Fable of Arachne (Las Hilanderas)*, 1657(?). Oil on canvas, app. 5 ft. 6 $^{7}/_{8}$ in. × 6 ft. 2 $^{3}/_{4}$ in. (1.70 m × 1.90 m). Museo del Prado, Madrid. (Scala/Art Resource)

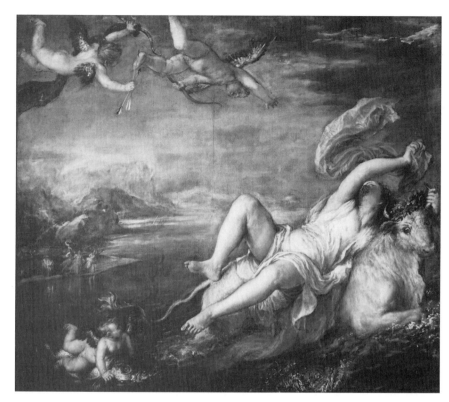

4.8 Titian, *The Rape of Europa*, 1559–1562. Oil on canvas, 5 ft. 10 in. × 6 ft. 8 ³/₄ in. (1.78 m × 2.05 m). Isabella Stewart Gardner Museum, Boston.

the succession of the Venetian master, just as he had done by installing his paintings in the Hall of Mirrors."[15]

Essentially, Velázquez created an artistic genealogy linking himself to Philip IV as Titian had been linked to Philip's grandfather and greatgrandfather. That he was a prince of painters was evident in his position at court, but he wanted to be counted a prince among princes and, as had been indicated in my reading of *The Feast of Bacchus*, a knight among knights.

Also linking the *Fable* with the earlier picture is Velázquez's pitch for the elevated status of painting. For just as the wool is the raw material of weaving, so paint is the substance from which Velázquez made his pictures. In the *Fable*, he "pictures" the

very process of making pictures, and the woven tapestry is made a metaphor for the art of painting. That the tapestry picture within the picture is based on Ovid's text not only speaks to the revival of Classical tradition, but also allies the picture with the liberal art of poetry.

In the *Fable of Arachne*, Velázquez unites the seemingly disparate foreground and background by thematic, iconographic, and formal parallels. Five figures occupy each space. Athena's raised spindle finds an echo in the spindle held aloft by the woman seated at the spinning wheel. The woman at the far right of the stage turns to gaze on the foreground spinners, beyond whom the viewer must look in order to witness the mythological contest. By the spa-

tial juxtaposition of contemporary with mythic figures, Velázquez also creates a temporal juxtaposition of present and past. Myth itself combines past and present, for its events have already taken place. But it is in the nature of a myth that it lives in the present. In so doing, myths, like dreams and pictures, do not necessarily respect the laws of consciously constructed time. By formally distancing the events on stage, therefore, Velázquez places them in the past. By virtue of Arachne's tapestry, he places Titian in the realm of myth and makes him a god of painting. He also makes painting an art of gods.

Las Meninas

In *Las Meninas* (4.9), which is considered the summation of Velázquez's career and has been the subject of numerous interpretive efforts, the artist merges in a single space what is juxtaposed in the *Fable*. According to Brown, Velázquez makes the same "claims for himself and his art" in *Las Meninas* as he had in the *Fable of Arachne*, only more so.[16] The setting is the Galería de Cuarto del Príncipe in the Alcázar, and the figures comprise members of the royal household, including the artist himself. Velázquez is at the left, holding his palette and brush and gazing out of the picture. He tilts to the right, while his canvas slants to the left beyond the frame. The disposition of the figures reiterates the diagonals of the artist and his canvas, creating a medley of Baroque planar shifts as we read the painting from left to right. At the far right, the small figure in red directs us

back toward the center as he steps on the back of the dog.

The central figure is the infanta Margarita, born in July 1651 and the first child of Philip and Mariana. She is flanked by two *meninas* (maidservants) and, like the painter, gazes at the viewer. Velázquez depicts himself as the creator of *Las Meninas* by the similarity of the unformed colors on his palette with those used to form the painting. The predominance of reds and whites on the palette recurs on the infanta's dress and those of her attendants. Daubs of paint portray a shimmering light and seem to glide effortlessly over the silky material surfaces. Like the threads in the *Fable of Arachne,* the paint daubs on the white silk convey the impression of form in the very process of becoming.

At the right of the painted room are male (in red) and female (in black and white) dwarfs and the dog. In the middle ground, a widow inclines her head toward an unidentified man, while José Nieto, master of tapestry works, is silhouetted against the background doorway. All but the man standing by the widow have been identified by Velázquez's biographer, Antonio Palomino (1655–1725), who arrived at court eighteen years after Velázquez's death. Palomino interviewed several of the people who appear in the picture and others who had also known the artist personally. As a result, his biography is a source of valuable information on the life of Velázquez.

According to Palomino, the mirror on the back wall reflects the unseen painting that the artist is working on. Brown believes that the figures' attention is directed at the king's presence in, or entry into, the room. He, rather than Margarita, is thus

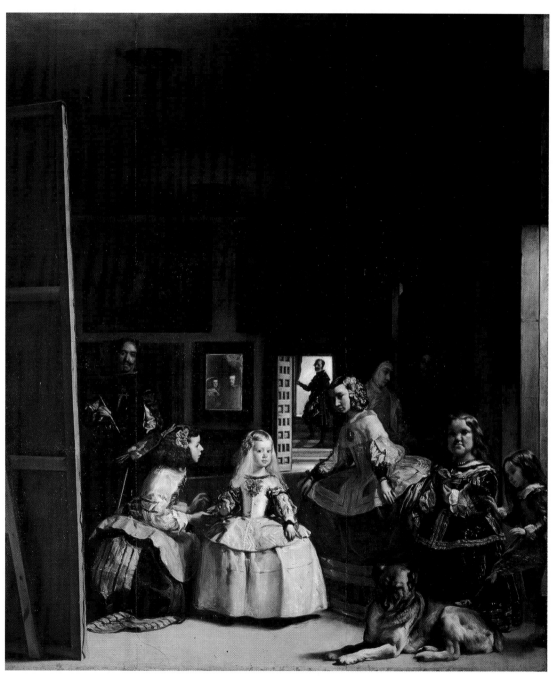

4.9 Diego Velázquez, *Las Meninas,* 1656. Oil on canvas, 10 ft. 6 $^3/_8$ in. × 9 ft. 2 $^5/_8$ in. (3.21 m × 2.81 m). Museo del Prado, Madrid. (Scala/Art Resource)

"the focal point of the picture, . . . who 'interrupted' the figures in *Las Meninas* whenever he entered his summer office."[17] In any case, the mirror reflects the king and queen either because they are the subject of the unseen painting, or because they are standing in front of the infanta, or both. They, in turn, if they are in the room as their reflection indicates, would be gazing at their daughter, as indeed they appear to be doing from the mirror's image. The red curtain over Philip's head is a formal reminder of his solar role as the Planet King.

One of the unique aspects of *Las Meninas* is the fact that Velázquez has transformed what is essentially a portrait of the royal family into an allegory of the art of painting and of the artist's ambition. Hanging on the walls of the painted room are the very pictures that hung in the actual room of the Alcázar. They represented mythological scenes, the two over the mirror on the back wall depicting artistic contests between gods and mortals—namely, Arachne and Athena, and Marysas and Apollo. The former reiterated the theme of the *Fable,* while the latter showed the flaying of the satyr Marsyas after his defeat in a musical contest with Apollo.

In either case, the message is clear. Mortals who challenge the gods are destined to lose. Velázquez's first portraits at court leave no doubt that he understood protocol and intended to bow to its requirements in order to achieve personal success. In *The Feast of Bacchus,* he literally does so. Nevertheless, just as Bernini was able to synthesize erotic character with Counter-Reformation spirituality and mysticism, so Velázquez achieved a synthesis of courtly propriety with soaring ambition. By centering the mirror image of the king and queen

below the mythological contests, he assigns them a prominent position, but one that is below the gods. At the same time, Philip IV's role as Planet King as well as the haloesque red glow above his head ally him with the sun god Apollo.

In *Las Meninas,* the pictures on the back wall, like the other pictures of myths in the room, evoke the Classical past and make it present in the seventeenth-century Spanish court. On the one hand, they warn against the dangers of hubris and, on the other, reveal Velázquez's ambition to rival the gods and to join Titian in the pantheon of artists. They also recall the artist's struggle in competition with the lesser artists working for Philip.

Velázquez uses myth here and in the *Fable* as an exemplary backdrop, much as the Renaissance humanists he was emulating had done. In representing the lessons of the past, myths play a parental role in human development and in human history. They create a link to earlier times, both historically and developmentally, and can be externalizations of internal conflicts. In this case, they seem to reflect Velázquez's concerns about competition among artists and among different branches of the arts. In addition to the characteristic Baroque fusion of realism and naturalism with illusionism, Velázquez uses myth to merge the external and internal worlds, and conscious reality (for example, the inevitable victory of the gods) with unconscious fantasy (the unreal and childish notion that the gods can be defeated).

According to Palomino, Velázquez finished *Las Meninas* in 1656, when the infanta was five years old. Two years later, after a great deal of effort, he received the red cross of the noble Order of Santiago,

which he proudly displays on his chest. Palomino reports that the king had the red cross added after the artist's death, but the nature of the brushwork suggests that it could have been painted by Velázquez himself.[18] With the addition of the cross, the ambitions expressed in *The Feast of Bacchus* are finally realized. Velázquez has become a knight, achieving the noble status he sought his entire life. With the execution of *Las Meninas,* he created the most significant Baroque painting in Spain.

NOTES

1. Jonathan Brown, *Velázquez* (New Haven and London, 1986), pp. 66–67.

2. *Ibid.,* p. 67.

3. *Ibid.,* p. 66.

4. See Steven N. Orso, *Philip IV and the Decoration of the Alcázar of Madrid* (Princeton, 1986).

5. *Ibid.,* p. 109.

6. Brown, p. 43.

7. Orso, p. 109.

8. *Ibid.,* p. 110.

9. Brown (p. 251) argues that Velázquez's "desire to join a military order first surfaced in 1650." However, if my reading of the *Bacchus* is correct, it actually surfaces—although in disguised form—much earlier: in the "self-image" as the soldier.

10. Reconstructed as proposed by Brown, p. 124, fig. 108.

11. See Brown, pp. 250–253.

12. For a psychoanalytic reading of the Arachne myth, see Laurie Schneider Adams, *Art and Psychoanalysis* (New York, 1993), p. 288.

13. Brown (*op. cit.*) reads this element as an indication that Velázquez is emphasizing Titian's equality with the gods, for Arachne's tapestry is declared equal to that of Athena: "Titian is equated with Arachne, and Arachne could 'paint' like a god"; therefore, Brown argues, Velázquez pays homage to Titian. But, in view of the dangers of claiming talents equal to the gods, it seems that there must be another meaning in Velázquez's iconographic choice—namely, his insight that one cannot win by challenging the gods.

14. *Ibid.,* p. 253.

15. *Ibid.*

16. *Ibid.*

17. *Ibid.,* pp. 259–260.

18. *Ibid.,* p. 257.

French Baroque

The most Classical expression of French Baroque can be found in the paintings of Nicolas Poussin (1594–1665), who was born in Normandy, in northern France, and who lived most of his adult life in Rome. From the 1620s, his work was widely admired, and his access to important patrons was ensured. Partly in reaction to the exuberance of Baroque, especially in Rome, Poussin took Raphael as his primary artistic model. As a result of his formal precision, Poussin has been called a "cerebral" painter, even though he used Baroque techniques to convey an enormous variety of emotional expression. His subject matter includes biblical, mythological, and historical events, landscape, and portraiture. Like the Carracci, Poussin was drawn to Classical texts as the inspiration for much of his imagery. But he infused the textual underpinnings with emotional depths that convey a new thoughtfulness and solemnity even in his most joyous works. Poussin's views on painting would become the text of Academic art in France.

In France itself, the traditional solar imagery assimilated by Philip IV into his projected image as the Planet King rose to a new level of grandeur, unprecedented in Europe, at the court of Louis XIV (ruled 1643–1715). The two key monuments of his reign were the remodeled palace of the Louvre in Paris and the gardens and buildings of Versailles. These combined Classical architectural features with Baroque opulence to produce the embodiment of absolute monarchy on a vast scale. As a result, although artists and architects in fact created the works, the guiding force behind their style and iconography was the king.

Nicolas Poussin

Poussin's popularity in Rome soon brought him to the attention of Louis XIV's father, Louis XIII, whose interest in art was longstanding. He had been a painter himself and, with his chief minister, Cardinal Richelieu, recognized the political advan-

tages of imagery. In 1639, through the intermediary of two brothers, Roland and Paul Fréart, Louis sent for Poussin to assist with decorating the palace of the Louvre. Paul, the lord of Chantelou, would become Poussin's lifelong friend and correspondent as well as a diarist who recorded the activities of several Baroque artists—notably Poussin and Bernini. Chantelou also collected Poussin's work.

In 1640, Poussin went to Paris. But, in contrast to Velázquez, administrative duties and court intrigues were not congenial to his temperament. Less than two years later, Poussin returned to Rome. Richelieu died in 1642, and Louis died in 1643, which relieved Poussin of having to serve the French court. Mazarin, Richelieu's successor, who would supervise the education of Louis XIV, was not inclined to require Poussin's presence in Paris. The artist thus spent the rest of his relatively quiet life working in Rome.

Despite the vast literature on Poussin, the chronology of some of his major works remains in dispute. Around 1637, before his sojourn in France, Poussin painted the Louvre version of *The Rape of the Sabine Women* (5.1). It is widely considered one of the key monuments of his oeuvre. The setting, like the text, is Classical—notably the temple front and the costume. In it, Poussin captures the frenzied reactions of the Sabines when confronted with the reality that their women will become Roman wives and that their civilization will be absorbed into the Roman Empire. The scene takes place in a confined space that enhances the sense of claustrophobic entrapment. "Despite the fact that both figures and buildings are properly scaled down as

they recede into the distance," writes Alain Mérot, "the viewer's eye is not free to travel far in that direction, but is compelled instead to move endlessly from side to side."[1] This circumstance epitomizes the psychology of rape itself, for it accentuates the helplessness of the victims confronted with the implacable force of the Roman legions.

Chantelou's description of Poussin's working procedure—the artist organized his compositions by arranging models of his figures in rectangular boxes—is readily evident in the stagelike regularity of the space. And although the painting is immediately read as a unified scene of struggle and panic, it actually consists of discrete vignettes organized into a totality. Poussin's painting is thus choreographed to show that the events that change history are comprised of individual dramas. He also alleviates the violence with moments of relief, as figures quietly observe the action from their balcony; in the distance, a tiny couple exits the scene.

The central foreground groups consist of Roman soldiers grasping at resisting Sabine women. On the left, the woman being carried off has apparently knocked her attacker's helmet to the ground. Its prominent position is an irony, for it both signifies Roman power and implies its unmanning. At the right, the soldier still wears his helmet as he grasps the fleeing woman preceded by a Sabine man. Slightly behind this group, to the extreme right, another soldier pushes away an old woman attempting to protect a young victim. Behind the fallen helmet, another old woman pleads for mercy. The uselessness of her gesture is reinforced by the empty space be-

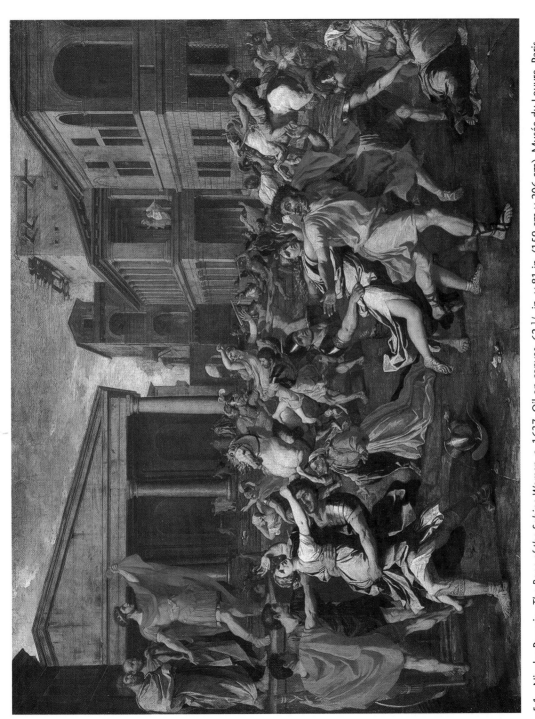

5.1 Nicolas Poussin, *The Rape of the Sabine Women*, c. 1637. Oil on canvas, 62 $^1/_2$ in. × 81 in. (159 cm × 206 cm). Musée du Louvre, Paris. (Scala/Art Resource)

5.2 Nicolas Poussin, *The Arcadian Shepherds (Et in Arcadia Ego)*, c. 1640. Oil on canvas, 33 $^1/_2$ in. × 47 $^1/_2$ in. (85 cm × 121 cm). Musée du Louvre, Paris. (Art Resource)

tween her hands and by her resemblance to figures of Mary Magdalene vainly protesting the death of Christ.

At two points in the painting, soldiers mounted on white horses gallop through the crowd, forming prominent diagonal planes as each reaches out to carry off a Sabine woman. Others run on foot, brandishing their swords. Quietly but grandly dominating the entire event is the elevated Roman ruler, who raises his red cloak in a sweeping gesture of command, denoting the submission of the Sabines to Rome.

Around 1640, Poussin painted *The Arcadian Shepherds*, also called *Et in Arcadia Ego*, after the inscription on the tomb (5.2). As in *The Rape of the Sabine Women*, the figures' costumes and setting are Classical but the mood is altogether different; it is meditative and somber. This was one of several allegorical works created by Poussin for Cardinal Giulio Rospigliosi, the future Pope Clement IX. In this case, the "text" is literally written into the picture, and it has frozen the figures in a moment of recognition. Related to the pastorals of antiquity,

particularly the *Eclogues* of Virgil, *The Arcadian Shepherds* is about time and death.

Three shepherds, otherwise contentedly living an idyllic existence, have suddenly come upon a message from a former inhabitant of Arcadia about the future: "I, too, lived in Arcadia" is inscribed on the tomb, warning the figures that death is a reality, even in Arcadia.[2] Poussin's orchestration of responses to the inscription is evident in the studied poses and gestures, which formally and psychologically unite the figures around the tomb. At the right stands a female figure who has been identified as the Muse of history. Her vertical, statuesque stance, echoed by the trees, signifies her steadfast commitment to the reality of time. History, like the trees and the tombstone, Poussin seems to be saying, will continue; human beings will not.

The shepherd at the left, leaning on his staff, is quietly introspective. He rests his arm on the tomb so that his hand falls just above the head of the kneeling shepherd. He, in turn, traces the inscribed words like a blind man making physical contact with a written message. His shadow on the tomb is a metaphor for his own death. His forefinger leads the viewer's eye to the left hand of the third shepherd, who turns toward the Muse. She rests her hand on his shoulder as if to confirm his reading of the message. Her face is highlighted against the darkened trees, a reflection of her enlightened comprehension of time.

In contrast to the vigorous movement in *The Rape of the Sabine Women*, the sense of time and motion in *The Arcadian Shepherds* is stopped. Formally, the verticality of the Muse arrests the diagonals that create the narrative enacted by the shepherds. They

are depicted at a transitional moment, as if just awakening from the shock of understanding, and, like the viewer, are slowly absorbing the import of the message. In the background, the sky echoes the temporal significance of the picture, for it is depicted at sunset, in transition from day to night.

In 1648, Poussin painted *Landscape with the Funeral of Phocion* (5.3), one of four he executed for Jacques Sérisier, a wealthy French businessman. Here, in the earliest known painting of the subject, the theme of death reflects a political subtext. Drawn from Plutarch's *Lives,* the picture epitomizes Poussin's taste for heroic, pastoral landscape painting. Phocion was an Athenian general wrongly accused of treason and condemned to death by the assembly. Funeral rites in Athens were prohibited, and his body was taken to Megara and burned. In the companion picture, Phocion's widow gathers his ashes in a similar pastoral landscape setting. For Poussin, the story of Phocion evoked the dangers of mob psychology. In particular, it referred to the contemporary Fronde uprising, which would not end before 1653—a revolt by the French peasantry against the power of Mazarin and an effort by the nobility to limit the monarchy.

The manifest iconography of the picture is Phocion's lonely funeral procession proceeding across the foreground. It consists only of two men carrying the stretcher on which his body has been laid out. White drapery entirely covers Phocion, uncannily depriving him of an identity, just as in death he is denied a proper Athenian burial. Behind this scene, life goes on: in the middle ground, a shepherd tends his flock, a man in red gallops by, an ox-drawn cart has stopped along the road, a musician

5.3 Nicolas Poussin, *Landscape with the Funeral of Phocion*, 1648. Oil on canvas, 45 in. × 67 in. (114 cm × 175 cm). National Museum of Wales, Cardiff (on loan from the Earl of Plymouth.)

with a lyre sits with two other figures, and two men stop to converse under a tree at the left. Each figure, as in *The Rape of the Sabine Women,* participates in an individual tableau and contributes to the dramatic effect of the entire scene.

As in *The Arcadian Shepherds,* each element, whether human or landscape, reinforces the atmosphere of the *Funeral.* In the distance, the buildings of Athens are visible, ironic reminders that the city where democracy was born has succumbed to the tyranny of a mob. A procession of figures approaches the temple precinct, and the reds and whites of their draperies are repeated throughout the picture plane. Likewise, the whitened sky responds to Phocion's white shroud, while the tree at the right arcs slowly toward him. Echoing the somber, melancholic mood of the *Funeral* is the slow pace of the stretcher bearers and the subdued greens and browns pervading the landscape.

Two years after the *Landscape with the Funeral of Phocion,* Poussin painted his famous *Self-Portrait* (5.4), now in the Louvre. It was for his friend and patron Chantelou, who shared the artist's taste for Classical order and clarity as well as for the study of history in the training of an artist. Poussin depicts himself as a strong, assertive personage, dressed in an academic robe. His hand rests on a portfolio bound with a red ribbon; gold ring, hand, and face are highlighted. His shadow, like that of the central shepherd in *The Arcadian Shepherds,* falls across written text—here a kind of epitaph on an otherwise blank canvas, rather than on a tombstone. The Latin "EFFIGIES," or "effigy," reinforces this reading, conflating the notion of "effigy" in the sense of "image" with its mortuary implications. The rest of the text cites Poussin's age as fifty-six and notes that the picture was painted in Rome in the jubilee year 1650.[3]

Poussin himself gazes intently, with a slight frown, but to the side rather than at the viewer. Signifying that he is a painter are the frames visible behind him. Only one contains an image, an allegorical female in profile view being embraced by two arms belonging to an unseen person. The play on seeing and not seeing is particularly striking in this picture, for the pictures in the painted room are simultaneously visible and not visible. In contrast to Velázquez's large canvas in *Las Meninas,* Poussin shows the front of the canvases, but, aside from the female and the inscription, we see nothing of them.

The tiara worn by the woman contains an eye, its symbolic character confirming her allegorical purpose. According to Bellori, she represents "Painting welcomed by Friendship,"[4] although there is nothing to identify the owner of the outstretched arms. The meaning of the eye in the tiara is elusive, but the hieroglyph for God, known since the Renaissance, was an eye in a pyramid. This configuration has been split up by Poussin into its component parts—the ring contains a gold pyramidal shape, and the eye is displaced onto the woman. Such iconographic features raise the question of whether Poussin intended to depict himself in the guise of artist-god, reflecting the convention that as God creates nature, so artists create replicas of nature. In so doing, Poussin would be representing himself, as well as the woman, as personifications of the art of painting. And the writing on the otherwise empty canvas would be the epitaph of his life as a painter.

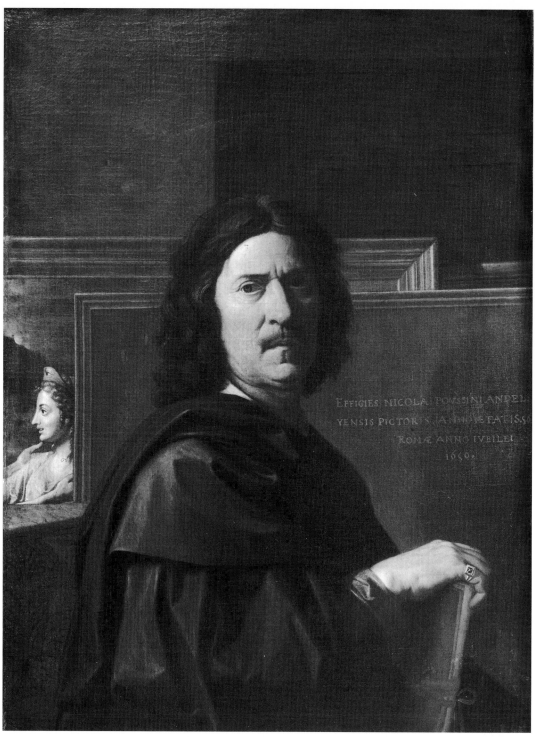

5.4 Nicolas Poussin, *Self-Portrait,* 1650. Oil on canvas, 38 $\frac{1}{2}$ in. x 29 in. (98 cm × 74 cm). Musée du Louvre, Paris. (Art Resource)

Louis XIV:
The Sun King (*le Roi Soleil*)

Louis XIV's self-image as the French state is well reflected in Hyacinthe Rigaud's (1659–1743) portrait of 1701 (5.5). Painted when the king was sixty-three, the portrait is filled with signs of Louis's reign. The pattern of the blue velvet robe embroidered with gold *fleurs-de-lis* is repeated on the ottoman at the left and the throne in the background at the right. Rich materials—satins, silks, ermines, gold—are designed to project an image of national abundance.

Louis stands proudly on the red high-heeled shoes (designed by him) that offset his short stature, leaning on his scepter and wearing a jeweled sword. The crown rests on the ottoman in front of the colossal column that refers to the "grand manner" of Louis's classicizing architecture. Just as the massive pedestal supports the column, so Louis XIV is the support of France, an image that is reinforced by the Roman triumphal arch in the left background. The person of the king is depicted as an architectural metaphor, one that is descended from antiquity and legitimized by the weight of tradition.

There is also a revelatory quality in Rigaud's portrait, conveying Louis's association with the sun, which is enhanced by the theatrical character of the Baroque style. A lush red satin curtain is pulled aside, as Louis himself seems to have just risen from his throne and descended one step to display the "body of the king." He points his toe at an oblique angle calculated to draw the viewer's gaze upward toward himself. The suggestion of a halo in the form of the curtain is repeated in the billowing folds of white ermine that are thrown back to reveal the "architectural" legs of the king. And finally, Louis's face, highlighted in light, seems to emerge like the sun from the darkness of a voluminous black wig.

The same image had occurred almost fifty years earlier, when, in 1653, Louis danced the role of the sun. He followed the dawn and brought light to the world in a court performance of the *Ballet de la Nuit* (5.6). The image of Louis-as-sun, which is clearly the theme of his costume, would become the hallmark of his reign, his architecture, and his iconography.

At the age of five, on the death of his father, Louis XIII (ruled 1610–1643), Louis XIV became king of France with his mother, Anne of Austria, installed as regent. His first minister, Cardinal Mazarin, trained him to be a king. Louis' education under Mazarin focused on statesmanship rather than on the humanist ideals of Velázquez and his Renaissance models. Nevertheless, the young French king was thoroughly exposed to the arts of drawing, music, and dance. And he often participated in court theatricals, many of which were based on Classical mythology.[5]

In 1654, Louis danced the role of Apollo in a costume embroidered in gold and decorated with rubies, diamonds, and pearls. On this occasion, his lines were specifically political. Like Poussin's *Landscape with the Funeral of Phocion,* they alluded to the Fronde uprising, which had ended the previous year. His speech was prophetic of both his future as an absolute monarch and his solar image as the source of reason and order. In Louis XIV, as in the great pharaohs of Egypt, would reside the

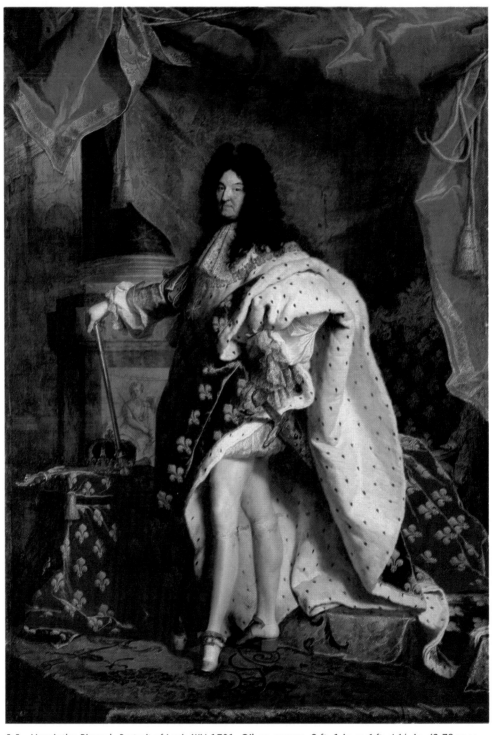

5.5 Hyacinthe Rigaud, *Portrait of Louis XIV,* 1701. Oil on canvas, 9 ft. 1 in. × 6 ft. 4 $\frac{1}{8}$ in. (2.79 m × 2.4 m). Musée du Louvre, Paris. (Scala/Art Resource)

supreme control of his domains. His control of the arts would prove to be as absolute as his monarchy.

> *I have vanquished that Python who*
> *devastated the world,*
> *That terrible serpent whom Hell and the*
> *Fronde,*
> *Had seasoned with a dangerous venom:*
> *The Revolt, in one word, can no longer*
> *harm me;*
> *And I preferred to destroy it,*
> *Than to hasten after Daphne.*[6]

By vanquishing the Python, the dragon who held sway at the Delphic oracle under the earth goddess Gaia, Louis, like the Olympian Apollo, eradicates the forces of evil darkness and establishes a new order based on light and reason. By allying the Fronde with Hell and charging both with nourishing the Python, Louis relegates those who would disrupt the established order to the level of Satan, and he himself emerges as a conflation of Apollo and Christ. Furthermore, his preference for destroying the Python over pursuing Daphne (the nymph who fled Apollo's advances and was turned into a tree) alludes to his dedication to matters of state over lust and to the forces of civilization over impulsiveness.

Louis XIV thus manipulated the age-old tradition that equated monarchs by divine right with the sun and reinforced the metaphor with vast architectural and iconographic programs. The association with Apollo fulfilled this equation for the French king. But Apollo was also the god of music and healing as well as of solar light and reason. The former function was con-

5.6 Louis XIV as the sun in the 1653 *Ballet de la Nuit*. Bibliothèque Nationale, Paris.

sistent with Louis's theatrical Apollonian roles and with his lifelong interest in the arts, while the latter served as a reminder of the miraculous curative powers of the "king's touch." Implied in the manifest Apollonian iconography was the latent subtext of Louis' identification with Christ—an even more potent source of power in seventeenth-century France.

When Mazarin died in 1661, Louis assumed personal rule of France, with Jean-

5.7　Claude Perrault, Louis Le Vau, and Charles Le Brun, east façade of the Louvre, Paris, 1667–1670. (Art Resource)

Baptiste Colbert as his minister. Both Colbert and Louis recognized the power of the academies in reinforcing state control of the arts and in dictating taste. Under Louis XIII, Cardinal Richelieu had founded the French Royal Academy with a view to standardizing the French language. Under Louis XIV, Colbert's wide-ranging talents encompassed politics and economics as well as the arts. He restructured French economic policies to enrich the crown and in 1663 reorganized the Royal Academy of Painting and Sculpture. He also instituted the Little Academy (*la Petite Académie*), composed of scholars whose task it was to supervise the symbolic and allegorical content of royal iconography. In particular, they emphasized Louis' role as the sun—a source of light, reason, power, and paternal concern for the well-being of his subjects. Several other academies would follow, including those of Science, Music, and Architecture.

The Louvre

The earliest key monument of Louis' personal rule was a remodeled east façade of the palace of the Louvre and the transformation of a portrait gallery there into a Gallery of Apollo. The painter Charles Le Brun (1619–1690) was responsible for decorating the gallery, which was begun the same year as the establishment of the Little Academy. It was a long, barrel-vaulted room, with a **lunette** at each end. According to Le Brun's plan, the walls and ceilings were adorned with gilded reliefs that functioned as framing devices for the paintings. The main picture was intended to represent Apollo in his horse-drawn chariot traversing the sky on his daily course. Here, as in the roles danced by Louis XIV as an adolescent, the sun dispels the night—personified by both Diana (the moon goddess) and Morpheus (the god of sleep).[7] Twelve **tondos** depicting the labors of the months and signs of the zodiac—images of time—alluded to the sun's daily trajectory across the sky.[8]

Although not completed in Louis' lifetime, the gallery came to stand for the new order imposed by the Sun King. The façade, in contrast, *was* finished, but only after several plans had been submitted and rejected.

Originally, Colbert had accepted Bernini's plan, but acceded to the French architects who objected to a foreigner designing their royal palace. The final design was the work of three men: architect Louis Le Vau (1612–1670); medical doctor and mathematician Claude Perrault (1613–1688), who became an architect; and Le Brun (5.7).

The long horizontal plane of the façade conveys a sense of dignity and grandeur characteristic of Louis's taste. Its harmonious proportions, symmetry, and use of Classical motifs reflect the assimilation of the architectural ideas of Vitruvius, Palladio, and Vignola. The façade is divided into five sections, two of which are projecting blocks with a pair of Corinthian pilasters at each end. Each projection has two pedimented rectangular windows framing a larger central, round-arched window, above which is a royal crest. The horizontal plane between the projections at each end is unified by repeated pairs of Corinthian columns supporting a Classical entablature. As at Saint Peter's in Rome, the cornice is surmounted by a balustrade; but this one is shorter and without statues, and is, therefore, more restrained. The central block, with its pedimented crown derived from the Greek temple **portico**, presides over and dominates the façade. Its subtle yet majestic appearance is a metaphor for the king himself, while the allusion to the Greek temple reinforces Louis' association with the gods.

Versailles

More than any other architectural project, the vast palace and elaborate gardens of Versailles are thought of as the expression of Louis XIV's self-image as the Sun King. There were over seven miles of gardens, which were adorned with colorful floral designs framed by clipped hedges, fountains, pools and lakes, grottoes, theaters, and various small structures designed for private use. Work on the project began with the expansion of his father's hunting lodge after 1661. Louis entrusted the work to Le Vau and Le Brun, who also designed the Louvre, as well as to André Lenôtre (1613–1700), a royal gardener since 1637.

The *View of Versailles* (5.8), painted in 1668, shows the progress to date and the east-west axis line established in 1665 to reflect the sun's movement across the sky. Three roads mark the location of the main avenues running east from the palace toward the new town of Versailles. They meet at the opening of an oval space flanked by obelisks, allusions to the solar identification of the Egyptian pharaohs. Like the Greek portico on the east façade of the Louvre, the obelisks evoked the ancient gods; in Egypt, they were situated at temple entrances and were probably capped with gold to reflect the rising sun. The symmetrical, radiating layout of Versailles, which is evident in the painting, continued to be a feature of its design and was an obvious reference to the Sun King. In the seventeenth century, on August 25 (the feast day of Saint Louis), the sun set on the western end of the axis,[9] thus conflating Louis XIV's mythological association to the sun with Christian allusions.

On either side of the roads and the oval are buildings for the nobility and their courtiers. A large gateway, gilded along the top, leads from the oval to a rectangular courtyard framed by kitchens, stables, and

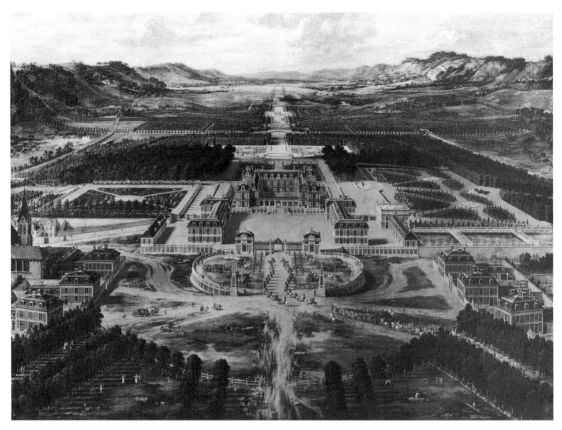

5.8 Pierre Patel, *View of Versailles,* 1668. Oil on canvas. Musée National du Château de Versailles. (Photo: Réunion des Musées Nationaux, Art Resource)

servants' quarters built around 1662–1663 according to Le Vau's plans. At the far end is Louis XIII's original palace. On the grounds of the park, Le Vau also designed a zoo for exotic animals.

Built in stages over a period of twenty years, the gardens and palace at Versailles never wavered from their intimate connection with the person of the king. Repeatedly exemplifying Louis's identification with the sun was the iconography of the sculptures made by his artists. In 1664, for example, Le Vau designed an architectural grotto—de-

stroyed six years later—with three niches framing sculptures denoting the end of Apollo's daily journey. In the side niches, the god's weary horses were groomed and fed. In the center, Apollo himself, relaxed and reclining, was tended by Thetis and her nymphs (5.9), a metaphor for the nightly retirement of Louis XIV after his daily attentions to affairs of state.

At the other end of the east-west axis, the Fountain of Apollo (5.10) was put in place in 1671. Reflecting Baroque enthusiasm for fountains is the exuberant charac-

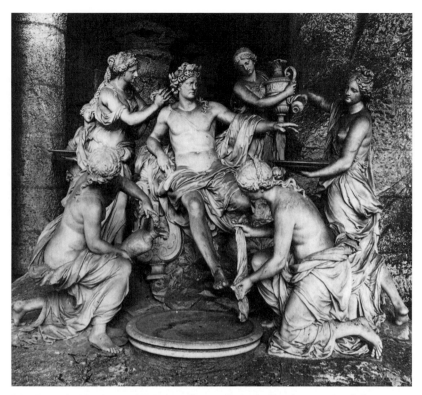

5.9 François Girardon and T. Regnaudin, *Apollo Bathed by the Nymphs of Thetis,*
1666–1675. Marble. Versailles. (Art Resource)

ter of the group, which is enhanced by the streams of water. Driven by Apollo in his chariot, the four horses of the sun seem to rise as at daybreak from the pool. Their gilded surfaces sparkle in the sunlight and are, in turn, mirrored in the water. At the sides, four dolphins swim away from the central group, as four Tritons (demigods of the sea) blowing conchs trumpet the dawn of a new day.

Along the same main axis is the elaborate group comprising the Latona Fountain (5.11) that celebrates Apollo's birth. In 1687, the earlier version of the fountain was redesigned by Jules Hardouin-Mansart

and reoriented to face the Fountain of Apollo (5.12). White marble sculptures of Latona and her children surmount three circular layers of pink-and-white marble.

The iconography of the Latona group is derived from Ovid (*Metamorphoses* 6.336–381). He describes the birth of Apollo and his twin sister, Diana, on the island of Delos, where their mother, Latona, was given sanctuary from the jealous wrath of Juno. Afterward, still fleeing Juno, Latona and her children arrive at a small lake, where she tries to quench her thirst. But a group of peasants gathering rushes prevents her from drinking. When she cries

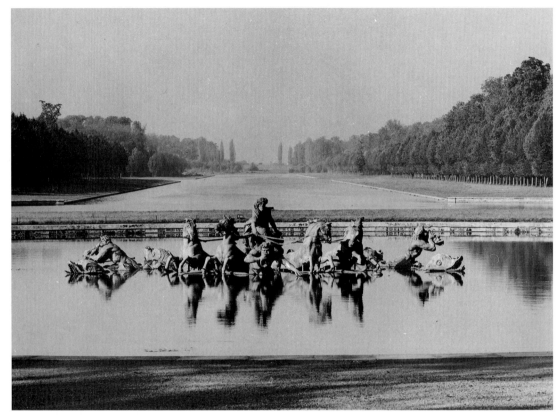

5.10 Charles Le Brun and Jean-Baptiste Tuby, *Fountain of Apollo*, 1668–1670. Gilded metal. Versailles. (Art Resource)

out that the enjoyment of water is a common right (*"quid prohibetis aquis? usus communis aquarum est"*), they insult her and stir up the mud at the bottom of the lake by leaping up and down. At this, Latona beseeches the gods: *"Aeternum stagno . . . vivatis in isto!"* [Live then forever in that pool!].[10] The peasants are turned into frogs, continuing to use their tongues harshly, swelling their throats, and croaking. Their bodies, Ovid writes, become green and white, and they leap in the muddy water.

At Versailles, gilded peasants, frogs, turtles, and lizards surround the central figures of Latona and her twins. The hierarchical

arrangement of the fountain clearly signifies the French state under Louis XIV. Proclaiming his own divine lineage are the gods and their mother at the top, with the peasants and the lesser species below. It has also been suggested that the fountain's iconography may contain specific political allusions to the Fronde uprising, in which case it is also a reminder that the absolute authority of the king is challenged at one's peril.[11]

Connecting these three sculptural groups is a temporal relationship that traverses the space of the main axis—the *Allée Royale*. The sculptures span the time from Apollo's birth, showing his mother gazing on his

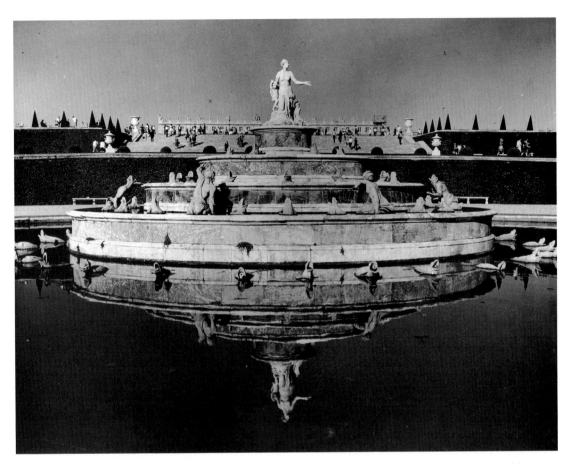

5.11 Marsy brothers, Latona Fountain, 1668–1670. Revised by Jules Hardouin-Mansart, 1687–1689. Marble. Versailles. (Art Resource)

triumphant renewal of light each day, to the conclusion of his daily rounds. In the iconography of the sculptures as well as in their alignment, the designers of Versailles were able to unify the vast garden spaces both formally and thematically.

The new palace of Versailles was expanded in two main stages: the first, from 1668, was under the direction of Le Vau, and the second, from 1678 onward, was supervised by Jules Hardouin-Mansart. The entrance side extends outward in a series of expanding spaces created by the disposition of the buildings, which, at the same time, seem to draw visitors toward the interior. The garden façades, in contrast, are primarily horizontal. Their restrained classicizing character is enlivened by Baroque features such as the projecting sections and the statues on the balustrade.

The gardens are formal. The view of the garden façade (5.13) shows a section of the ordered, geometric parterres (flower beds surrounded by hedges). The building itself

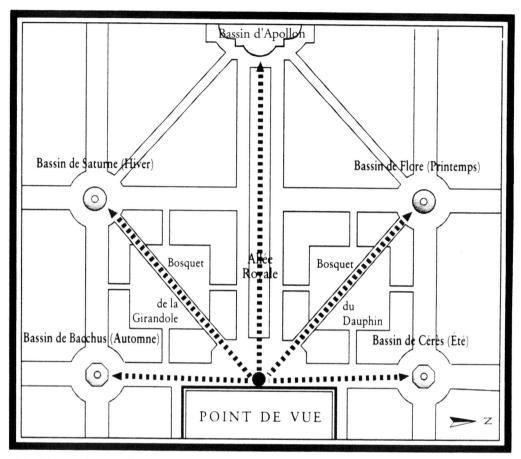

5.12 Diagram showing the view of the main axis (*Allée Royale*) from the Latona Fountain, Versailles.

is three stories high, slightly **rusticated** on the ground floor, with large, round-arched windows. Taller windows are repeated on the first floor and alternate with Ionic pilasters. The top story is shorter, its wall pierced by rectangular windows between short pilasters. On the first story, the projections are colonnaded, interrupting the potential monotony of the long horizontal. Accentuating the top of each colonnade is a group of statues, and reinforcing the horizontal unity are the balustrades over the ground and upper stories, and the entablature over the first story.

The interior of the palace was as lavish as the gardens, and the theme of its decoration was Louis XIV, *le Roi Soleil*. Rooms were decorated with frescoes, gilded and stucco moldings, tapestries, oil paintings, inlaid wood, marble sculptures, and so forth. Louis's apartments, located at the center of Versailles's main axis, consisted of seven rooms dedicated to the seven planets; the throne room was the *Salon d'Apollon*. Each

5.13 Louis Le Vau, modified by Jules Hardouin-Mansart, garden façade, Palace of Versailles, 1668–1678. (Photo: Marburg, Art Resource)

room, supervised by Le Brun, was decorated according to mythological themes associated with the relevant planet. The king's bedchamber, where most state transactions took place, was also the site of his ritual *lever* and *coucher,* which he performed daily in imitation of the rising and setting sun.

In the *Salon de la Guerre* at Versailles (5.14), Louis's military triumphs are celebrated in an iconographic program calculated to evoke the traditions of antiquity. Gilded reliefs glitter on the marble walls and are reflected in the corner mirrors. A large oval with a relief by Antoine Coysevox depicts the king on a horse rearing over a fallen enemy in the manner of imperial Roman equestrian portraits. A pair of Greek winged Victories above trumpets his success, and, below, emblazoned *fleurs-de-lis* signify French royalty. The twisting figures trailing garlands and the tilting curved pediments over the mantel are typical Baroque features.

Connecting the *Salon de la Guerre* with the *Salon de la Paix* is the 240-foot-long *Galerie des Glaces* (Hall of Mirrors) on the west front of the palace (5.15). Begun in 1678,

5.14 François Mansart and Charles Le Brun, *Salon de la Guerre,* Palace of Versailles, 1678–1686.

the hall is a long gallery, originally planned to contain a cycle of paintings depicting Apollonian myths. But these were rejected in favor of scenes, on the barrel vault, of Louis' divinely inspired military victory over the Dutch. Each individual vault is supported by a **truss**. A wall of seventeen mirrors flanked by gilded Corinthian pilasters faces a corresponding wall of windows. Mirrors and windows echo each other formally; they are of the same height and have round arches. The desired effect of the gallery—namely, to impress and in-

timidate ambassadors—was enhanced by the reflected exterior light on the mirrors. It also embodied the solar power of the king.

All told, it took some twenty years to complete the palace, which reached a length of nearly 2,000 feet. By Louis' death in 1715, the two hundred paintings he had inherited had grown to two thousand. (They formed the basis of the French national collection, now in the Louvre.) The members of the nobility (including the royal family and the king's mistresses) re-

5.15 Jules Hardouin-Mansart and Charles Le Brun, Hall of Mirrors, Palace of Versailles, begun 1678. (Photo: Girardon Art Resource, New York.)

siding in the palace now numbered five thousand, servants and military personnel amounted to fourteen thousand, and thirty thousand of Louis' subjects in the town of Versailles were in the employ of the court.

The vast scale of Louis' undertaking was unprecedented in seventeenth-century Europe. It was a single-minded effort to project the absolute monarchism of a king in all matters of state, society, and taste. In the *Metamorphoses* (2.1ff.), Ovid describes the palace of the sun: it is tall, with high columns on the façade and decorations in gold, bronze, ivory, and silver; but the workmanship surpasses even these lavish materials. Inside, a radiant Apollo occupies a gleaming throne adorned with emeralds. Ovid's mythical palace of the sun was finally given concrete form in the palace and gardens of Versailles.

Like Poussin, Louis XIV was an advocate of the Classical tradition. His academies, which succeeded in large part in legislating taste, were proponents of Poussin's preferences for order and clarity, qualities that

were allied with the self-image of France itself. Poussin and Louis XIV also advocated the representation of grand historical and mythological themes, reflecting the epic character of mankind. Both men left a lasting mark on the theory and practice of the arts. For centuries, Poussin would be thought of as a "Classical" painter and Louis XIV as having used Classical imagery to project the image of absolutism. His long reign was largely responsible for the shift in the art patronage of Western Europe. From Rome, which had dominated patronage since the High Renaissance, the center of the art world became Paris and would remain so until World War II.

NOTES

1. Alain Mérot, *Nicolas Poussin* (New York, 1990), p. 193.

2. For the translation and significance of the inscription, see Erwin Panofsky, *Meaning in the Visual Arts* (New York, 1955), ch. 7.

3. For more on the written text, see David Carrier, *Poussin's Paintings* (University Park, Pa., 1993), esp. "Overture."

4. Mérot, p. 147.

5. Robert W. Berger, *A Royal Passion: Louis XIV as Patron of Architecture* (New York, 1994), p. 14.

6. *Ibid.,* p. 15.

7. *Ibid.,* p. 28.

8. *Ibid.*

9. Stéphane Pincas, *Versailles: The History of the Gardens and Their Sculpture* (New York, 1996), p. 118.

10. Ovid, *Metamorphoses,* trans. Frank Justus Miller (Cambridge, Mass., and London, 1984), pp. 311–315.

11. Berger, p. 60.

Baroque Painting in Flanders and England

The greatest genius of Flemish Baroque, Peter Paul Rubens (1577–1640), was a man of prodigious energy and commitment to life. This is manifest even in the late *Self-Portrait* sketch of around 1635 (6.1). At nearly sixty, Rubens is in full command of his art. His voluminous form, accentuated by the billowing diagonals of his drapery, seems almost too large for the picture space. He gazes sharply at the viewer from under a wide-brimmed hat, the slight downward curve of his lips injecting a sober note into the artist's flare for courtly bravado. In the more "finished" painted version (6.2), Rubens stands by a column, one hand gloved and the other resting on the hilt of a sword. The quickly sketched hatching lines of his costume have become nearly solid black, and his hat is now a strong black silhouetted against a dark brown, slightly textured wall. His head, framed by the white collar, and the softly wrinkled flesh reflect his age and his intelligence. At the same time, however, the illumination of the face records Rubens' con-

tinuing zest for life. The sword, animated by light highlights, together with the sense that his hand plays over its surface, reflects the inherent vitality of Rubens the artist, whose legacy includes some eighteen hundred paintings, the man who was devoted to his family, and the diplomat actively engaged in the politics of his time.

Peter Paul Rubens

Rubens was born in Westphalia, in Germany. His parents had left the Catholic Church for Calvinism and fled religious persecution in Antwerp, which was under the control of the Spanish king. Rubens' father, a high government official, was imprisoned for two years—released through the efforts of his wife—for an affair with the mentally disturbed princess of Orange.

On his father's death in 1587, when Rubens was nine, his mother returned to Antwerp, where she rejoined the Catholic Church. The Netherlands, at this point,

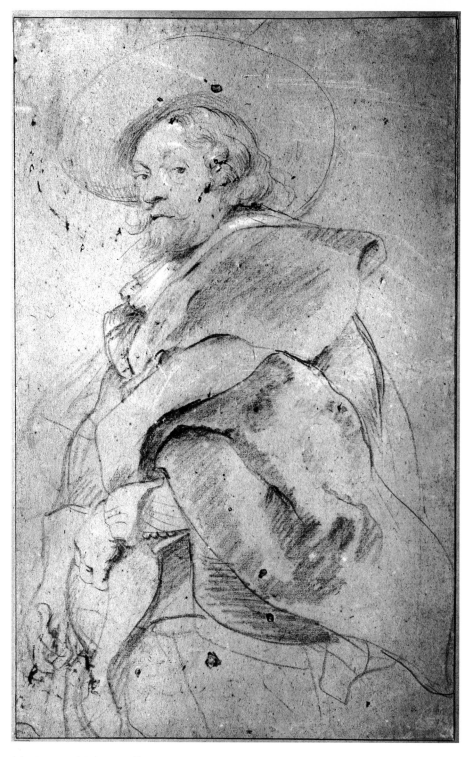

6.1 Peter Paul Rubens, *Self-Portrait,* c. 1635. Drawing. Musée du Louvre, Paris. (Art Resource)

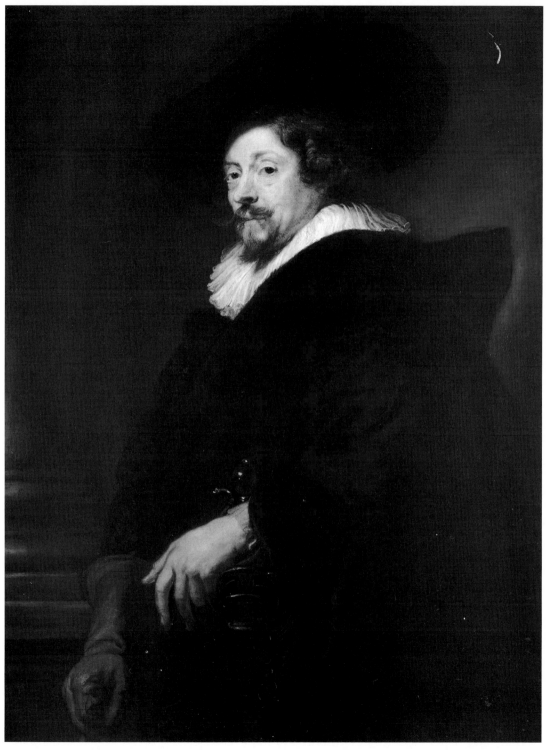

6.2 Peter Paul Rubens, *Self-Portrait,* c. 1648–1650. Oil on canvas. Kunsthistorisches Museum, Vienna. (Art Resource)

had been divided between the Protestant (Calvinist) North and the Catholic South. Conflicts between these regions and Spain continued until 1609, when an uneasy, twelve-year truce was signed between Spain and the so-called United Provinces of the North. As a result of the turmoil over Spanish rule, Antwerp's position as the European center of trade had suffered.

Rubens was himself a devout Catholic and, like Bernini, produced imagery that satisfied post-Tridentine, Counter-Reformation requirements. He also painted Classical subjects and, like his classicist brother, had humanist inclinations. Having returned to Antwerp from Germany, Rubens was at first taught by two minor masters. He was then apprenticed to the prominent humanist artist Otto van Veen (or Vaenius), who had studied in Italy. In 1598, at the age of twenty-one, Rubens became a master in the painters' Guild of Saint Luke.

Two years later, in May 1600, Rubens left Antwerp and went to Italy. He stayed nearly nine years, during which time he studied Italian art, copied the works of Titian, Michelangelo, Tintoretto, and Veronese, and also collected. He read and wrote Latin, and spoke Italian fluently. For much of his stay, Rubens was in the employ of Duke Vicenzo I of Mantua, who sent the artist to Spain on a diplomatic mission. In Spain as well as Italy, Rubens received important commissions and was instrumental in motivating Velázquez's trips to Italy to study the High Renaissance masters. After spending three years on and off with his brother in Rome, where he studied ancient sculptures, Rubens returned to Antwerp toward the end of 1608. That same year, he married Isabella Brant, the niece of his brother's wife. Their marriage lasted seventeen years, until Isabella's death in 1625.

Rubens' success in Antwerp permitted the couple to purchase a large house in the city, where his patrons included the Archduke Albert and Archduchess Isabella (daughter of Philip II of Spain)—regents of the Spanish (South) Netherlands—the Church, and wealthy private citizens. He ran a large workshop and trained assistants to help with his numerous commissions. The split between North and South, however, resulted in the loss of the Dutch market, which prompted Rubens to hire an engraver to copy his pictures. These engravings were sold throughout the Netherlands as well as in France, England, Germany, and Italy.

For most of his life, Rubens combined a genius for painting with diplomatic skills. Possibly his lifelong efforts to bring about a peace between Catholics and Protestants reflected a wish to repair the exile of his early years caused by his parents' flight from religious persecution. In any event, in addition to being the court painter to Albert and Isabella, Rubens painted, and collected for, the royal families of Italy, Spain, and France. He was also commissioned by Charles I of England to decorate the ceiling of London's Whitehall Banqueting House (see Chapter 9)—which had been renovated by the court architect, Inigo Jones (1573–1652)—with nine canvases commemorating the reign of his father, James I. The fifty-three-year-old Rubens returned to Antwerp in 1630 and in December married the sixteen-year-old Hélène Fourment. This marriage was as happy as the artist's first marriage and lasted until his death.

The Raising of the Cross

From 1609 to 1621, Rubens painted a large number of works—especially monumental altarpieces—for the cathedral of Antwerp and the city's churches. In 1609–16, he executed one of the key monuments of his career: *The Raising of the Cross* (6.3), which was the center panel of a triptych for the high altar of the church of Saint Walburgis. Its remarkable energy, warm colors, and rich textures reflect Rubens' assimilation of the sixteenth-century Venetian painters, which he has transformed into the vigorous, dramatic character of Baroque.

The theme is triumph, the triumph of Christ through suffering a martyr's death that was exalted by the Counter-Reformation's militant efforts to reassert the authority of the Church. "A triumphal Passion was particularly appealing to Rubens," for it provided him with the opportunity to merge the Classical motif of soldiers "struggling to raise a trophy" with a Christian context.[1] Rubens' muscular figures, reminiscent of Michelangelo's Sistine *Ignudi*, twist, push, and pull against the weight of the Cross. Its broad diagonal plane leads the viewer's gaze from the lower right corner across the picture toward the upper left, where Christ's gaze seems focused on his future in heaven. He literally "rises above" his physical suffering, triumphantly extending his arms skyward.

In contrast to the radical foreshortening and vigorous *contrapposto* of the Romans, the extension of Christ's body and his outstretched arms suggest liberation from earthly conflict and his power to lift the weight of sin. The inscription above his head proclaims the traditional "Jesus of Nazareth, King of the Jews" in Hebrew, Greek, and Latin. Christ is bathed in a rich yellow light, wearing a white loincloth that contrasts with the red and blue draperies of the Romans and with the armor of the soldier at the left. The darkened areas, most prominent in the upper part of the picture, suggest the influence of Caravaggio's tenebrism. They provide a backdrop from which Christ emerges as the "Light of the World." The barking dog, forming a sharp diagonal at the lower left, echoes the pervasive tension of the scene. It also reinforces the particularly bestial nature of the muscular, subhuman "strongman" leaning backward and pushing upward on the Cross, and of Crucifixion itself.

There are liturgical implications in *The Raising of the Cross* that are related to the theme of triumph. Its original context, over the high altar of Saint Walburgis, invited comparison with the Host-as-Christ's-body in the performance of the Mass. Christ's carnal presence in this painting "confirmed the central Catholic dogma, denied by Protestants, of a real 'bodily presence' in the Eucharist."[2]

The Descent from the Cross

Like *The Raising of the Cross*, Rubens' *Descent from the Cross* (or *The Deposition*) in Antwerp Cathedral (6.4), begun slightly later, is a quintessentially Baroque conception, here depicting defeat and the reality of death. Also the center panel of a triptych, it can be read in relation to the earlier work. Christ is rendered with the gray pallor of death, as he slumps lifelessly into the arms of his followers. The smooth, upward

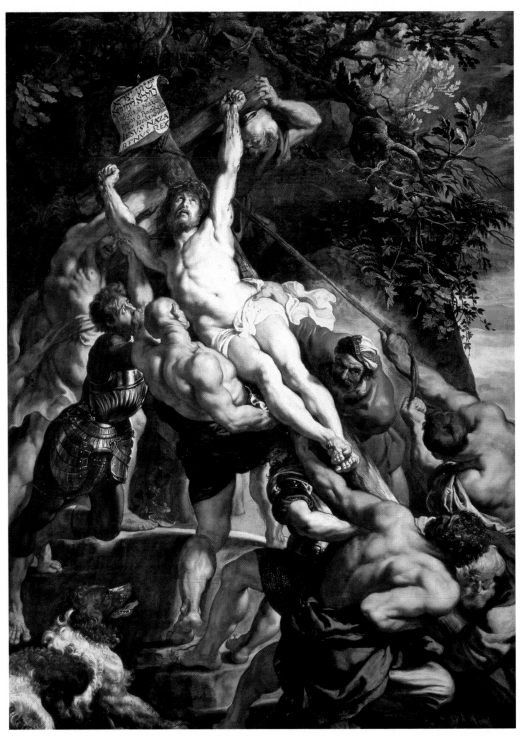

6.3 Peter Paul Rubens, *The Raising of the Cross,* originally for the high altar of Saint Walburgis, 1609–1616. Approx. 15 ft. (4.6 m) high. Cathedral, Antwerp. (Bridgeman Art Library)

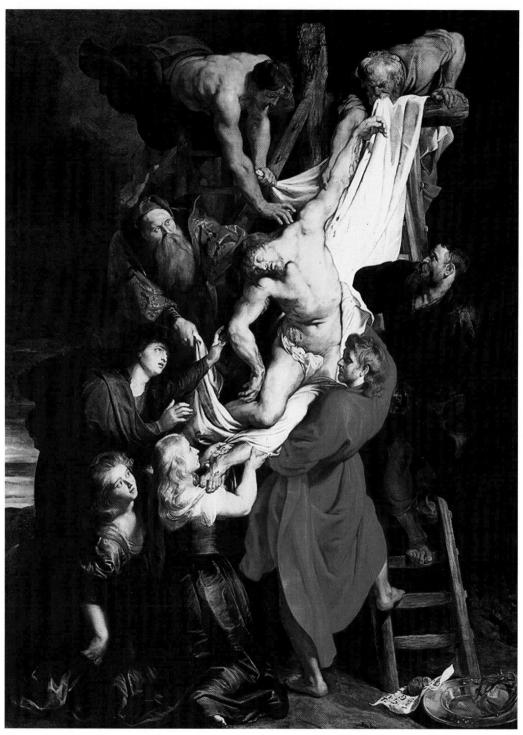

6.4 Peter Paul Rubens, *The Descent from the Cross (The Deposition),* for Antwerp Cathedral, 1611–1614. Oil on canvas, app. 15 ft. (4.6 m) high. Cathedral, Antwerp. (Scala/Art Resource)

diagonal of the earlier picture has become a slow curve of white drapery, which is marred by the undignified, uncontrolled, zigzag pose of Christ's mangled body.

In place of the efforts to raise the Cross, five men struggle to prevent Christ from falling. John the Apostle, in vivid red drapery and a pose echoing that of the "strongman," bears most of Christ's weight as he steps on the ladder for support. At the left, the three Marys insert an element of feminine grace, accentuated by their richly textured silk draperies and flowing hair. Whereas in *The Raising of the Cross* Christ's triumphant humanity towers over the brutishness of his executioners, in *The Descent,* it is his followers whose humanity radiates from the scene.

The tenebrism in *The Descent* is more pronounced than in the earlier work—which also depicts the earlier event—and blackens the sky. The stark white of Christ's drapery, juxtaposed with nature's traditional response to his death, is an ironic allusion to his role as the world's light. Discreetly referring to Christ's ultimate triumph, and with it that of the Catholic Church, is the gold plate at the foot of the ladder. It contains blood, the Crown of Thorns, and a nail, all of which denote Christ's Passion.

Resting like a paperweight on the inscription is a small bread, referring to the Eucharist. It makes visible the doctrine of transubstantiation—according to which the bread and wine of Communion are the literal body and blood of Christ—which was reaffirmed by the Council of Trent. The text of the inscription, elevated in triumph in *The Raising of the Cross,* has here descended to earth. Its triumph now lies in the future of the Church Triumphant.

The Rape of the Daughters of Leucippus

Around 1618, Rubens painted the work known as *The Rape of the Daughters of Leucippus* (*The Rape of Princesses Phoebe and Hilaira, Daughters of King Leucippus, by the Hero Twins, Castor and Pollux*) for an unknown patron (6.5). In it, he displays his passion for rippling, voluptuous female flesh, his interest in formal violence, which here corresponds to the content, as well as his enthusiasm for the dynamic energy of powerful animals. He uses Baroque diagonals, a sharp highlight of red in the cape, an abrupt juxtaposition of foreground conflict and a peaceful distant landscape, and intense interlocking forms to convey the dramatic narrative.

In Greek mythology, Castor and Pollux, the Dioscuri (literally "sons of Zeus"), twin sons of Zeus and Leda, abducted the daughters of Leucippus, killed their fiancés, and married the women. The story was known from several ancient sources, among them the *Idylls* (22.137) of Theocritus and the *Fasti* (5.699) and *Ars amatoria* (1.679–680) of Ovid. In Rubens' image, the struggling figures are pressed up against the picture plane in a tour de force of fleshy bravado.

Castor and Pollux, famed equestrians, gaze lovingly at their future brides while using violent means to win them. The ambivalence of this procedure has been masterfully conveyed by Rubens, who shows the women as conflicted as their abductors. The poses and gestures of the princesses reiterate traditional poses of female sexuality and receptiveness, while their flailing arms seem to protest the will of the Dioscuri. At the same time, prominently placed in the lower foreground, the toes of one princess rest on the foot of the dismounted twin. The space between her buttocks and his leg

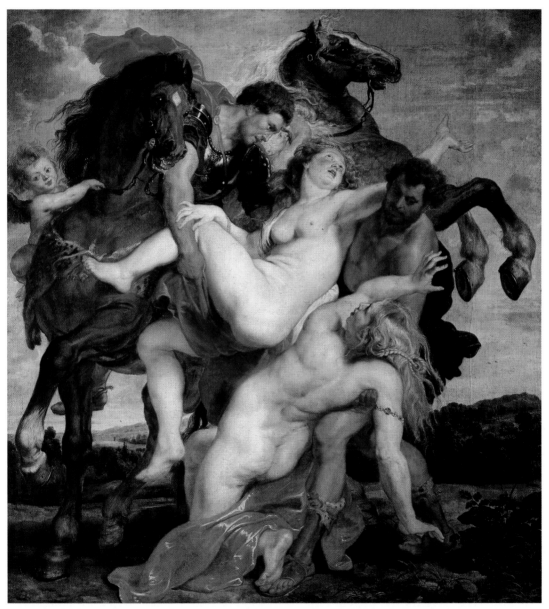

6.5 Peter Paul Rubens, *The Rape of the Daughters of Leucippus (The Rape of Princesses Phoebe and Hilaira, the Daughters of King Leucippus, by the Hero Twins, Castor and Pollux)*, c. 1618. Oil on canvas, 7 ft. 3 in. × 6 ft. 10 in. (2.21 m × 2.08 m). Alte Pinakothek, Munich. (Art Resource)

is closed up by a flowing drapery, whose silky folds are conveyed by rich yellow highlights, uniting the figures in a softness that belies the manifest violence.

Rubens emphasizes certain contrasts between the princesses and the twins that both highlight their difference and reveal their mutual attraction. The skin tones of the men are darker and their muscles emphasized, in contrast to the pampered pink-and-white dimpled flesh of the women. The men are clothed and occupy dominant positions—one standing, the other mounted and armored—whereas the nudity and lower placement of the women accentuate their helplessness. At the same time, however, the women are rendered as ensnaring the gaze of the men. Like Rubens himself, the Dioscuri are captivated by the vision of their captives. That they are symbolically also tamed, in the sense of becoming civilized by their own captivation, is evident from the two Cupids who bridle the horses.[3]

The horses themselves serve as foils for the "bridled" and "unbridled passion" of the twins.[4] Associated with horsemanship in antiquity, the Dioscuri are here identified with their steeds. The gray horse rears, his head tilting toward the upraised hand of the princess. The brown horse turns abruptly to gaze at the women, his leopard skin reinforcing his wild nature. Together, the horses provide a backdrop of animalistic lust, contrasting horsehair with human flesh, that is a feature of the original myth. Ovid himself asserts that, despite their initial resistance, women wish to be won over by violence.[5]

Since the commission and context of the painting are not known, various interpretations of its meaning have been suggested. These include an "allegory of marriage,"

and an unlikely Neoplatonic reading as the soul's progress toward heaven.[6] A more apt proposal places the picture in the political context of Rubens' time and relates its iconography to a royal marriage negotiated by Marie de Médicis, mother of Louis XIII.[7] The future French king was engaged to the sister of Philip IV of Spain, who, in turn, was engaged to Louis' sister. The twins are thus conflated in Rubens' image with the monarchs, who exchange sisters in order to become brothers-in-law.[8]

This reading identifies the political theme of the painting as an idealization of absolute monarchy, which traditionally appropriated mythological rapes and abductions for palace iconography. In such cases, the earthly ruler was implicitly identified with Zeus and Jupiter, both of whom were above human law. Rubens thus casts the kings (Philip IV and Louis XIII) "as actual brothers" and represents "their acquisition of wives as a joint sexual adventure, which at once consolidates the fraternal bond and . . . serves the familiar function of demonstrating their princely *virtù*."[9] Such a message would also have appealed to Rubens' patrons, Albert and Isabella, who favored an alliance between France and Spain. By cloaking absolutism in mythological guise, its essential violence appears mitigated and is exalted as a noble political ideal.

A more general motif in Rubens' oeuvre that reflects his attraction to animals as signs of power is his frequent depiction of lions. His famous *Lion Hunt* for the duke of Bavaria won him several commissions for similar scenes. Whereas the horses of Castor and Pollux allude to the equestrian portraits of Roman emperors, the lion evoked the traditional identification of kings with

lions that can be traced to the ancient Assyrian Empire. Like the Assyrian rulers who kept lion parks and, in their palace reliefs, depicted ritual lion hunts by the kings, the rulers of Europe maintained menageries of such animals.

The drawing in figure 6.6, even more so than the horses in *The Rape of the Daughters of Leucippus,* exhibits a compression of space made possible by the lioness's radical foreshortening. It is a remarkable portrayal of inherent power combined with the sleek gracefulness of the animal. Its position in the picture space draws the viewer's gaze inward, toward the the bared teeth and extended left paw that denote deadly aggression. Like the absolute monarchs of seventeenth-century Europe, the lioness is elegant, regal, even beautiful, but potentially ferocious and implacable.

Henri IV Receiving the Portrait of Marie de Médicis

In 1621, Rubens received a major commission that was manifestly political. It consisted of twenty-one canvases depicting and exalting the reign of Marie de Médicis. In this case, there is no question but that Rubens combined artfulness with art when he depicted the life of the physically unattractive, personally difficult, unpopular dowager queen of France. He did so by representing her rule as having fulfilled the will of the Olympian gods.

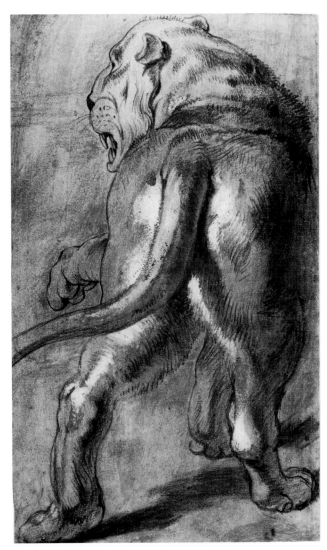

6.6 Peter Paul Rubens, *Lioness,* c. 1614–1615. Drawing. © Copyright The British Museum.

The fourth in the series shows Henri IV being presented with Marie's portrait by a Cupid and the marriage god, Hymen (6.7). The king, still wearing his armor from the distant battle, stands riveted to her regal image. His left leg and foreshortened left

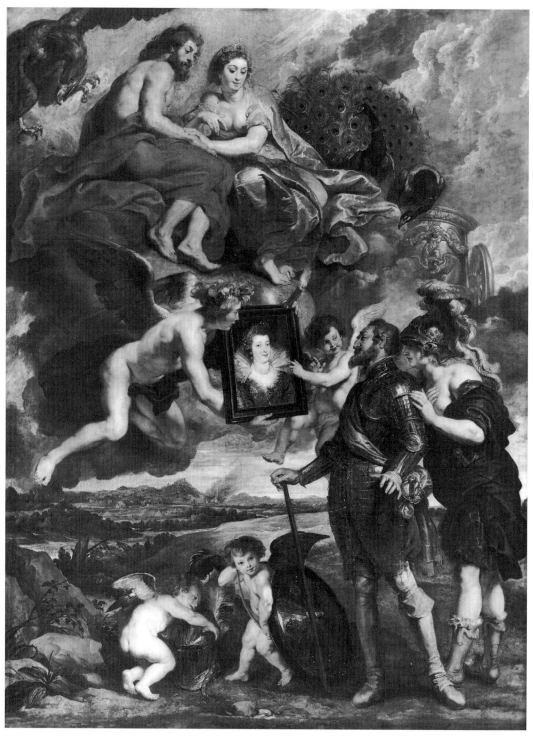

6.7 Peter Paul Rubens, *Henri IV Receiving the Portrait of Marie de Médicis,* 1621–1625. Oil on canvas, 12 ft. 11 $^{1}/_{8}$ in. × 9 ft. 8 $^{1}/_{2}$ in. (3.94 m × 2.95 m). Musée du Louvre, Paris. (Art Resource)

hand are arrested in mid-movement. Behind him, a figure who seems to be a conflation of France personified and the goddess Minerva apparently counsels him to focus on the portrait. Below, two Cupids playfully carry off his helmet and shield, an allusion to Henri-as-Mars and the tradition of the war god being disarmed by Love. On Juno's silver chariot, a gilded Cupid tramples the bellicose eagle, reinforcing the theme of love's triumph over war. Henri's excitement on viewing his bride is displaced onto the swirling clouds, the draperies worn by Juno and Jupiter, and the contorted eagle grasping Jupiter's bolt of lightning.

The rulers of Mount Olympus hold hands in an image of marital harmony and gaze benignly at the earthly king gazing on his future queen. One of Juno's peacocks stares at the earthly event, while the other spreads its feathers, multiplying the gaze with a chorus of eyes. Only they, and the Cupid with Henri's shield, look out of the picture toward the space of the viewer.

In this painting, Rubens uses the glorification of the queen and its narrative content to exalt his own art. Minerva herself is an arts goddess, who is as captivated by Marie's portrait as is Henri. The power of the image, in this case a picture painted by Rubens within a picture painted by Rubens, arrests gods and mortals alike. It has been brought to a king by a god of love and a god of marriage and, therefore, affects the course of history and the destiny of the French monarchy.

The towering reputation of Rubens was difficult to rival in seventeenth-century Antwerp. His student Anthony van Dyck (1599–1641) was particularly talented in portraiture. But he left the city, rather than try to compete with Rubens, and became court painter to the English king, Charles I. This position was well suited to van Dyck's taste for somewhat understated aristocratic elegance and a generally more secular focus than Rubens. In England, van Dyck would set the standard for royal portraiture well into the eighteenth century.

Anthony van Dyck

Van Dyck's father was a silk merchant, who apprenticed his son in the Guild of Saint Luke. By the age of nineteen, van Dyck was a master in his own right and visited the court of James I for a brief period in 1620. The king gave the artist a stipend, which permitted him to study in Italy as Rubens and Velázquez had done. Van Dyck remained in Italy from 1621 to 1626, returned to Antwerp, and set up a studio. But shortly after Rubens' own return from England, where he executed the Whitehall paintings for Charles I, van Dyck again departed. From 1632 until 1639, he worked as court painter to Charles I, who paid him well and granted him a knighthood. He married a noblewoman and left England only when rebellion broke out against the king. But his attempt to reestablish himself in Flanders failed, and he returned to London, where he died at the age of forty-two, eighteen months after Rubens.

A comparison of Rubens' drawing of the lioness (6.6) with van Dyck's preparatory sketch of Charles I's horse (6.8) illuminates some of the essential differences between these two Flemish artists. Although the horse is depicted with as sturdy an underlying structure as the lioness, and despite its

6.8 Anthony van Dyck, *Study for the Great Horse,* c. 1638. Pen and ink with brown wash, heightened with white, on blue-gray paper. © Copyright The British Museum.

foreshortening, it does not radiate the same sense of compressed power. Monumental as the horse is, van Dyck accentuates the elongated grace of the head and positions the figure so that there is open space between the legs. Rubens also emphasizes the sleek textures of the animal's fur with areas of smooth, nearly solid blacks and hatching lines of varying lengths. But the horse, with its delicately textured body surface and the merest suggestion of a rider, seems to be of a lighter, more translucent substance than Rubens' lioness. The calm, downward gaze of the horse, compared to the slightly raised head and bared teeth of the lioness, conveys an air of sadness that has traditionally been seen to characterize the portraits of Charles himself.

As with other court artists and their kings, van Dyck's portraits of Charles I are, in a sense, a collaboration between painter and patron. They also have a political agenda that involves an elaborate iconographic subtext. Such is the case with van Dyck's monumental, 12-foot-high portrait—*Charles I on Horseback* (6.9).[10]

In 1625, the Stuart Charles ascended the English throne and married Henrietta

6.9 Anthony van Dyck, *Charles I on Horseback,* c. 1637–38. Oil on canvas, 12 ft. × 9 ft. 7 in. (3.67 m × 2.9 m).
National Gallery. (Bridgeman Art Library)

Maria, daughter of Henri IV and Marie de Médicis. In 1629, a peace was entered into with Spain and France, and Parliament was dissolved. From then until 1640, Charles ruled without Parliament in what he called the period of Personal Rule and what his detractors called the Eleven Years' Tyranny. As conveyed by van Dyck as well as by the mythology of the court, the king's image was multifaceted and, like those of other seventeenth-century monarchs, was intended to enhance his right to the throne. It combined kingship with divinity, soldiering with chivalry, and humanism with philosophy.

The calm, pastoral setting of *Charles I on Horseback* is the English countryside, denoting an England over which the king presides by divine right. The idyllic landscape, with the large tree framing Charles, stands for England itself, a land that has achieved peace through the virtue of its ruler. As Louis XIV danced the role of Apollo in court performances, so Charles I acted roles that corresponded to his desired political image. In England, the vehicle for such performances was the masque, which was conceived of as a mirror of the court.[11] The genre itself appeared under James I and became a staple of Stuart mythologizing. The Whitehall Banqueting House had been renovated as a setting for such masques, with Inigo Jones constructing the scenery and Ben Jonson providing the literary texts. Inspired by Italian perspective stage sets, Jones designed each scene to reflect the message of the performance, which typically consisted of dialogue, singing, and dancing. Engineering tours de force intended to achieve illusionistic effects in which members of the court appeared as

gods in heaven mirrored the delusional isolationism of the court. This was even more the case under Charles I, whose masques, because Jonson had split from Jones, lacked the literary quality they had had during his father's reign. In a court masque—*Triumph of Peace*—of 1634, for example, Charles played Jupiter, and the queen played Themis, mythic parents of Peace, Law, and Justice.[12] Similar masques, performed throughout Charles's Personal Rule, reflected the court's denial of reality and constructed a picture, like the portrait itself, that was at odds with the national mood.

The equestrian motif had a long history, which informed the meaning of van Dyck's painting. In antiquity, Roman emperors were represented on horseback, a theme revived in the Renaissance for celebrating the virtue of military heroes. In the sixteenth century, Titian had portrayed the Holy Roman Emperor Charles V on horseback, and in the seventeenth century both Philip IV and Louis XIV were so depicted by Velázquez and Bernini, respectively. In the context of English history as well, equestrian iconography had become current from the early 1600s with the accession of James I. Consistent with taking the Roman equestrian portrait as an iconographic model for royal portraiture, the Stuarts identified with Rome in tracing their ancestry to Troy. Like the ancient Romans, the Stuarts could thus claim a divine lineage.

This claim is manifestly the text of van Dyck's painting of 1633 entitled *Charles I Riding Through a Triumphal Arch* (6.10). Here, the horse approaches the picture plane as the king is revealed against a stormy sky by drawn curtains. The arch, like the mounted sovereign, denotes the

6.10 Anthony van Dyck, *Charles I Riding Through a Triumphal Arch,* 1633. Oil on canvas. The Royal
Collection. © Her Majesty Queen Elizabeth II.

Roman imperial past more self-consciously than in the examples by Titian and Velázquez. Their riders are depicted as self-reliant, conveying a strength of character that is curiously lacking in England's Charles. He, in contrast, seems to require props—the arch, the columns, the crest and crown at the left—to shore up his imperial image. The result, like the Stuart court itself, is rather theatrical and dependent on illusion.

Alluding to the king's imperial character in *Charles I on Horseback* is the framed inscription on the tree: "*CAROLUS I REX MAGNAE BRITANIAE.*" The fictional identification of Charles as king of Great Britain did not lessen the impact of the painting's message. For, in reality, James I's efforts to be recognized as emperor of Scotland, France, and Ireland as well as of England failed. Likewise, when Charles tried "to unite the kingdoms ecclesiastically," he "precipitated the war which led to the collapse of the personal rule."[13] Calling attention to the inscription is the figure highlighted in red silk who holds the king's helmet and a bundle of feathers. He seems to have just entered the picture space and, like the corresponding figure in Figure 6.10, directs the viewer's attention to the king enthroned on his horse.

Van Dyck's depiction of Charles as a soldier is evident in the shiny armor, the long diagonal sweep of the sword, and the baton of rule. Around his neck hangs a gold chain with a medallion of Saint George and the Dragon. By virtue of this detail, sainthood and chivalry are merged with Charles' military persona. The parallel between Saint George and Christ, and the dragon and Satan, was in line with traditional Christian typology. In addition to being the patron saint of England, Saint George was a paradigm of chivalry, for in killing the dragon he rescued the princess. This, too, was part of the royal mythology, influenced by Henrietta Maria herself, who brought from France a taste for the chivalric tradition. It was given dramatic form in the court masques—Charles the knight, and the queen his lady—and iconographic form in the court paintings.

In van Dyck's *Charles I on Horseback*, despite the layers of meaning that reinforce the king's perfection, Charles lacks the energetic self-confidence and firm grip on reality of Rubens' figures. Even Rubens' *Henri IV*, whose gaze is "trapped" by the image of Marie de Médicis, is depicted with a greater sense of both inner strength and outer vigor than van Dyck's Charles. Enthroned as he is on an impressive steed, armored, and affirmed by the inscription on the tree as king of Great Britain, there is a sense of languorousness about him. In contrast to Velázquez's *Philip IV*, who executes the *levade*, and *Balthasar Carlos*, who gallops forward, Charles I tilts back in his saddle. His mood (like that of the landscape) is contemplative, his proportions are slim, and his eyes watery. Van Dyck's penchant for aristocratic understatement, like Charles' somewhat unrealistic character, emerges in a painting manifestly proclaiming the king's divine virtue and power.

In 1642, around four years after van Dyck's portrait and one year after the artist's death, civil war broke out between Charles I and Parliament. In 1649, Charles was beheaded.

NOTES

1. From Robert Baldwin, unpublished survey text.

2. *Ibid.*

3. This is an ancient theme, found as early as the *Epic of Gilgamesh,* in which the wild Enkidu is tamed and civilized by a harlot. Like Rubens' depiction of the Dioscuri, the author of the epic describes a man's transition from a primitive to a civilized state through his love for a woman.

4. See Baldwin, *op. cit.*

5. Cited by Margaret D. Carroll, "The Erotics of Absolutism: Rubens and The Mystification of Sexual Violence," *Representations* 25 (Winter 1989): 3–29. Reprinted in *The Expanding Dis-course,* ed. Norma Broude and Mary D. Garrard (New York, 1992), p. 140.

6. *Ibid.,* p. 139.

7. *Ibid.,* ch. 8.

8. *Ibid.,* p. 147.

9. *Ibid.,* p. 148.

10. The following iconographic reading of the portrait is indebted to Roy Strong, *Van Dyck: Charles I on Horseback* (London, 1972).

11. See Roy Strong, *Art and Power* (Woodbridge, Suffolk, 1984), for a more thorough account of the Stuart masques.

12. Strong, *Van Dyck,* p. 85.

13. See *ibid.,* ch. 3 and pp. 45–46.

Seventeenth-Century Dutch Painting I: Rembrandt

Politics and Patronage

A discussion of seventeenth-century Dutch painting requires a brief excursus on the political and religious developments of the period. In 1579, the Union of Utrecht declared Holland an independent republic. Holland was actually the most prosperous and populous of the seven provinces of the northern Netherlands (the others were Friesland, Groningen, Gelderland, Overijssel, Utrecht, and Zeeland) and generally refers to the entire territory. Officially, it was called the Dutch Republic.

Following the Protestant Reformation, the northern Netherlands, like most of Europe, was in turmoil. But by 1600, the government, which was a federation of provinces with delegates at the court of The Hague, the favorite residence of the ruling House of Orange, was controlled by Protestants. In the course of the seventeenth century, Holland became primarily Calvinist, established important universities, and at-

tained considerable wealth from shipbuilding and international commerce.

The effect of these developments on patronage of the arts was considerable. In contrast to the Catholic Church, Protestant churches did not encourage lavish decoration, and the absence of a powerful monarch eliminated the need for court artists. In the northern Netherlands, and especially in Amsterdam (in Holland), the new source of patronage was the middle class. As a result, iconography was less likely to glorify the Church or a ruler. This also meant that artists worked independently and had to establish markets for their work among the general public.[1]

As subject matter became more secular and as paintings more and more decorated homes rather than churches or courts, the relatively new genres—especially still life and landscape—increased in popularity. Portraiture, of which Rembrandt was the undisputed master, also appealed to the middle and professional classes. The land-

scapes of Ruisdael, as well as those of Rubens and Rembrandt, reflected an interest in land and national geography. They also indicated a new awareness of the world's expanse, possibly influenced by international trade. Certain paintings by Vermeer, notably his *Astronomer* and *Geographer,* seem to have been informed by contemporary explorations of the globe and advances in optics. Vermeer's interest in optics has been much discussed by scholars, and his use of the *camera obscura* is virtually certain. He, more than any of his contemporaries, painted meticulously detailed surfaces and plumbed the iconography of quiet interiors for their psychological complexity. When biblical subjects were depicted—particularly by Rembrandt—their spiritual qualities derive from their humanity rather than from Counter-Reformation suffering in the service of martyrdom.

Rembrandt van Rijn

Rembrandt (1606–1669) was born in Leiden, a center of humanism and home of the first Protestant university in the Netherlands. His father, a Calvinist, was from a family of millers; his mother's family were bakers and Catholic. Rembrandt himself was well educated; he attended the Leiden Latin school for seven years (from seven to fourteen) and was briefly enrolled at the university. His Classical education infiltrates his imagery in both its human character and the attention paid to texts, particularly the Bible.

Rembrandt worked in a wide range of techniques and media, including drawing, etching, drypoint, and painting. His breadth of human subjects, from infancy to old age, from poverty and misfortune to wealth and status, reflects his essentially humanist view of the world. Four of his drawings of children reflect his genius for conveying aspects of infantile character and for merging medium and technique with psychology. The *Two Studies of a Baby with a Bottle* (7.1), made about a year after he married, are as sketchy in execution as is the baby's stage of development. The actual drawing seems calculated to correspond to the unfinished nature of infancy itself. In the lower of the two sketches, the "mother" is the hand that holds the bottle, accurately replicating the baby's oral experience of reality. Reflecting the anxiety that accompanies an infant's hunger is the forward thrust of the baby's features and the firm intent of the mother's responsive hand. The upper sketch depicts a state of greater calm. The baby contentedly nurses, the mother's hand has all but disappeared, and the drawing lines have decreased, leaving a smoother, more serene picture surface.

In *Two Women Teaching a Child to Walk* of around 1640 (7.2), Rembrandt depicts the child's ambivalence toward mastery and independence. The two architectonic, foreshortened women tower over the child and also support her; the one at the left literally "points the way," implying a future in time as well as in space. The child herself is shown on the brink of a new developmental stage, the dramatic moment when one learns to walk. A sense of apprehension is revealed by the slight downward turn of the mouth, and the child's tensed efforts to remain evenly balanced and upright between the women. This is accentuated by

7.1 Rembrandt, *Two Studies of a Baby with a Bottle,* c. 1635. Drawing. Staatliche Graphische Sammlung, Munich.

7.2 Rembrandt, *Two Women Teaching a Child to Walk,* c. 1640. Drawing. British Museum, London.

7.3 Rembrandt, *Woman Carrying a Child Downstairs,* c. 1636. Drawing. (The Pierpont Morgan Library/Art Resource)

onto him. He is at once "seated" on the woman's left arm and lying forward on her chest. His more overt anxiety, in contrast to her determined concentration, is revealed in the physiognomy, the repeated hatching lines of the face, and the energetic curls. Rembrandt emphasizes the potential for falling by the contrast of the dark vertical wash echoing the plane of the woman with the blank space to the left of the child's less stable, diagonal plane.

In the drawing *A Naughty Child* (7.4), Rembrandt depicts the uncontrolled rage of a tantrum. The mother's vain efforts to

the horizontal plane of her cap and extended arms, firmly gripped by the women. That she leans very slightly forward, in contrast to the sharp angles of the adult poses, is suggested by the upturned back rim of the cap and the condensed space of her upper torso.

The circumstance of a child's willing dependency is shown in *Woman Carrying a Child Downstairs* (7.3). Here the adult leans backward, steadying herself for the descent and the weight of the child. The child, on the other hand, leans forward, grasping the woman's back, as she, in turn, holds firmly

7.4 Rembrandt, *A Naughty Child.* Drawing. Staatliche Museen, Preussischer Kulturbesitz, Kupferstichkabinett, Berlin.

"get a grip" on the child seem doomed to failure as he continues to flail violently. He is in a precariously unstable position, insecurely raised up, and courting the danger of being dropped on the ground. The agitated lines echo his psychological state, while the other figures—a woman and two children—are riveted by the scene. The calm fascination of the two children in the doorway is conveyed by their relative stillness and quiet, compared with the zigzags of the screaming boy.

In Rembrandt's famous etching *The Blindness of Tobit* (7.5), the artist combines his psychological insights with a biblical text that had interested him for years. His personal preoccupation with old age and blindness is projected onto Tobit, who becomes blind when bird's dung falls on his eyes and then waits years for the return of his son Tobias, who cures him. Typical of the later etchings, this one is composed of clear hatching lines and areas of rich darkness created by dense cross-hatching.

Falling and dependency are as much features of old age as of childhood, which Rembrandt masterfully captures in the figure of Tobit. The old man has been sitting by his fireplace and leaps up when he hears the sounds of his son's return. In so doing, he knocks over the spinning wheel and, true to the text of the Dutch Bible, hits his hand against the door.[2] In an ironic play on mirroring, Tobit moves not toward the open doorway, but toward his own shadow cast against the solid wall. He shows no sign of noticing his son's dog, which has run on ahead to greet him. The sense of disarray and frustration, caused by Tobit's simultaneous eagerness and blindness, is compounded by the multiplication of mis-

Engraving, Drypoint, and Etching

Engraving, drypoint, and etching are **intaglio** printing methods in which an image made by incised, inked lines is transferred from a metal plate to paper. Usually, the ink is slightly raised from the surface in the finished print, which enhances the textural qualities of the image. In engraving, a **burin**, or graver, a metal tool with a sharp point, is pushed through the resin-coated surface of a metal plate. The resulting lines are generally precise and end in a point.

In drypoint, the graver is pulled, rather than pushed, across the metal surface of the plate. As a result, drypoint lines have more texture than engraved lines. Drypoint is often done in combination with etching, in which a needle is used to draw into the metal, producing lines that are somewhat rounded at the ends. The plate is then placed in an acid bath that eats into the etched lines. The longer the plate remains in the bath, the deeper and darker the lines when printed.

aligned events: the overturned wheel, the unacknowledged dog, the unaccustomed speed of the old man, and the headlong rush toward a shadow.

Although Rembrandt concluded his formal schooling around the age of fourteen, he had received a solid grounding in Classical literature. He first studied painting in Leiden from the age of fifteen to seventeen, and from about seventeen to eighteen he studied in Amsterdam with Pieter Lastman, a leading history painter. Lastman himself had been to Italy, and it was through his influence that Rembrandt, who would never

7.5 Rembrandt, *The Blindness of Tobit,* 1651. Etching, Rijksmuseum, Amsterdam.

visit Italy, came into contact with the dramatic tenebrism of Caravaggio. The following year, 1625, Rembrandt returned to Leiden and set up his own studio, but the city's former prosperity had begun to decline.

Sometime around 1631 or 1632, Rembrandt left Leiden and moved to Amsterdam, which had usurped Antwerp's position as the trade center of Western Europe. There he was almost never at a loss for patronage, including commissions from the court. In 1634, he married Saskia van Uylenburgh, who brought a reasonably substantial dowry to the union. Of their four children, only Titus survived into adulthood. Saskia died at the age of twenty-nine, after which Rembrandt lived with Geertge Dirx, his son's nursemaid, and from the 1640s with Hendrickje Stoffels until she died, in 1663. That he did not remarry has been attributed to the terms of Saskia's will, which would have deprived him of half her estate.

Rembrandt and the Bible

The enormous number of biblical paintings executed by Rembrandt are unique in their humanity. In Protestant Holland, he was neither constrained nor influenced by Counter-Reformation requirements and did not have to engage in constructing royal mythologies. His biblical figures were inspired by the citizens of Amsterdam, including the inhabitants of the Jewish ghetto, and his "text" was human character, which he portrayed with unsurpassed depth.

Perhaps his most famous etching of a biblical subject is *Christ Healing the Sick*, or "The Hundred-Guilder Print" (so called after the price it fetched at an auction), in which Christ preaches to the Jews and cures the sick (7.6). Rembrandt's ability to control formal light and dark in the service of meaning is nowhere more evident than in this print, where he achieved a richness and variety of texture by combining drypoint with etching. The influence of Caravaggio's tenebrism in the large areas of dark is clearly evident, as Baroque shifts of light and dark contribute to the drama of the scene.

From the looming blackness of the background, Christ emerges in light, his stature enhanced by the cruciform elevation of the wall behind him. He is rendered as a formal, intellectual, and spiritual source of light who is both of the people and unique among them. They enter the picture through the round arch at the right, which denotes the triumph of Christ's teaching. As they progress across the picture plane, darkness and the infirm are placed to the left of Christ, while the physically healthy, who are brightly illuminated, are on Christ's right. This arrangement corresponds to traditional left-right symbolism in which the left alludes to the pre-Christian era and the right signifies the New Dispensation. It also looks forward to the Last Judgment, when the saved appear on the right of Christ and the damned suffer in hell at his left.

The crowd itself consists of the very young and the very old, the healthy and the sick. At the far left, the Pharisees argue over Christ's message, revealing its revolutionary character. They have been asked to accept a new way of thinking, and their disturbance is manifest. At the back of the

7.6 Rembrandt, *Christ Healing the Sick* ("The Hundred-Guilder Print"), c. 1648–1650. Etching, 11 in. × 15 ¹/₂ in. (27.9 cm × 39.4 cm). Rijksmuseum, Amsterdam.

group, a young rich man holds his head, pondering the instruction to give away his wealth to the poor. Approaching Christ with an infant is a young woman whom the bald Saint Peter tries to push away. But Christ "suffers the little children to come unto" him, and welcomes them. With his outstretched hand, he simultaneously receives the woman and holds back Peter, who seems to be questioning his message.

Prominently placed on an illuminated strip of ground in front of the lame figures is a scallop shell. Its iconographic association with resurrection and rebirth as well as with pilgrimage defines its function here. Christ's message brings intellectual rebirth in life, while adherence to his message brings resurrection after death. Pilgrimage is both a literal and a spiritual journey, the former indicated by the figures who have traveled to a place of healing. The latter is more complex, involving internal change and development, and its difficulty is reflected in the disturbance it causes among the Pharisees as well as in the reaction of Saint Peter.

The meaning of the painting known as *Jeremiah Lamenting the Destruction of Jerusalem* (7.7) has remained elusive. Nevertheless, it is a remarkable study of brooding melancholy in which psychology is made visible. The old prophet, his illuminated head resting on his hand in the manner of the young rich man among the Pharisees in "The Hundred-Guilder Print," is in mourning. For what, however, is not clear. The burning city at the left and the large column behind Jeremiah define an architectural setting. He, himself, with his rich velvet, fur-lined, and brocaded robes, seems to have salvaged something from the devasta-

tion. A few gold bowls are stacked before him, and under his elbow is a large book, possibly the Bible.

It would appear that one theme of the painting is the juxtaposition of human creativity with its impulse for self-destruction. Jeremiah's prophetic powers showed him the future. As the embodiment of the Old Jewish law, therefore, Jerusalem as Jeremiah knows it will be symbolically destroyed by the future New Dispensation. As the enemy of Rome, it is in fact destroyed in the present. Rembrandt's Jeremiah, who prophesied the destruction of both Jerusalem *and* its temple, seems to meditate on time and the events of history. The force of his thought is indicated by the highlighted forehead furrowed with age and by the salvaged text of the book on which he leans for support.

In *Jacob Blessing the Sons of Joseph* (7.8), Rembrandt's text is well known. It is Chapter 48 of Genesis, in which Jacob blesses his two grandsons in the presence of their parents—Joseph and Asenath. Although the Bible omits Joseph's wife, who was Egyptian, Rembrandt accords her a prominent place in the scene. At the same time, however, she is outside the intimate group comprising three generations of the male line of Israel. Here, as in many of Rembrandt's works, the sense of touch is combined with a juxtaposition of sight and insight, and conveys relationships between people.[3] In the biblical account (Genesis 48:10), Jacob's eyes—"the eyes of Israel"—"were dim for age, so that he could not see." Joseph brought his sons to Jacob, taking "Ephraim in his right hand toward Israel's left hand, and Manasseh in his left hand toward Israel's right hand. . . . And Israel stretched

7.7 Rembrandt, *Jeremiah Lamenting the Destruction of Jerusalem,* 1630. Oil on panel, 1 ft. 11 in. × 1 ft. 6 1/3 in. (58.3 cm × 46.6 cm). Rijksmuseum, Amsterdam.

7.8 Rembrandt, *Jacob Blessing the Sons of Joseph,* 1656. Oil on canvas, 5 ft. 9 in. × 6 ft. 11 in. (175.5 cm × 210.5 cm). Gemäldegalerie, Kassel. (Bridgeman Art Library)

out his right hand, and laid it upon Ephraim's head, who was the younger, and his left hand upon Manasseh's head, guiding his hands wittingly; for Manasseh was the firstborn" (Genesis 48:13–14).

Joseph objected to his father placing his right hand on his younger son and tried to remove it. But Jacob, in his blindness, was able to see more clearly than Joseph, and he told his son that Ephraim would be greater than Manasseh. This, like the prophecy of Jeremiah, was later interpreted as a reference to the triumph of Christianity over Judaism.[4] Rembrandt alludes to this tradition in the haloesque glow of light around the head of Ephraim, whose blond, angelic quality and crossed hands reinforce his association to the Christian future. The elder Manasseh, in contrast, is rendered with darker hair, wide-open eyes, and a slight frown, suggesting an awareness that he is being slighted by his grandfather.

Formally binding the generations of Israel is their tightly knit pyramidal arrangement, their chromatic unity, and sense of physical contact. Joseph gazes downward as he attempts to lift his father's right hand from Ephraim's head. The gesture of the blind Jacob is at once light and determined, while Manasseh, just below this gestural play, places his own hand on the bed covering. Gazing fondly on the scene, and apart from it, is Asenath. Her difference is accentuated by the gold headdress and jewelry, suggesting the opulence of Egypt. She, alone, does not engage in the significant gestures of the males; instead, she holds herself apart, clasping her hands together against her dress, and separated from the formal pairings of the male figures.

Portraits

Saskia and Hendrickje

In 1633, the year before he married Saskia, Rembrandt drew her in a straw hat (7.9). He inscribed the drawing with the date June 8, 1633, and noted that it was the third day of his engagement. With a light, subtle touch, he has suggested his fiancée's lively youthfulness and has given her a slight smile. Her penetrating eyes reflect a depth of character to which Rembrandt was always attracted. She holds a flower, as she does in a portrait of the following year (7.10), signifying an association with Flora, the ancient Italian goddess of fertility.

In the painting, Saskia wears a costume that provided Rembrandt with a variety of materials suitable to a textural tour de force. It is a celebration of Rembrandt's

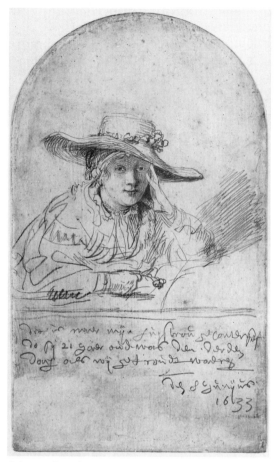

7.9 Rembrandt, *Saskia in a Straw Hat*, 1633. Silverpoint on white prepared vellum, 7 $\frac{1}{4}$ in. × 4 $\frac{1}{5}$ in. (18.5 cm × 10.7 cm). © Bildarchiv Preussische Kulturbesitz, Berlin.

love for his young wife and his wish for a fertile union. The bright red hat, adorned with gold brocade and a large feather, forms a broad, undulating diagonal much like the straw hat in the drawing and echoes the form and color of the lips. Glass beads are entwined in Saskia's hair; the pearl earring and necklace, and gold bracelets shimmer with reflected light. Draped over the rich, red velvet dress is a

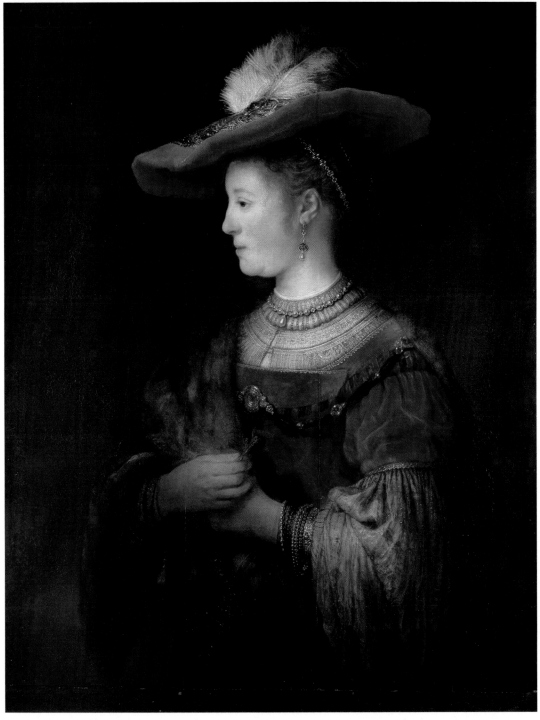

7.10 Rembrandt, *Saskia,* c. 1634. Oil on panel, 3 ft. 4 in. × 2 ft. 7 in. (99.5 cm × 78.8 cm). Gemäldegalerie, Kassel. (Bridgeman Art Library)

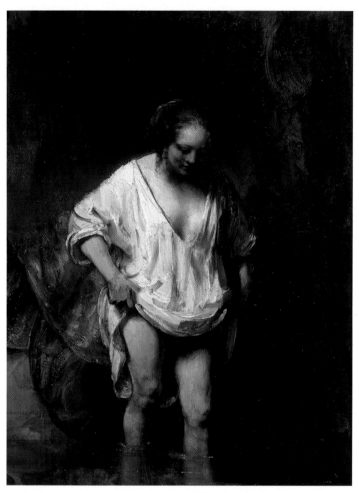

7.11 Rembrandt, *A Woman Bathing*, 1655. Oil on panel,
2 ft. $^1/_3$ in. × 1 ft. 6 $^1/_2$ in. (61.8 cm × 47 cm). National Gallery, London.
(Bridgeman Art Library)

fur, while the voluminous sleeves and lace collar are flecked with gold. The varieties of material contrast with the texture of Saskia's flesh, softened by Rembrandt's characteristic yellow light.

Some twenty years later, Rembrandt would also paint his mistress Hendrickje as Flora, although in a less refined manner.

More provocative, and more interesting, however, is his 1655 picture of Hendrickje bathing, also called *A Woman Bathing* (7.11). Hendrickje's sexuality is more overtly depicted than Saskia's, although Hendrickje actually conducts herself rather modestly.[5] She has removed her rich robes of red velvet and gold (leading some scholars to identify

her as a representation of Bathsheba), and raises her plain white shirt as she steps forward into a calm pool. The wide brushstrokes defining the shirt are considerably looser than the tight precision of Saskia-as-Flora of twenty years earlier. Even the luxurious robes have submerged their detail to painterly, rather than material, textures. How much these changes are a result of Rembrandt's formal development and how much they are related to Hendrickje's lower-class status and ambiguous position in the artist's household compared with Saskia's is a question that has not been resolved.

In raising her shirt, ostensibly to prevent it getting wet, Hendrickje exposes herself. However, while she herself is highlighted in light, a shadow covers her nakedness. She is thus exposed and not exposed at the same time. Gazing with intense concentration at the mirrorlike surface of the water—which can be read simultaneously as "watching her step" and studying her own reflection—she arouses the gaze of the viewer. The genius of this painting, which has evoked numerous interpretations, resides in its combination of formal appeal and complex meaning. Rembrandt's application of paint is deceptively casual; its shimmering surfaces and shifting textures contradict the intense focus of the woman and the stillness of the water. That Hendrickje was also Rembrandt's focus, erotically and artistically, is inherent in the very act of painting her in this guise.

The Syndics (De Staalmeesters)

Of Rembrandt's public commissions, the so-called *Syndics*—officially, *The Sampling Offi-cials of the Clothmakers' Guild*—is one of the best known from the 1660s (7.12). It is the portrait of a group, which requires that each figure be shown both as an individual and as part of a whole. That Rembrandt was particularly gifted in satisfying such conditions is attested by his popularity in Amsterdam as a painter of official civic groups.

The syndics served one-year terms, during which they were responsible for overseeing and regulating the cloths produced by the clothmakers. The appointment of this particular group lasted from 1661 to 1662, the latter corresponding to the date that Rembrandt signed the painting.[6] Alluding to their leadership in matters of quality is the beacon, "a symbol of civic virtue," painted into the paneling of the fireplace at the right.[7]

Like *A Woman Bathing, The Syndics* is a synthesis of movement and stasis. The manifest content of the image is a group of six men gathered around a table in an austere, wood-paneled room. But Rembrandt has arranged them in moments of transition, each with an individually vibrant, animated character. The sharp contrasts of light faces and white collars against blacks, as well as the five black hats, enliven them in a way that contradicts their official sobriety. Most of all, their sharp gazes, accentuated by the dense blacks of their pupils, engage the viewer. For each syndic seems to be looking at viewers who have just entered the room and distracted them from their official duties. Two seated syndics, for example, look up from a large book they have been examining. A third, at the far right, grasps a piece of material, and the syndic leaning over the table, at the left, keeps his place in another book.

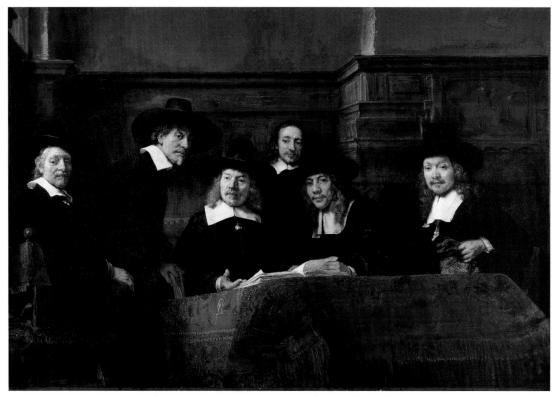

7.12 Rembrandt, *The Sampling Officials of the Clothmakers' Guild (The Syndics),* 1662. Oil on canvas, 6 ft. 3 $^3/_8$ in. × 9 ft. 1 $^{13}/_{16}$ in. (191.5 cm × 279 cm). Rijksmuseum, Amsterdam.

The pen-and-wash study (7.13) shows that Rembrandt had worked out this pose in a way that would enhance the formal rhythms of the painting. In the drawing, the syndic stands to the left of an architectural vertical, signifying the uprightness of his office. In the painting, he is caught in transition—whether in the process of standing up or sitting down is not entirely clear. But his gaze is calculated to respond to that of the viewer. Also drawing viewers into the picture space is the oblique angle of the table and its colorful cloth. Formally stabilizing the flow of figural movement as well as the table's slightly tilted placement is the stand-

ing, hatless man by the back wall and the securely seated man at the far left. The vertical of the latter's hat continues into an architectural vertical, a motif repeated in the placement of the hat on the far right.

Both the architecture and the table function as formal and iconographic metaphors for the syndics. The room itself is composed of a horizontal plane with marked verticals at the corners. Echoing these are the rectilinear seat and back of the chair at the left and the related planes of the man occupying the chair. In the context of the group portrait and the civic purpose of the officials, the setting stands for the serious-

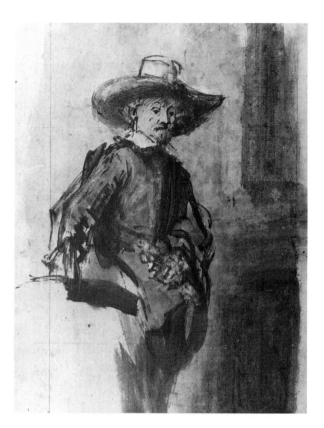

7.13 Rembrandt, *Study of a Syndic,* c. 1660s. Pen and bister wash. Museum Boijmans van Beuningen, Rotterdam.

ness with which they take their position. The very fact that the syndics "look viewers in the eye" reinforces the sense of their moral rectitude. The red tablecloth, on the other hand, refers to the product for which they are responsible. Even though the syndics judged only blue and black cloths,[8] the intricate material of the tablecloth, its orange color woven with gold threads illuminated at the left, is a sign of their high standards of quality.

Self-Portraits

More than any other artist before him, Rembrandt used his own features to create a visual autobiography in color and line in etching, drawing, and painting. His youthful self-portraits show him as a rebel, with unruly, "romantic" curls, a bulbous nose, and parted lips. At the same time, however, his upright posture and semblance of a coat and collar create an impression of self-assured distinction. As a young man, it would seem, Rembrandt had full confidence in his genius to convey character. His early *Self-Portrait* drawing (7.14) as an "angry young man" exemplifies his habit—shared with Caravaggio and Bernini—of studying his own features and expressions in a mirror.

Some two decades later, in 1648, Rembrandt executed an etching of himself seated by a window (7.15). He has grown

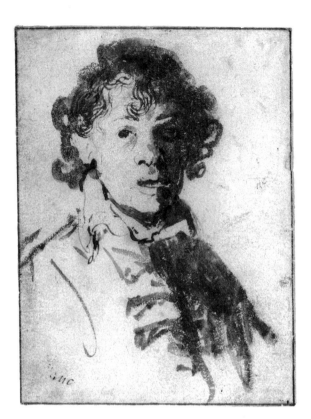

7.14 Rembrandt, *Self-Portrait.* Drawing with pen and bister, brush and sepia, and gray wash, 5 in. × 3 3/4 in. (12.7 cm × 9.5 cm). © Copyright The British Museum.

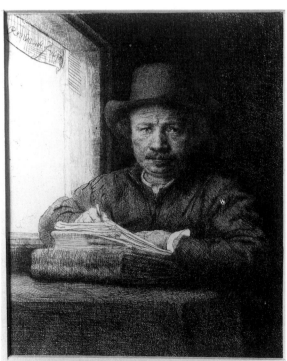

7.15 Rembrandt, *Self-Portrait Drawing at a Window,* 1648. Etching, drypoint, and burin, 6 $^5/_{16}$ in. × 5 $^1/_8$ in. (16 cm × 13 cm). Rijksprentenkabinet, Amsterdam.

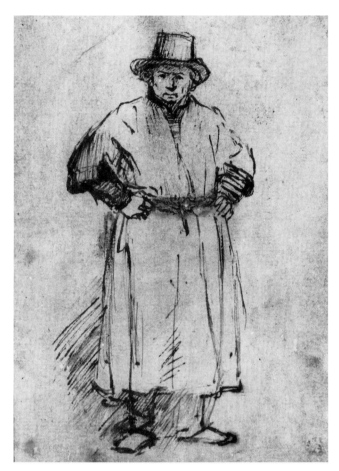

7.16 Rembrandt, *Self-Portrait.* Pen with brown ink on paper. Museum The Rembrandt House, Amsterdam.

in between are formed by different densities of cross-hatching calculated to define a wide variety of texture. As a self-image, it would seem that this picture is about the very nature of line, of light and dark, and of an artist whose identity is inseparable from his technique.

Rembrandt's self-confidence re-emerges in another drawing with a similarly purposeful hat (7.16). Here he has represented himself in painter's clothing, arms on his wide hips, feet firmly on the ground. He tilts his head, countering the slight diagonal recession of his body. His stance is a challenge, and it remains ambiguous as to whether he is gazing at an imagined viewer or contemplating his own reflection in a mirror.

The painted self-portraits, like the drawings and etchings, span Rembrandt's lifetime. The *Self-Portrait as Saint Paul* of 1661 (7.17) was painted two years before Hendrickje's death and shows evidence of Rembrandt's financial problems and emotional tragedies. His form stands out from a background divided into a textured light and a solid dark reminiscent of Caravaggio's tenebrism. Once again, the Bible is a key iconographic element, rendered here as an open text; both the book and the sword, which is barely visible next to his torso, are traditional attributes of Saint Paul. The Bible is allied, through light highlights, with Rembrandt's head and, therefore, with intelligence and inspiration. His hat encircles his

heavier, and his flesh is beginning to sag. The furrows in his forehead and his wistful expression betray an air of apprehension. He no longer portrays himself as a rebel; his seriousness is reinforced by the rectangularity of the space and by the hat firmly resting on his head. Rembrandt has made use of the sharpest range of light and dark—from pure white in the window to nearly solid black above his head, on his left shoulder, and at the far right. The areas

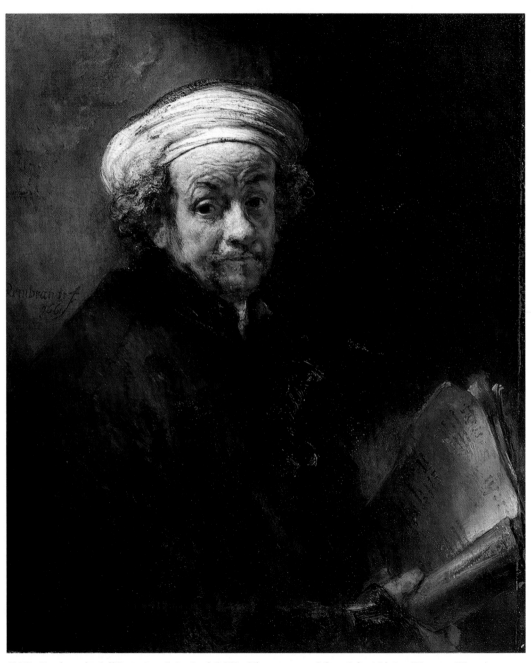

7.17 Rembrandt, *Self-Portrait as Saint Paul,* 1661. Oil on canvas, 3 ft. × 2 ft. 6 ¹/₄ in. (91 cm × 77 cm). Rijksmuseum, Amsterdam.

head like a halo, the gold and yellow strips of material signs of his saintliness embedded into the physical substance of the paint. Some of the light catches his wispy gray hair and sheds a yellow glow over it. He holds up the Bible, which is also illuminated, and turns with a quizzical expression toward the viewer. Rembrandt's identification with the beleaguered Saint Paul, called the Apostle of the Gentiles, like all the self-portraits, surely has autobiographical meaning.

Rembrandt plumbed the depths of whatever subjects he chose to represent, including himself. His courageous self-expression combined with his insight into human character was unprecedentedly intense. His technique merges content with form, and his paint often becomes meaning. In many ways, what Shakespeare was to theater, Rembrandt was to painting. Both discarded religious orthodoxy and portrayed the broad range of human expression, emotion, and experience.

NOTES

1. See Svetlana Alpers, *Rembrandt's Enterprise* (Chicago and London, 1988).

2. Julius S. Held, *Rembrandt's "Aristotle," and Other Rembrandt Studies* (Princeton, 1969), p. 114.

3. Madlyn Millner Kahr, *Dutch Painting in the Seventeenth Century* (New York, .1993), pp. 138–139, relates this picture to Rembrandt's biography, noting that he, like Joseph, had two children and was concerned about family continuity.

4. *Ibid.,* p. 139.

5. For a different but not incompatible reading of this painting, see Avigdor W. G. Posèq, "Rembrandt's Obscene *Woman Bathing,"* *Source: Notes in the History of Art* 19, no. 1 (Fall 1999): pp. 30–38.

6. The date of 1661 presently visible at the upper right is an eighteenth-century addition.

7. Kahr, p. 148.

8. Gary Schwartz, *Rembrandt, His Life, His Paintings: A New Biography with All Accessible Paintings Illustrated in Colour* (New York, 1985), p. 336.

Seventeenth-Century Dutch Painting II: Landscape, Still Life, and Vermeer

The Dutch interest in landscape, still life, and even genre was already apparent in fifteenth-century Flanders. In seventeenth-century Holland, with the development of landscape as an independent category of painting, artists generally depicted panoramic views expressing the flatness of Dutch topography through vast expanses of sky and distant horizons. Dutch still life depicts everyday objects frequently endowed with symbolic meaning. In the works of Vermeer, genre scenes—apparently of everyday life—combine aspects of landscape and still life with a new intensity. It is through concentrating on one or two individuals occupying a tightly controlled space and painting with jewel-like precision that Vermeer achieves a remarkable range of psychological complexity.

Landscape

Born over twenty years before Jacob van Ruisdael (1628/9–1682), the greatest of the seventeenth-century Dutch landscapists,

Rembrandt set the stage for this genre in Holland. The majority of his landscapes are, in fact, etchings and drawings, in which he uses line to convey the expansiveness of the flat Dutch terrain. In the little *View of Amsterdam* (8.1), Rembrandt enlivens the etching lines, opening up spaces between them. As in the *Self-Portrait Drawing at a Window* (7.15), he uses the white ground of the paper to indicate bright outdoor light. The distant skyline of Amsterdam, animated by windmills and a church steeple, is seen from the viewpoint of the ground and is contrasted with the flatness of the natural landscape. Two tiny human figures mediate between the foreground and the buildings, among which are the storehouses of the East and West India Companies that enriched the Dutch economy in the seventeenth century.

Jacob van Ruisdael

Rembrandt's panoramic views influenced Ruisdael and set a precedent for depicting

8.1 Rembrandt, *View of Amsterdam*. Etching, 4 3/8 in. × 6 in. (11.2 cm × 15.3 cm) Rijksmuseum, Amsterdam.

distant cities silhouetted against the sky.[1] Born in Haarlem, which was a center of landscape painting, Ruisdael entered the painter's guild in 1648. He produced a variety of landscapes, including winter scenes, views of towns and cities, waterways, and forests, all of which are typical of Holland, as well as atypical rocky mountains with waterfalls. Ruisdael creates moody, "romantic" atmosphere with dramatic Baroque shifts of light and dark, chromatic gradations, and vast panoramas juxtaposed with minute human figures.

Ruisdael's *The Mill at Wijk bij Duurstede* of around 1670 (8.2) belongs to his great phase of landscape painting, after he moved to Amsterdam.[2] Its iconography is clearly orchestrated to convey a sense of national identity. The distant boats, toward which the Baroque diagonal of the land mass seems to reach, evoke the economic importance of maritime trade, which extended to the Far East. Likewise, the looming windmill, whose blades echo the diagonals of the volumetric cloud formations, is an impressive and imposing icon of the

8.2 Jacob van Ruisdael, *The Mill at Wijk bij Duurstede*, c. 1670. Oil on canvas, 32 $^2/_3$ in. × 39 $^3/_4$ in. (83 cm × 101 cm). Rijksmuseum, Amsterdam.

Dutch economy. Ruisdael has monumentalized the mill so that, like the medieval Gothic cathedrals, it dominates the landscape, carries the gaze upward toward the sky, and transforms architecture into an image of cultural power.

The ominous weightiness of the clouds, on the other hand, emphasizes the precariousness of Holland's geography. This is underscored by the wooden pilings pressed up against the coastline, making visible in the land of dikes the constant threat of the sea to the country's very existence. Echoing the pilings, several of which are silhouetted against the water in the near foreground, are the distant vertical masts and the three sturdy women at the right. The small size of the women, juxtaposed with the mill, might, in the work of a different artist, suggest their insignificance. Here, however,

their determined advance seems infused with an energy calculated to express the stolid work ethic that helped to create the success of the seventeenth-century Dutch economy. The genius of this scene resides in Ruisdael's ability to merge landscape with national character. He shows both Holland's vulnerability to the elements and its ability to overcome them through hard work and resourcefulness.

Ruisdael's *Wheatfields* (8.3) of around the same time as *The Mill at Wijk bij Duurstede* expresses the flat expansiveness of the Dutch landscape. Because the viewpoint is elevated and the depth of the panorama more explicit than in *The Mill, Wheatfields* exemplifies the so-called "mapping impulse" of Dutch artists.[3] Here Ruisdael varies the textures of topography, accentuated by Baroque light and dark highlights resulting from the shifting clouds. The forces of nature seem to dominate this landscape, while also being inseparable from it.

Instead of architectural forms Ruisdael has depicted trees tilting to the right toward a diagonal of darkened clouds rising to the top of the picture plane and appearing to advance forward over the road. The road, in turn, recedes into the distance, its broad expanse in the foreground becoming radically foreshortened as it approaches the distant forest. At the same time, the rolling quality of the trees' outline against the sky is carried through the clouds at the left.

Trudging along the road, as in *The Mill,* are tiny human figures. Even smaller than those in *The Mill,* these emphasize the fact of walking over the land, of the land as a geographic surface. Cultivated by human hands as the land may be, it nevertheless is shown to have preceded humanity in this painting. There are no architectural forms documenting the process of urbanization and no boats signifying trade. The land is more definitely *there,* as a presence and a foundation. The very presence of the land and the constant potential for its absence (through flooding) that is part of the Dutch world view contribute to the effect of Ruisdael's painted landscapes. In *Wheatfields,* the woman and child approach the darkened forest but seem to have slowed their pace. Following more rapidly is the man at the right, whose longer shadow identifies time with space and reveals the artist's close observation of nature.

Enveloped as the figures are by the vast expanse, they remain distinct from it. Here, as in *The Mill,* the clouds threaten but do not erupt, their hovering presence a source of "dangerous waters," displaced from sea to sky. The apparent serenity of the fields, of what has been produced by people, like the architecture in *The Mill,* persists with as much definiteness as the uncultivated aspects of nature. Just as the man-made windmill stands as a sign of human presence in *The Mill at Wijk bij Duurstede,* so the yellow highlighted wheat fields reflect the sense of survival in relation to landscape that characterizes the Dutch nation.

Still Life

Dutch still-life painting of the seventeenth century approaches the world from a different point of view than landscape painting. Still-life artists focused on details of specific objects, ennobling and allegoriz-

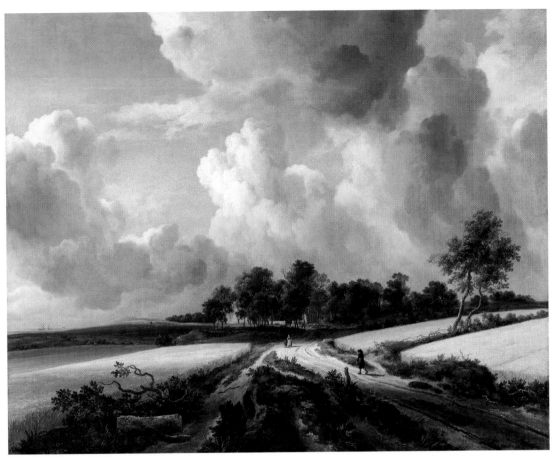

8.3 Jacob van Ruisdael, *Wheatfields,* c. 1670. Oil on canvas, 3 ft. 2 ³/₄ in. × 3 ft. 6 ¹/₂ in. (98.5 cm × 108 cm). Copyright © 1994 By The Metropolitan Museum of Art, New York.

ing them. They delighted in textures, "mapping" material surfaces as the landscapists mapped terrain. Honing in on particularity, Dutch still life is consistent with the contemporary interest in lenses and microscopes. The prevalent still-life categories in seventeenth-century Holland are flower paintings, so-called breakfast pieces (*ontbijte*), *pronkstilleven*—or ostentatious still lifes—and, most popular after 1620, **vanitas** still lifes.

Pieter Claesz

Pieter Claesz (1595/6–1661) of Haarlem is best known for his *ontbijte*. His *Still Life* of 1636 (8.4) creates the impression of an interrupted breakfast: someone, it seems, had been there but left before finishing. As in Dutch still life generally, human presence is palpable even though human figures are rarely seen. Claesz's picture conveys a monumental simplicity, as the glass towers over

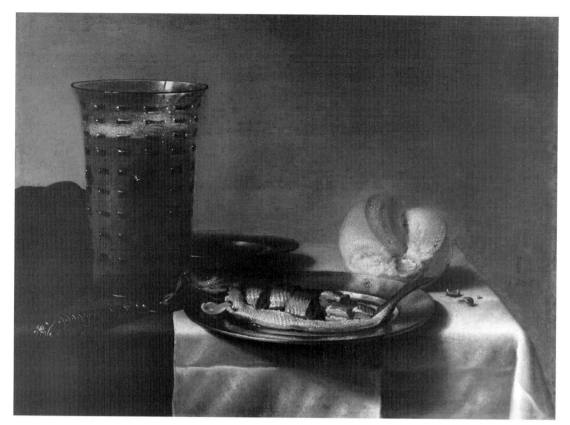

8.4 Pieter Claesz, *Still Life,* 1636. Oil on canvas, 14 ¹/₈ in. × 19 ¹/₃ in. (36 cm × 49 cm). Museum Boijmans van Beuningen, Rotterdam.

the two plates. Leading the viewer's eye toward the foreground plate hanging over the edge of the table is the diagonal of a knife, whose patterned handle corresponds to the texture of the glass. The plate contains a herring, cut up into bite-size morsels. Someone has neatly cut a section from the fruit and has presumably eaten it. The glass is still full, waiting.

In spite of the painting's appeal to sensuality, it is somber and nearly monochrome. Its formal regularity, achieved by the rectangular table and cloth, the geometry of the glass, plates, and fruit, even the pieces of

herring, conveys a calculated, constructed quality. Movement is created by strong contrasts of light and dark rather than of color, which is limited in range and subdued. At the same time, there is a studied attention to texture—the raised surface of the glass and knife handle, the outer skin of the herring, and the juiciness of the fruit's interior.

Willem Kalf

The sense of order in Claesz's pictures gives way to an appearance of cluttered space and

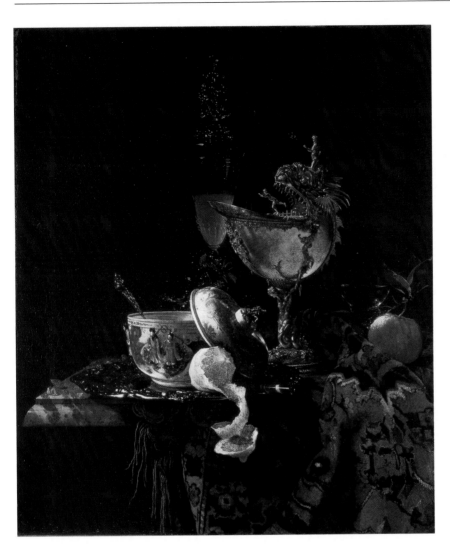

8.5 Willem Kalf, *Still Life with a Nautilus Cup and other Objects*, 1662. Oil on canvas, 31 1/8 in. × 26 3/8 in. (79 cm × 67 cm). Thyssen-Bornemisza Collection, Madrid.

crowded objects in the *pronk* still lifes of Willem Kalf (1619–1693) of Rotterdam. His *Still Life with a Nautilus Cup* of about 1660 (8.5) delights in a wide variety of richly crafted objects that must have appealed to upper-class tastes. They are feasts for the eye, while also arousing the senses of taste and touch. Spots of light glistening from the plate and the Venetian glass in the background enliven these objects. A woven Oriental carpet is draped over a marble table-top, visible at the left. Things seem to have been hurriedly assembled, causing the rumpled appearance of the carpet. Blues and yellows are the dominant colors, the former patterned on the Delft bowl and the latter defining the lemon. Both the spiraling rind echoing the fringe of the carpet and the spoon casually left in the bowl suggest, as in the Claesz, that someone was recently there.

The centerpiece of Kalf's composition is the elaborate, filigreed nautilus cup, itself a tour de force of the craftsman's art. An Atlaslike figure supporting the cup on its back forms the stem, while a monstrous sea creature emerges from the rim. Standing on the head of the monster and holding a trident is a human figure, small and insignificant by comparison. Running from the creature's jaws is another figure, accentuating the pun contained in the object's imagery. For anyone drinking from the cup must face at close range the open mouth and sharp teeth of the sea monster.

Maria van Oosterwyck

Maria van Oosterwyck's *Vanitas Still Life* of 1668 (8.6) exemplifies Dutch *vanitas* iconography and combines it with flower painting. Each element, highlighted with light and color against a dark background, is both a closely observed and minutely rendered object and also a symbolic reference to the transient vanity of life. In its allegorical character, *vanitas* is related to the Northern Renaissance interest in the proverb as a moral commentary on human folly. The Dutch tulip at the center of Oosterwyck's floral bouquet also contains a warning against economic folly, for Dutch speculation in tulip bulbs—the so-called tulip craze—had collapsed in 1637. Flowers may be beautiful, but they wilt and die. Like the disintegrating skull, the half-eaten ear of corn, and the mouse eating the stalk of grain, they are symbols of the brevity of life, aging, and the death of what has been. The two flutes refer to the transience and material insubstantiality of music.

In the juxtaposition of the flies and butterfly with the astrological globe, Oosterwyck contrasts the scientific observation and visual rendering of nature's smallest creatures with the vastness of the universe. The notion that human fate is determined by the stars and by one's horoscope challenges efforts to control one's destiny in the earthly world. Two worlds, representing two realities, are thus referenced in this painting—the measurable reality of scientific observation and the unexplored, limitless space of the universe.

Standing on two books in front of the globe is the hourglass, whose falling sand marks the passage of time. This traditional feature of *vanitas* iconography is reinforced here by texts in the form of titles or as notes randomly visible on pieces of paper.[4] The large book, curling and crisp with age, is entitled *Rekeningh* ("Reckoning"), which has the double meaning of financial accounting and the final accounting at the end of time. Written below *Rekeningh* is the ironic adage "We live to die and die to live," its content related to the admiral butterfly, which signifies both the immortal soul and high social rank on earth.

Clearly noted on the paper visible at the right is the term *"SELF-STRYT,"* meaning "self-struggle" and referring to the *psychomachia* tradition of the soul's moral conflict. The *imitatio Christi* refers to the manual of spiritual devotion attributed to Thomas à Kempis. Additional warnings occur in the text from Job 14: 1: "Man that is born of a woman is of few days, and full of trouble." The next line of Job (14:2),

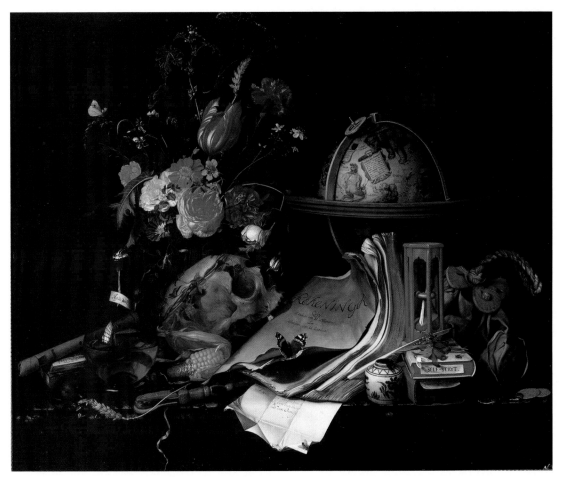

8.6 Maria van Oosterwyck, *Vanitas Still Life,* 1668. Oil on canvas, 29 in. × 35 in. (73.7 cm × 88.9 cm). Kunsthistorisches Museum, Vienna.

which does *not* appear in the painting, is more specific: "He cometh forth like a flower, and is cut down: he fleeth also as a shadow, and continueth not." This is directly related to Oosterwyck's iconography, in which the prominent bouquet of flowers is a metaphor for the brevity of human life, and the tulip for human folly.

The rich reds of the flowers recur in the carafe of aquavit, in which a window and the painter herself are reflected. This derives from fifteenth-century Flemish iconography—notably van Eyck's well-known *Arnolfini Wedding Portrait*—in which mirrors are used to expand the viewer's range of vision. In particular, the artist's

role as creator is emphasized in such imagery, calling on Pauline notions of the earthly world as a dim reflection of the heavenly world. Implicit associations of artists with gods as makers of material things are contained in Oosterwyck's inclusion of herself. At the same time, however, she participates in the *vanitas* warning. Her tiny size and her existence in the picture as a mere reflection diminish her prominence, while insisting on her presence.

Genre and Allegory: Johannes Vermeer

One of the most accomplished, complex, and elusive of all Western painters, Johannes Vermeer (1632–1675), is also one of the least well documented.[5] He was born in Delft, married a Catholic, and probably converted to Catholicism himself. At the end of December 1653, he entered the Guild of Saint Luke and at his death left a widow with ten children. His affairs were in disarray—he was virtually bankrupt—and Antony van Leeuwenhoek, the anatomist and microscopist, was retained to put them in order. Apart from the relatively small number of paintings, there are no known surviving documents by Vermeer's hand.

Perhaps because there are also no self-portraits, Vermeer's personality is less apparent than Rembrandt's. It is hidden in the precision of his forms and spaces, his tight chromatic unity, and the air of tension that pervades his canvases. Vermeer's preoccupations, however, emerge in his iconography, and they well reflect his time and place in seventeenth-century Holland.

His works are filled with actual, existing maps and globes, which are painted with attention to accuracy of detail. These, like his *Geographer* and *Astronomer,* are evidence of the new scientific interest in the world and its "mapping" as well as in the exploration of the unknown.

Taken as a whole, Vermeer's oeuvre combines the physical intimacy of still life and surface texture with the landscapists' depictions of the outside, natural world. The smallness of Holland and the wide world outside are juxtaposed in Vermeer's canvases. He endows domestic interiors with the tension of confinement, while referring to the freedom of an exterior space. The latter is typically indicated by a window, a globe, a map hanging on a wall, or a painting of a landscape or seascape. New discoveries had led to an awakened awareness of the scale of the universe, which Vermeer juxtaposed with interior, psychological depth. This he indicates in the poses and gestures of his human figures as he provides clues to their interior selves through devices such as mirrors and pictures within pictures. As Shakespeare's play within a play makes his theme more explicit, so the pictures within pictures clarify Vermeer's message.

The Art of Painting

Vermeer's *Art of Painting* (8.7) has been the subject of considerable art-historical discussion. Usually described as an allegory, it depicts an artist before an easel, his back turned to the viewer, painting a model. The model has been identified as Clio, the Muse

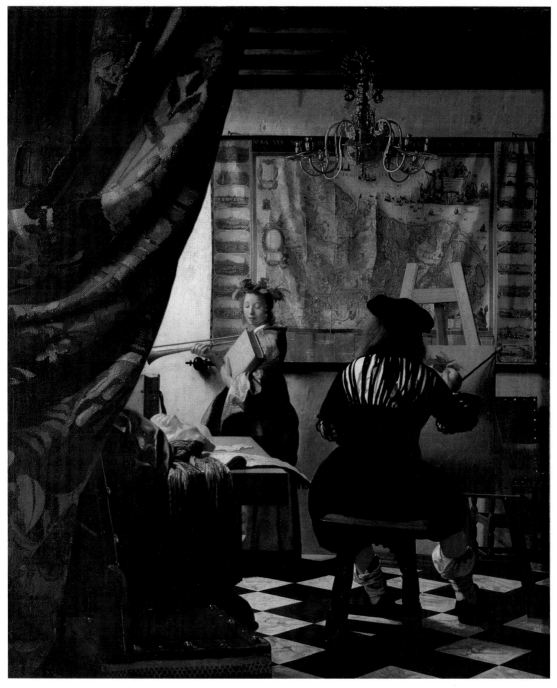

8.7 Johannes Vermeer, *The Art of Painting,* c. 1666–1670. Oil on canvas, 3 ft. 11 ¹/₄ in. × 3 ft. 3 ³/₈ in. (120 cm × 100 cm). Kunsthistorisches Museum, Vienna.

of history, by certain elements recorded in Cesare Ripa's *Iconologia,* an Italian emblem book translated into Dutch before 1664. Clio holds a trumpet denoting fame and a large yellow book confirming the importance accorded texts as preservers of history. The mask lying on the table alludes to the painter's art of imitating nature. The blue of Clio's laurel wreath is repeated in the dress and, with yellow, is one of Vermeer's two favorite colors. Laurel itself is a traditional symbol of triumph, fame, and immortality, all of which are transmitted verbally by texts and pictured in the visual arts.

The artist is, at this moment, painting Clio's blue laurel wreath, committing the living model to immortality on the canvas. His own identification with painting is indicated by the red tip of the *mahlstick* (painter's stick), which repeats the red of his stockings. The recurrence of red highlights in the large map signed by Vermeer also shows his identification with the landscape of Holland. He and the Muse are formally united by the map, which contains blue highlights and includes their heads within its area.

The map, which records the Holland of an earlier period and represents the seventeen Netherlandish provinces before their independence from Spain in 1648, has been painted in minute detail, including the evidence that it has aged.[6] An elaborately designed chandelier, enlivened by pinpoints of glittering light, seems to crown the map. At the top are two emblematic eagles of the Habsburgs, who had previously controlled the Netherlands. Dutch history is thus merged with the history of painting in Vermeer's *Art of Painting;* the map, the book, and the painting itself are all texts designed to engage the viewer in different kinds of reading.

Alpers, reading the mapped image in relation to the Muse, notes that "the mapping of town and of country are compared to the delineation of a human visage."[7] The formal relationship of Clio's face to the map confirms the allusion and evokes the tradition in painting—evident in Leonardo's *Mona Lisa*—in which a woman is a metaphor of landscape.[8] In the context of Vermeer's map, it has been suggested that Clio's laurel may denote the Dutch victory over Spain, whose domination is present in the map, but which is absent at the time of the painting.[9]

Vermeer's woman is also related to the map by virtue of the book she holds, linking written history with words identifying geographic locations on the map. Whereas the book is read diachronically in sequence and through time, the map is visually graspable, if not completely seen, at a single glance. By its very nature, the map mediates between word and image, which it combines within itself, and, in Vermeer's picture, between history as a verbal art and the visual art of painting.

One final observation on the *Art of Painting* is the iconographic play on the theme of presence and absence that characterizes certain Dutch still lifes as well as most of Vermeer's work. The artist's presence is accentuated by the deep black of his costume, but his personal identity is absent. Likewise, we sense the presence of a window on the left wall whose light highlights Clio, but we do not see the window.

The curtain, combining the reds, blues, and yellows present elsewhere on the canvas, is drawn aside, revealing the intimacy and quiet concentration of artist and model. As such, the curtain invites the viewer into a kind of sacred space, where history and geography meet painting, even offering him or her a chair. For just inside the curtain is an empty chair, facing the interior and formally related to the chair against the far wall. Both are of dark brown leather, their backs and seats "framed" by pinpoints of light highlighting their studs. The foreground chair is turned from the picture plane on a slight diagonal so that the viewer's gaze is directed to the back of the painter, who immortalizes painting by painting the laurels of the Muse of history. In placing the laurels on the canvas, Vermeer may be said to be putting diachronic history within synchronic painting, submitting narrative art to descriptive art.

The Music Lesson

In *The Music Lesson* (8.8), Vermeer appears to have painted the musical equivalent of *The Art of Painting*. In both works, the spatial context is defined by a receding tiled floor, horizontal ceiling beams, a rich tapestry of darker colors in the foreground, and an artistic transaction between a man and a woman occurring in a more brightly colored background. The chromatic arrangement in *The Music Lesson* progresses from the subdued reds and blues of the tapestry, through the paler blues of the chair bordered by bright yellow studs, to the red, yellow, and dark blue of the woman's costume.

The chair thus links the tapestry with the woman through color and the man with the woman by its position between them. In *The Music Lesson,* the space is extended by comparison with *The Art of Painting,* and the curtain is absent so that the side wall is visible. As a result, the windows are present and clearly define a source of light.

Whereas in Renaissance art theory, as codified by Alberti, painting was a window through which nature is perceived, in Vermeer the windows do not reveal nature. Instead they confirm the presence of nature by its very absence in the painted space. Vermeer's pictures within pictures, like his mirrors and maps, are more likely psychological windows revealing interior meanings. In *The Music Lesson,* for example, there is a partially seen painting behind the gentleman. It represents "Roman" Charity, a woman nursing a chained prisoner who happens to be her father. What the relationship of this painting is to the couple in the room is not explicit, but it has been suggested that the music, played by a woman, is a source of nourishment for the man.[10] In the vein of Shakespeare's "If music be the food of love, play on," the inscription on Vermeer's virginal reads "*Musica letitiae co[me]s medicina dolor[us]*" [Music is the companion of joy, the medicine of sadness].[11] The sense of nourishment, of "drinking in" the music, is also implied by the white jug, which relates the man to the painting of Charity. It is placed beneath the painting, while its whiteness repeats the color of the cuffs and collar of the man. It is also positioned in a way that accentuates its anthropomorphic quality, echoing the man's pose.

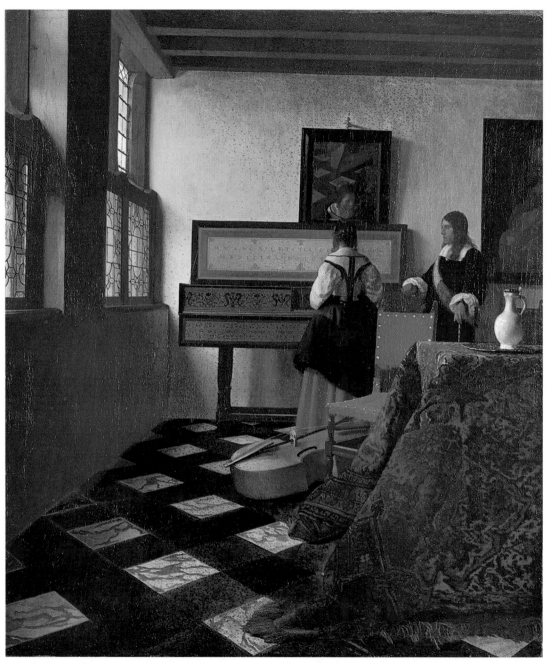

8.8 Johannes Vermeer, *The Music Lesson,* c. 1662–1670. Oil on canvas, 2 ft. 5 in. × 2 ft. 1 ¹/₈ in. (73.6 cm × 63.9 cm). The Royal Collection. © Her Majesty Queen Elizabeth II.

That there is a hidden relationship between the woman and the man is indicated by the mirror. It has been slightly tilted to reveal that she is gazing at him while playing. The man in *The Music Lesson* wears a black and white costume, as does the artist in *The Art of Painting*. The latter, however, has red stockings, a color that recurs in the skirt of the female musician. In both works, it is the performer—the painter and the musician—who wears red, the warmest color in a palette primarily composed of cool blues and yellows.

A conjunction of presence and absence similar to that in *The Art of Painting* informs this picture. Lying on the floor, its diagonal plane parallel to that of the chair, is a viola da gamba without a player. Likewise, the chair is unoccupied. Its absent occupant could belong to the idle instrument or to a listener who is not there. Whereas the chair in *The Art of Painting* is turned *toward* the couple in the room, this one turns away from them. The position of the chairs is thus directly related to the nature of the art represented in the paintings: the chair turned away depicts the fact that one listens to music; but to apprehend a picture, one must see it—hence, a chair facing the work in progress. The chair in *The Art of Painting* faces into the room, echoing the confinement implied by the unseen window. In *The Music Lesson,* the chair is turned away from the figures, conveying a greater feeling of space—as does the visible window.

The present but unseen artist in *The Art of Painting* is also simultaneously present and absent in *The Music Lesson*. There he is not seen at all, but part of his easel is reflected in the mirror. The mirror thus "maps" the presence of the artist, as it "maps" the relationship between the man and the woman by reflecting her gaze. That it is a relationship in which art and eroticism merge is evident in its partially hidden intimacy, which is echoed in the cropped painting of Charity, where benevolent nourishment merges with sexuality.

The theme of presence and absence recurs throughout Vermeer's work. On one level, it is related to the reality of seventeenth-century Holland, a small nation with an economy dependent on distant travel and trade. The psychological effects of such a reality are seen in Vermeer's women, who occupy interior spaces and receive letters from an absent person. Interior and exterior are an important aspect of this theme, which Vermeer the painter conveys through a series of displaced images—mirrors, maps, inscriptions, and pictures within pictures. He also engages the viewer in these images; in the two paintings discussed above, he positions a chair for viewing and a chair for listening.

In the painting variously entitled *The Letter* or *The Love Letter* (8.9), it is the letter, a written text, that connects the interior domestic space with the external world. It also connects the two women and, if it is a love letter, the woman with an absent man. The bright, colorful interior scene is visible from a darkened, nearly monochrome foreground through an opened door and a drawn curtain. Signs of household chores seem casually placed in the room—a laundry basket, a broom, and a pair of shoes—although the woman herself has been playing music.

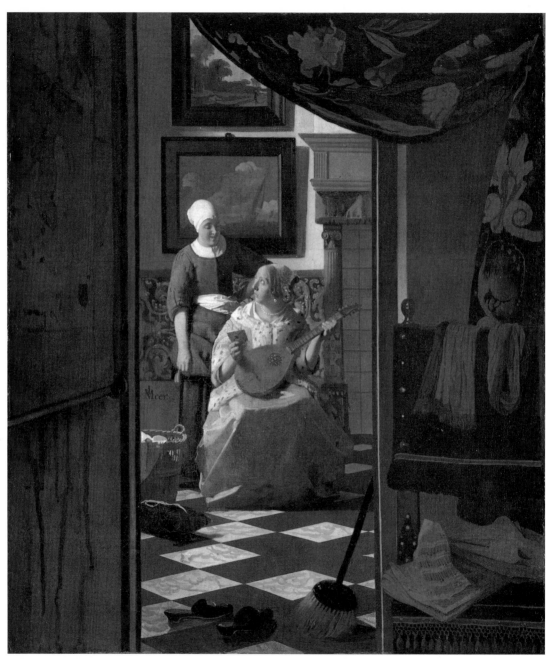

8.9 Johannes Vermeer, *The Letter (The Love Letter),* c. 1670. Oil on canvas, 17 $^1/_3$ in. × 15 $^1/_8$ in. (44 cm × 38.5 cm). Rijksmuseum, Amsterdam.

The sense of absence and of distance are conveyed by the two paintings on the wall, one a landscape with a solitary figure walking down a road, the other a seascape dominated by a ship's mast. In such combinations, orchestrated through masterful technique, meticulous attention to surface detail, and internal, psychological reality, Vermeer created a synthesis of images that reflect the interior and exterior concerns of his age.

NOTES

1. Wolfgang Stechow, *Dutch Landscape Painting of the Seventeenth Century* (London, 1966), p. 43.

2. Madlyn Millner Kahr, *Dutch Painting in the Seventeenth Century* (New York, 1993), pp. 214–215.

3. Svetlana Alpers, *The Art of Describing: Dutch Art in the Seventeenth Century* (Chicago, 1983), esp. ch. 4, on the "mapping impulse."

4. For translations from the Dutch as well as the interpretations of certain details, I am indebted to Elisabeth de Biève.

5. For documents relating to Vermeer's life, see John Michael Montias, *Vermeer and His Milieu* (Princeton, 1989).

6. Arthur K. Wheelock, Jr., *Vermeer and the Art of Painting* (New Haven and London, 1995), p. 132.

7. Alpers, p. 167.

8. See Laurie Schneider and Jack Flam, "Visual Convention, Simile and Metaphor in the *Mona Lisa,*" *Storia dell'Arte* 29 (1977): 15–24.

9. For this observation, I am indebted to Professor Mary Wiseman.

10. Alpers, p. 188.

11. See *ibid.* for translation.

Late Baroque and Rococo

The late Baroque style in English architecture lasted into the early eighteenth century with the work of Christopher Wren, Nicholas Hawksmoor, and John Vanbrugh, whereas in other parts of Western Europe it came to an end earlier. Beginning around 1715, the year that Louis XIV of France died, the Rococo style emerged, first in France and Germany, although examples also appeared in England, Italy, and elsewhere. Rococo is a lighter, sometimes more fanciful, extremely ornate version of Baroque, which emphasizes **pastel** colors, gilded sculptural details, and subject matter that ranges from frivolity to satire.

Pastel

Pastel (also called fabricated chalk) was a medium that appealed to Rococo levity. It is a kind of colored chalk of dry, powdered pigments bound with gum water and usually applied to a ribbed or tinted paper ground. Pastel allows artists to create a sketched, textured impression in soft tones of generally pale color. Originally used in the north of Italy in the sixteenth century, pastel was perfected in the eighteenth century by Baroque and Rococo artists and often used for portraits.

England

Dominating the first half of seventeenth-century architecture in England, Inigo Jones (1573–1652) had visited Italy and had been inspired by Vitruvius and Palladio, especially the latter's *Four Books of Architecture*. As court architect to Charles I, Jones had designed the Banqueting House (9.1), primarily for performances of masques. (Rubens had painted the ceiling with frescoes glorifying the reign of Charles's father, James I). The Banqueting House epitomized Jones's classicism and was an important source of Italian influence on Christopher Wren (1632–1723), the leading English architect in the second half of the century. Wren

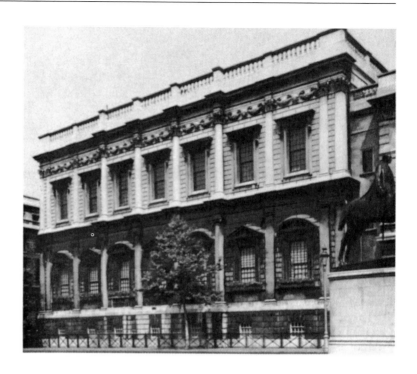

9.1 Inigo Jones, Banqueting House, palace at Whitehall, London, 1619–1622.

never traveled to Italy but knew the writings of Vitruvius and was familiar with Roman buildings through the engravings of Sebastiano Serlio.

Christopher Wren

Wren was born in 1632, the same year that van Dyck became court painter to Charles I. Charles was then in the third year of his eleven-year Personal Rule, but Calvinism was spreading throughout England, its adherents demanding reforms within the Church. From 1642 to 1648, the country was embroiled in conflicts between Puritans and royalists, and during this period court patronage of the arts—especially the masques—was virtually nonexistent. After Charles' execution in 1649, Parliament came under Puritan control and was led by Oliver Cromwell (1599–1658), who advo-

cated a commonwealth government based on a constitution and universal male suffrage.

When Cromwell died, another Stuart, James II (1633–1701), ascended the English throne. In 1661, Christopher Wren, a Latinist, scientist, and mathematician, was appointed professor of astronomy at Oxford. In 1666, a fire broke out in London that lasted ten days, resulting in a vast rebuilding campaign for the city and its churches. Three years later, Wren, known for his inventive mind and talent for problem solving, was charged with the task of supervising this program and was given the title Surveyor-General of the King's Works.

If Wren had had his way, London would not look as it does today. His design for renovating the city, which was rejected, was based on Bernini's urban plan for Rome. In 1665, Wren visited France, where he saw many domed Baroque churches and French

châteaux of the Renaissance and Baroque eras. He met and was impressed by Bernini, who had been invited to submit a design for the new façade of the Louvre.

Wren's designs are noteworthy for the variety of their steeples and plans, and the originality of the interiors. The steeple of Saint Mary-le-Bow of 1670–1680 (9.2), for example, reflects the classicizing influence of Bramante, although the final result is Baroque in its combination of features. It is supported by a square tower containing a **belfry**. Each wall of the belfry has a round-arched window that is flanked by pairs of Ionic pilasters supporting an entablature with a projecting cornice. Above the cornice is a balustrade with an urn supporting scroll-shaped sculptural elements at each corner.

The steeple itself begins as a miniature round temple, similar to Bramante's Tempietto in Rome, with a balustrade over the cornice. Above the balustrade is a central core surrounded by twelve curved brackets. This, in turn, supports a square element with Corinthian colonnettes and additional smaller curved brackets, which is surmounted by a tall pyramidal feature supporting a weather vane in the shape of a dragon on top of a ball. The brackets, which are Wren's translation of bows into architectural form, are the origin of the name of the church.

The view of the section (9.3) shows the interior of the steeple's construction. The belfry has a cone-shaped dome extending to the small temple. The cylindrical core contains a wooden stairway that winds around a central **newell** leading from the belfry to the floor of the upper square. The core itself narrows into a second cone at the top of the square and supports the elongated pyramid.

Wren's inventiveness, exemplified in Saint Mary-le-Bow's steeple, had its greatest expression in the key monument of his career, the cathedral of Saint Paul's in London (9.4). Efforts to preserve parts of Old Saint Paul's after the Great Fire of 1666 failed. As a result, Wren had to demolish the old building, a difficult task accomplished with workers using pickaxes, gunpowder, and a battering ram.

In keeping with Wren's preference for centralized plans, the first design for Saint Paul's, proposed in 1670, was a Greek-cross plan, with the arms connected by curved walls rather than meeting at right angles, as in Italy. Each arm would have had a Greek portico at the front; there would have been a large central dome and a smaller dome over the western vestibule. The design of the dome showed the influence of both Bramante and Michelangelo, in addition to other elements derived from Inigo Jones and Antonio da Sangallo. It has also been suggested that the concave walls connecting the arms were inspired by Mansart's drawings that Wren would have seen in France.[1] As in the steeple of Saint Mary-le-Bow, Wren synthesized multiple influences to create a unique, personal structure that is Baroque in the dramatic character of its combinations.

The Anglican clergy rejected the original plan in favor of a longitudinal Latin cross. This provided a nave big enough to accommodate very large congregations and the performance of the service in the choir. The final plan (9.5) retained the dome over the crossing supported by eight piers (9.6), as in the original plan. Otherwise, the changes were considerable. The nave consisted of five bays, the transepts and the choir three each; a small apse and a half bay were located at the eastern end.

9.2 Christopher Wren, steeple of Saint Mary-le-Bow, London. (Photo: A.F. Kersting, London)

9.3 Steeple and section diagrams, Saint Mary-le-Bow, London. (From *Wren Society* 9: pl. xxxv)

Curved porticoes fronted the transept entrances, while at the western entrance, there was a large horizontal portico (see 9.4). This consists of two stories of paired Corinthian columns, clearly related to the east façade of the Louvre (cf. 5.7) as well as to Jones's Banqueting House (9.1), and a pediment decorated with relief sculptures. The strong shifts of light and dark that characterize Wren's façade, despite its Classical inspiration, are, like the curved porticoes of the transepts, typical Baroque features. Also Baroque is the fusion of elements belonging to different styles. Classical elements are juxtaposed with Gothic features (the paired vertical towers), while Renaissance symmetry and classical unity are combined with a new dramatic exuberance of form.

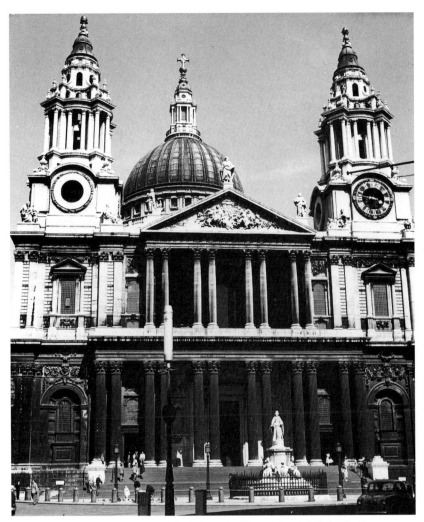

9.4 Christopher Wren, west façade of Saint Paul's, London, 1670–1680. (Art Resource)

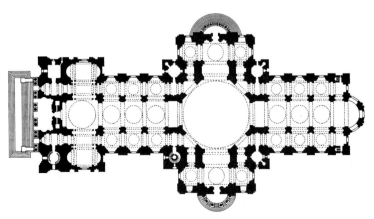

9.5 Final plan of Saint Paul's, London, c. 1675. After Roth.

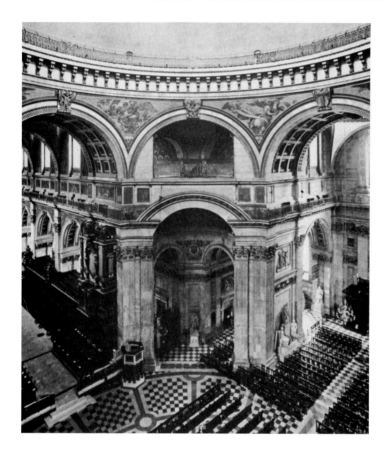

9.6 Central space of Saint Paul's, London, under the dome.

The interior of the huge lead dome of Saint Paul's is equal in diameter to the width of the nave plus that of the side aisles. On the exterior, the diameter is 102 feet. It is impressive not only in its scale, but also in its calm, integrated proportions. Like the dome of Saint Peter's in Rome, the vertical thrust of Saint Paul's dome is accentuated by a slightly oval shape. The lantern, through which light enters the area of the crossing, carries the height even farther and is surmounted by a ball and a Cross. The distance from the floor to the top of the Cross is 366 feet. Supporting the dome is the large drum surrounded by Corinthian columns, an entablature, and a balustrade. At regular intervals of every

fourth column of the drum, there is a solid, supporting wall with a round-arched niche. And above the balustrade is another wall pierced by square windows alternating with pilasters, also supporting an entablature. From this wall rises the dome itself, its surface enlivened by ribs that extend the vertical planes of the pilasters directly below them and converge in a smooth, curved movement at the base of the lantern.

The section drawing of the dome (9.7) shows that it was constructed with a triple shell. The outer, lead covering of the dome has a wooden structure, reinforced by a third, invisible layer consisting of a tall, brick cone supporting the lantern. The ex-

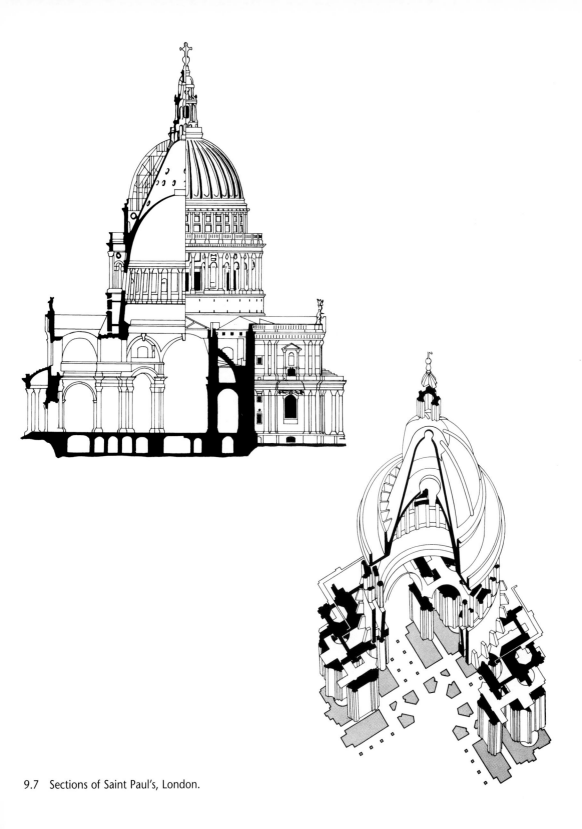

9.7 Sections of Saint Paul's, London.

ternal appearance of the dome clearly has affinities with Bramante's Tempietto, which also inspired the miniature temple on the steeple of Saint Mary-le-Bow. From the outside of the building, the overall effect of Wren's dome is one of towering height, while in the interior, one is impressed by the enormous scale of the domed space over the crossing (see 9.5) and the uplifting quality of the light that streams in through the lantern and windows of the drum.

The façade of Saint Paul's is flanked by two clock towers, rich in surface variations and decorative features. Corinthian columns, for example, support an entablature that is alternately convex and horizontal, recalling Borromini's churches in Rome (see Figs. 2.8 and 2.9). In Wren's tower, however, the projecting surface over the clockface also curves upward, conforming to the shape of the clock and echoing the curved entablature above it. Additional complex features include the stone vases accentuating the corner elements, the curved brackets connecting the vases with the vertical walls, and the concave-to-convex profile of the cap. The latter is surmounted by a gilded copper pineapple.

Wren designed similarly inventive Baroque details throughout the exterior of Saint Paul's. In the carving around the Dean's door, for example, Wren has enlivened the surface and opened the space with a broken pediment (9.8). Under the roof of the pediment are three cherubic heads with wings, *fleurs-de-lis,* and wreaths. The heads turn, forming diagonal planes, while the curvilinear wings echo the round arch of the door. Below the horizontal bases of the pediment, on either side of the arch, is an elaborate scroll over a cherub's head,

from which ornate floral designs tumble downward.

All told, Wren rebuilt fifty-two churches in London after the Great Fire of 1666. Of these, Saint Paul's was his masterpiece. It embodies his genius for integrating inventive forms, such as the pineapple on top of the tower and the drapery falling below the cherubs on the Dean's door, into a vast and impressive totality. He has furthermore synthesized some of the major Baroque features of French and Italian architecture, including Classical, Gothic, and Renaissance elements, transforming the Catholic notion of the Church Triumphant into a towering statement of Anglican power. Wren's later influence can be noted in American colonial architecture.

Hawksmoor and Vanbrugh: Blenheim Palace

In English Baroque architecture, the nearest monument to Versailles in style and inspiration is Blenheim Palace, built in the early eighteenth century in Oxfordshire (Fig. 9.9). Versailles, however, had been an expression of absolute monarchy and the ego of its royal patron. Blenheim Palace, in contrast, was the conception of the English Parliament, which provided the funds for its construction. It was conceived in gratitude to John Churchill, duke of Marlborough, ironically for his defeat of Louis XIV's forces in 1704 at Blenheim in Germany. The architect, John Vanbrugh (1664–1726), was a self-taught amateur who collaborated with Nicholas Hawksmoor (1661–1736) on the project. Hawksmoor had worked with Wren on Saint Paul's but began to use less classi-

9.8 Dean's door, Saint Paul's, London.

cizing forms and to emphasize shifts in mass and volume to a greater degree than Wren.

The palace comprises three sections—kitchens, stables, and the main house—with a garden at the rear (9.10). The entranceway, as at Versailles, draws the visitor toward itself by virtue of a narrowing forecourt. A central block with a projecting Corinthian portico accentuates the entrance and obscures the Doric colonnade that continues into the pavilions flanking it. On either side of the portico are horizontal walls containing giant, two-story Corinthian pilasters framing the windows. The pediment, as at Saint Paul's, is decorated with relief sculpture. Above and behind the front pediment is a second, plain pediment flanked by massive, blocklike walls. Altogether, Blenheim Palace, which combines features of palace and castle architecture, conveys an impression of imposing power.

Blenheim Palace embodies the high point of English Baroque. This is evident in the curving pavilion walls and elaborate, complex features. The balustrades over the cornice of both the central and the pavilion walls are decorated with statues that animate and open the spaces, just as they do on Bernini's colonnade for Saint Peter's Square. Fanciful ornamental details derived from

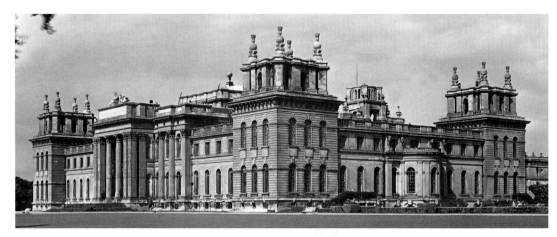

9.9 John Vanbrugh, view of Blenheim Palace, Oxfordshire, 1705–1724. Photo A.F. Kersting, London.

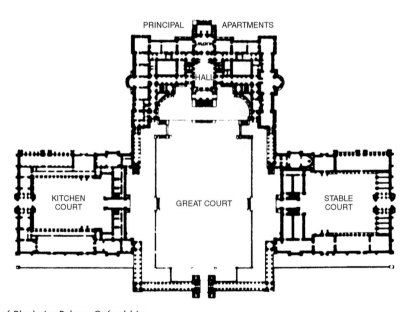

9.10 Plan of Blenheim Palace, Oxfordshire.

military hardware include cannonball finials surmounted by stylizations of the ducal coronet and supported by *fleurs-de-lis.*

The Rococo Conclusion of Baroque

The taste for fanciful details, especially in architecture, is elaborated in the Rococo con-

clusion of Baroque. The term itself is said to have derived from the French *rocaille,* meaning "pebble," and *coquille,* or "shell," both of which were used in garden decoration. The organic qualities of seashells as well as plant and rock formations are also characteristic of Rococo forms. The style begins, in part, as a response to the classicizing grandeur of

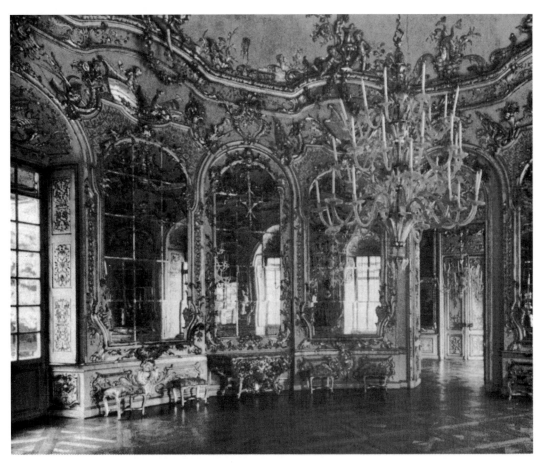

9.11 François Cuvilliés, the Amalienburg, Bavaria, 1734–1739.

Baroque, especially as it was expressed in the Versailles of Louis XIV. After his death in 1715, the French court moved to Paris, where the aristocracy began to entertain in private houses, or *hôtels*. These were highly decorated and were usually entered through a courtyard. They became settings for intellectual and social gatherings known as *salons,* which were typically presided over by an accomplished hostess, or *salonnière.*

The style became particularly popular in Germany. There, one of the most elaborate expressions of Rococo was the Amalienburg (9.11), a hunting lodge outside Munich in Bavaria. It was designed in 1734–1739 by François Cuvilliés (1695–1768) for Amalia (after whom it was named), the wife of the elector of Bavaria. Although the artist had been trained in France, he had worked since the age of thirteen for the Bavarian court, where Rococo was considered the height of fashion. The Amalienburg is the embodiment of the ornate Rococo interior, with its glass walls, delicate silver filigree, pastel blue backgrounds, and silver stucco.

Another feature of the late Baroque and Rococo interior was the staircase of the type

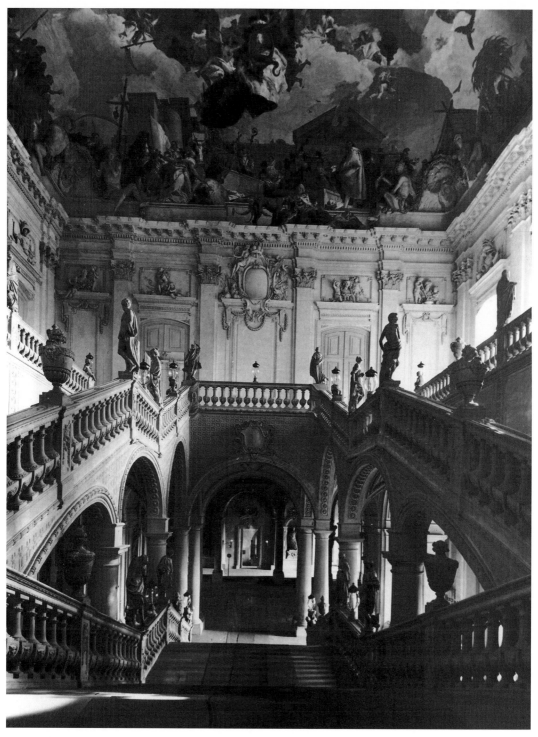

9.12 Johann Balthasar Neumann, staircase, Prince-Bishop's Palace, Würzburg, Germany, 1737–1742. Ceiling frescoes, executed in 1752–1753, are by Tiepolo. (Art Resource)

designed by Johann Balthasar Neumann (1687–1753) for the palace of Prince-Bishop Johann Philipp Franz Schönborn in Würzburg, Germany (9.12). Begun in 1737, the staircase has a central flight ascending to a landing at the rear wall (the foreground is illustrated in 9.12). It then divides into two flights, one on either side of the first flight, which continue upward (toward the distant wall in the illustration). The large space at the foot of the stairs was intended to accommodate the carriage of the prince-bishop, allowing it to enter the building and deposit him by the steps. Typical of the Baroque style is the curvilinear balustrade surmounted by statues and urns that open and animate the space. More Rococo are the gilt moldings and white stucco walls. The Rococo frescoes on the ceiling by the Venetian artist Tiepolo were painted in 1752–1753.

A comparison of the façade of Neumann's pilgrimage Church of the Vierzehnheiligen, or Fourteen Saints (9.13), with that of Saint Paul's in London illustrates some of the differences between Baroque and Rococo church architecture. In contrast to the imposing "grand manner" of Wren's classicizing horizontal façade, massive dome, and august clock towers, the Vierzehnheiligen stresses verticality in its towers, and its surface is enlivened by curvilinear details not necessarily conforming to structural reality. In place of the two-storied portico of Saint Paul's, for example, the central section of Neumann's church façade is convex and seems to pulsate forward from the main wall. The architectural details, like the towers, have greater variety of movement, which is reinforced by the poses of the statues. Saint Paul's appears more sedate and confronts visitors with an impression of imposing seriousness and structural weight.

Rococo painting appealed to a number of genres, from pure, frivolous fantasy to works with serious, ironic subtexts. Royal and aristocratic portraiture, especially with the tendency to flatter the sitters, was also an important category of Rococo. The most serious Rococo painter was the Flemish artist Antoine Watteau (1684–1721), who worked mainly in France. He studied in Paris, where he was particularly impressed by Rubens' cycle of paintings celebrating the life of Marie de Médicis.

The allegorical subtexts of Rubens' work recur in Watteau's iconography. His so-called *fêtes galantes,* "elegant entertainments," is best embodied by his *Embarkation for Cythera* of 1712–1717 (9.14). Cythera was the mythological birthplace of Venus and, therefore, an island of love. In Watteau's picture, groups of aristocratic couples abound, dressed in colorful Rococo silks and satins, as pink Cupids flutter in the air. At the far left below the Cupids, a gilded boat resembling a chariot awaits the lovers. Its shell is both an example of Rococo *rocaille* and a reference to the traditional birth of Venus in which the goddess is carried ashore on a scallop shell. The transient levity of the lovers is juxtaposed with the enduring stone statue of Venus, which has presided over the sacred island since antiquity.

In England, where the elegant character of Rococo appears—for example, in the aristocratic portraits of Gainsborough and Reynolds—another trend can be found in the outright satires of William Hogarth (1697–1764). These are consistent with the literary satires of Swift in England and Voltaire in France, which expressed the burgeoning Enlightenment views of government. Hogarth's best satire is found in several series of pictures on a particular so-

9.13 Johann Balthasar Neumann, Vierzehnheiligen Pilgrimage Church, Franconia, Germany, 1742–1772. (Art Resource)

9.14 Antoine Watteau, *Embarkation for Cythera*, 1717. Oil on canvas, 4 ft. 2 ³/₄ in. × 6 ft. 4 ³/₈ in. (129 cm × 194 cm). Musée du Louvre, Paris. (Art Resource)

9.15 William Hogarth, *The Marriage Transaction* (from *Marriage à la Mode*), 1742–1746. Engraving. Copyright © The British Museum.

cial theme. In *Marriage à la Mode,* for example, he executed six images showing the disastrous results of a marriage arranged between a poor nobleman and the daughter of a rich, socially ambitious merchant.

The first in the series, entitled *The Marriage Transaction* (9.15), depicts the overweight Lord Squander at the left, his foot bandaged and elevated because of gout. He points to a scroll bearing his family tree emerging from William the Conqueror. The merchant, at the table, studies the financial

terms of the marriage, while the future groom, a viscount, turns away from his bride to admire himself in the mirror. The bride, as uninterested in the groom as he is in her, listens to her future lover, the attorney Lord Silvertongue. The dogs in front of the viscount are chained and stare blankly, echoing the indifference and the impending "imprisonment" of the engaged couple.

Although Hogarth depicts his figures in the frilly costumes typical of Rococo and situates them in a room with elaborate picture

9.16 Jean-Baptiste-Siméon Chardin,
The Copper Cistern, c. 1733.
Oil on panel, 11 $^{1}/_{4}$ in. × 9 $^{1}/_{4}$ in. (28.6 cm × 23.5 cm).
Musée du Louvre, Paris.

and mirror frames, the scene is filled with biting satire. The content of the pictures is violence, murder, and martyrdom—a reflection of what the marriage has in store for the couple. On the right wall is a Medusa head, her snaky hair twisting in a gruesome formal repetition of the curvilinear, crowned frame. Her placement above the bride bodes badly for the latter's future. Through the window, a building left unfinished for lack of funds is visible, belying the supposed financial advantages of the marriage.

In the paintings of Jean-Baptiste-Siméon Chardin (1699–1779), yet another new trend, sometimes referred to as "bourgeois realism," emerges in the eighteenth century. Instead of scenes of aristocratic leisure and frivolity, Chardin focused on the working classes. His pictures are often set in a kitchen, showing figures hard at work on a repetitive chore. He also completed a number of still-life paintings, not the elaborate *vanitas* allegories of the Dutch and Flemish, but rather works with a few simple objects

that would influence nineteenth-century developments in the genre. Chardin's paint surface is generally thick, its **impasto** quality contributing to the simulated textures of his forms.

The Copper Cistern of around 1733 (9.16) exemplifies the richness of Chardin's still lifes. The cistern is monumentalized, ennobling the work associated with it. Placed around it, in a deceptively random manner, are kitchen objects that assume anthropomorphic qualities and suggest a recently present person. The textures of the copper and other metals are convincingly conveyed by their reflective surfaces. The play of shadows on the wall and floor reinforces the structural qualities of the objects, for it emphasizes their physicality. At the same time, Chardin's pictures have a quality of transience, although not in the courtly, aristocratic manner of Watteau and other Rococo artists. In emphasizing the bourgeois work ethic, Chardin also conveys the drudgery of household repetition and the sense that the work is never done.

One final eighteenth-century artistic trend was the rediscovery of Roman and Greek antiquity. To some extent, this was spurred by the excavations of Pompeii and Herculaneum, which contributed to a vogue for neoclassicism. By the end of the century, Neoclassical would be the style associated with revolutionary movements, both in France with Jacques-Louis David and in America with Thomas Jefferson and the Federal style. Ironically, the classicism that had inspired the "grand manner" of Baroque absolute monarchy would become a text for revolution and a model for republican governments.

NOTE

1. Margaret Whinney, *Wren* (London, 1971), p. 90.

Glossary of Art-Historical Terms

Cross-referenced terms that appear in the definitions are set in **boldface** type.

altar A structure used as a place of sacrifice. In Christianity, the altar is derived from the table of Christ's Last Supper and is used for the ritual of the Eucharist.

Apocrypha Unauthorized books of the Bible, popular as a source of **iconography** in Christian art.

apse A projecting semicircular section of a building—in a church, usually the site of an **altar.**

arcade A series of arches supported by piers or **columns.**

asymmetry An absence of **symmetry** (see below).

attic A section of a façade that is above the **entablature.** In a Roman triumphal arch, the attic is the rectangular section over the arch.

attribute (noun) An identifying characteristic.

balustrade A row of balusters (upright members) supporting a railing.

barrel vault An extension of round arches creating a semicylinder that resembles the inside of a barrel cut in half lengthwise.

basilica In ancient Rome, a rectangular building with a tall **nave, side aisles, clerestory** windows, and **apses.** In Christian art, an early form of the church building with features similar to the Roman basilica.

bay A decorative segment of the interior of a building, usually one of a series.

belfry A bell tower.

burin A pointed metal tool used for incising engraving plates.

bust A sculpture or picture of a person from the shoulders up.

cartouche A rectangle with curved short ends used in ancient Egypt to frame the name of a king.

caryatid A human or animal figure that functions as a vertical support for an **entablature.**

chapel A small section of a church containing an altar and used for prayer by individuals or private families.

chiaroscuro Forms rendered by shaded contrasts of light and dark to create an impression of three-dimensional contour.

choir The section of a church between the **apse** and the **nave** reserved for singing.

clerestory The upper story of a wall containing windows.

coffer A recessed interior ceiling panel, usually used for decorative purposes.

colonnade A series of **columns** supporting an entablature.

column A vertical, cylindrical support, having a shaft, a capital, and often a base.

contrapposto A stance of the human body in which the waist and hips are turned in different directions around a vertical central axis.

Corinthian One of the Greek **Orders of architecture**. It is more elaborate than **Doric** or **Ionic** but has the same general structure. The fluted **columns** have a base, unlike Doric, and the capitals are decorated with acanthus leaves.

cornice The top, usually slightly projecting, feature of an **entablature**, or the projection at the top of a wall or other structural element.

crossing The area in a church where the **transept** crosses the **nave**.

Doric One of the Greek **Orders of architecture**. On Greek temples, the Doric Order consists of three steps and fluted **columns** having a shaft and capital. The **entablature** has a **frieze** that consists of alternating triglyphs and metopes, an architrave, and a **cornice**.

drum A circular wall supporting a dome.

enamel Metal, glass, or pottery to which a vitreous coating is applied by heat fusion.

entablature The upper horizontal section of a classical **Order of architecture** consisting of the architrave, **frieze**, and **cornice**.

façade The front of a building.

foreshortening Creating an illusion of spatial recession on a flat surface by drawing a form in perspective.

frieze The central horizontal section of an **entablature**.

genre A category of art depicting scenes of everyday life.

grisaille A painting in gray tones to simulate the appearance of stone.

halo Light around the head of a holy figure.

iconography The meaning of the subject matter, or content, of a work.

illusionism The impression that a representation is the real thing.

impasto Thickly applied brushstrokes of paint that create a rough paint surface.

intaglio A process of incising lines in a printmaking surface.

Ionic One of the Greek **Orders of architecture**. It consists of steps, a fluted **column** with a round base, a shaft, and a volute (scroll-shaped) capital. The **entablature** consists of an architrave, a continuous **frieze**, and a **cornice**.

landscape A category of painting in which the main subject is the natural environment.

lantern The crowning feature of a dome or tower, often used as a source of light for the interior.

Latin-cross plan A church **plan** based on the form of the Latin cross, in which the vertical is longer than the horizontal.

loggia A covered, open-air gallery or **arcade**.

lunette A semicircular section of a wall.

martyrium (pl. **martyria**) A burial place for a martyr or the **relics** of a martyr.

nave The long central aisle of a church where the congregation gathers.

newell A central post around which winds a circular staircase.

niche A recess in a wall that often contains a sculpture.

obelisk A rectangular shaft that tapers toward the top and ends in a pyramidal tip. In ancient Egypt, obelisks were connected to sun cults.

oeuvre A French term used to encompass the entire body of work of a particular person.

Orders of architecture The arrangement of architectural features, particularly **columns** and an **entablature**, in a prescribed manner. The Greek Orders are **Doric**, **Ionic**, and **Corinthian**, and the Roman Orders are **Tuscan** and Composite.

pastel A chalky crayon used for drawing.

pediment In classical architecture, a triangular gable at the short end of a roof. In later architecture, a triangular or round architectural feature over a door, window, or **niche**.

pilaster An engaged rectangular pillar having a base, a shaft, and a capital.

plan (also **groundplan**) A diagram of the ground floor of a building as seen from above.

plane A flat surface lying in a direction of space.

podium (pl. **podia**) Either the masonry platform of a temple or a pedestal.

portal An elaborate doorway often decorated with sculptures on the exterior.

portico A roofed porch with a **colonnade** and sometimes a **pediment.**

portrait A visual likeness of a specific person.

refectory The dining room of a monastery or convent.

relic A body part of or an object associated with a sacred person.

rustication Roughly cut stone, having recessed joints, used to create the impression that a building is impenetrable.

sacristy The room in a church where the clergy prepares for services and where the robes and vessels for services are kept.

side aisle An aisle at the side of the **nave** in a church.

silhouette A sharply outlined, unmodeled form, often black.

spandrel A curved triangle between two arches.

still life A picture consisting mainly of inanimate objects.

symmetry A kind of aesthetic balance in which forms are arranged on either side of a central axis so that they correspond in size, shape, and/or color.

tenebrism A type of painting, developed by Caravaggio, in which large areas of dark are contrasted with bright areas of illumination.

tondo A round painting or relief.

transept A cross arm of a church set at right angles to the **nave.**

truss A structure in which triangular sections form a rigid framework.

Tuscan One of the Roman **Orders of architecture.** This is the Roman version of **Doric,** having a base, a smooth shaft, and a plain architrave and **frieze.**

vanitas A type of painting, the theme of which is the transitory quality of life and the inevitability of death. In the seventeenth century, still life is the genre most often associated with *vanitas.* The term itself means "emptiness" in Latin.

Bibliography

WORKS CITED

Adams, Laurie Schneider. *Art and Psychoanalysis.* New York, 1993.

Alpers, Svetlana. *The Art of Describing: Dutch Art in the Seventeenth Century.* Chicago, 1983.

_____. *Rembrandt's Enterprise.* Chicago and London, 1988.

Baldinucci, Filippo. *Vita di Bernini.* Translated by Catherine Enggass. University Park, Pa., and London, 1966.

Baldwin, Robert. Survey text. Unpublished.

Bellori, Giovanni Pietro. *The Lives of Annibale and Agostino Carracci.* Translated by Catherine Enggass. University Park, Pa., and London, 1968.

Berger, Robert W. *A Royal Passion: Louis XIV as Patron of Architecture.* New York, 1994.

Brown, Jonathan. *Velázquez.* New Haven and London, 1986.

Carrier, David. *Poussin's Paintings.* University Park, Pa., 1993.

Carroll, Margaret D. "The Erotics of Absolutism: Rubens and the Mystification of Sexual Violence." *Representations* 25 (Winter 1989): 3–29. Reprinted in *The Expanding Discourse,* edited by Norma Broude and Mary D. Garrard, ch. 8. New York, 1992.

Cellini, Benvenuto. *The Autobiography of Benvenuto Cellini.* Translated by John Addington Symonds. New York, 1937.

Derrida, Jacques. *The Truth in Painting.* Translated by Geoff Bennington and Ian McCleod. Chicago and London, 1987.

Garrard, Mary D. *Artemisia Gentileschi.* Princeton, 1989.

Held, Julius S. *Rembrandt's "Aristotle," and Other Rembrandt Studies.* Princeton, 1969.

Hibbard, Howard. *Caravaggio.* New York, 1983.

Holt, Elizabeth Gilmore, ed. *Literary Sources of Art History: An Anthology of Texts from Theophilus to Goethe.* Princeton, 1975.

Jones, Ernest. *Essays in Applied Psychoanalysis.* 2 vols. New York, 1964.

Kahr, Madlyn Millner. *Dutch Painting in the Seventeenth Century.* New York, 1993.

Martin, John R. *Baroque.* New York, 1977.

Mérot, Alain. *Nicolas Poussin.* New York, 1990.

Montias, John Michael. *Vermeer and His Milieu.* Princeton, 1989.

Orso, Steven N. *Philip IV and the Decoration of the Alcázar of Madrid.* Princeton, 1986.

_____. *Velázquez, Los Borrachos, and Painting at the Court of Philip IV.* New York, 1993.

Ovid, *Metamorphoses.* Translated by Frank Justus Miller. Cambridge, Mass., and London, 1984.

Panofsky, Erwin. *Meaning in the Visual Arts.* New York, 1955.

Pincas, Stéphane. *Versailles: The History of the Gardens and Their Sculpture.* New York, 1996.

Posèq, Avigdor W. G. "Rembrandt's Obscene Woman Bathing." *Source: Notes in the History of Art* 19, no. 1 (Fall 1999): 30–38.

Rosand, David. *Painting in Cinquecento Venice: Titian, Veronese, Tintoretto.* New Haven and London, 1982.

Roth, Leland M. *Understanding Architecture.* New York, 1993.

Schneider, Laurie. "Donatello and Caravaggio: The Iconography of Decapitation." *American Imago* 33, no. 1 (Spring 1976): 76–91.

Schneider, Laurie, and Jack Flam. "Visual Convention, Simile and Metaphor in the *Mona Lisa.*" *Storia dell'Arte* 29 (1977): 15–24.

Schwartz, Gary. *Rembrandt, His Life, His Paintings: A New Biography with All Accessible Paintings Illustrated in Colour.* New York, 1985.

Stechow, Wolfgang. *Dutch Landscape Painting of the Seventeenth Century.* London, 1966.

Strong, Roy. *Van Dyck: Charles I on Horseback.* London, 1972.

_____. *Art and Power.* Woodbridge, Suffolk, 1984.

Wheelock, Arthur K., Jr. *Vermeer and the Art of Painting.* New Haven and London, 1995.

Whinney, Margaret. *Wren.* London, 1971.

Wittkower, Rudolf. *Bernini.* London, 1966.

_____. *Sculpture: Processes and Principles.* New York, 1977.

Wren, Linnea H., ed. *Perspectives on Western Art.* Vol. 2. New York, 1994.

SUGGESTIONS FOR FURTHER READING

Adams, Ann Jensen, ed. *Rembrandt's "Bathsheba Reading King David's Letter."* New York, 1998.

Alpers, Svetlana. "Interpretation Without Representation, or the Viewing of *Las Meninas.*" *Representations* 1 (February 1983): 31–42.

_____. *The Making of Rubens.* New Haven and London, 1995.

Bal, Mieke. *Reading "Rembrandt": Beyond the Word-Image Opposition.* New York, 1991.

Bergström, Ingvar. *Dutch Still Life Painting.* New York, 1956.

Blunt, Anthony. *Nicolas Poussin.* 2 vols. Washington, D. C., and London, 1967.

Blunt, Anthony, ed. *Baroque and Rococo Architecture and Decoration.* New York and London, 1978.

Bredius, Abraham. *Rembrandt: The Complete Edition of the Paintings.* 3d rev. ed. Edited by Horst Gerson. New York and London, 1969.

Brown, Jonathan. "On the Meaning of *Las Meninas.*" In *Images and Ideas in Seventeenth-Century Spanish Painting.* Princeton, 1978.

Bryson, Norman. *Looking at the Overlooked.* Cambridge, Mass., 1990.

Chantelou, Paul Fréart de. *Diary of the Cavaliere Bernini's Visit to France.* Edited by Anthony Blunt. Translated by M. Corbett. Princeton, 1985.

Chapman, H. Perry. *Rembrandt's Self-Portraits.* Princeton, 1990.

Clark, Kenneth. *Rembrandt and the Italian Renaissance.* New York, 1966.

_____. *An Introduction to Rembrandt.* New York, 1978.

Enggass, Robert, and Jonathan Brown. *Italy and Spain, 1600–1750: Sources and Documents.* Englewood Cliffs, N.J., 1970.

Glen, Thomas L. "Should Sleeping Dogs Lie?: Once Again, *Las Meninas* and the Mise-en-scène." *Source: Notes in the History of Art* 12, no. 3 (Spring 1993): 30–36.

Goldscheider, Ludwig. *Johannes Vermeer.* London, 1958.

Gowing, Lawrence. *Vermeer.* London, 1970.

Haskell, Francis. *Patrons and Painters: Art and Society in Baroque Italy.* New Haven, 1980.

Jacobus de Voragine. *The Golden Legend.* Translated by William Granger Ryan and Helmut Ripperger. New York and London, 1948.

Jones, Stephen. *The Eighteenth Century.* New York, 1992.

Kahr, Madlyn M. *Velázquez: The Art of Painting.* New York, 1976.

Millen, Ronald Forsyth, and Robert Erich Wolf. *Heroic Deeds and Mythic Figures: A New Reading of Rubens' Life of Maria de' Medici.* Princeton, 1989.

Moffitt, John F. "The 'Euhemeristic' Mythologies of Velázquez." *Artibus et Historiae* 10, no. 19 (1989): 157–175.

Norberg-Schulz, Christian. *Late Baroque and Rococo Architecture.* New York, 1974.

Otto, Christian. *Space into Light: The Churches of Balthasar Neumann.* New York, 1979.

Palomino de Castro y Velasco, Antonio. *Lives of the Eminent Spanish Painters and Sculptors.* Translated by Nina A. Mallory. New York, 1987.

Panofsky, Erwin. "What Is Baroque?" In *Three Essays on Style.* Cambridge, Mass., 1997.

Puglisi, Catherine. *Caravaggio.* London, 1998.

Rosenberg, Jakob. *Rembrandt.* Cambridge, Mass., 1948.

Rosenberg, Jakob, Seymour Slive, and E. H. Ter Kuile. *Dutch Art and Architecture, 1600–1800.* New Haven and London, 1993.

Schneider, Cynthia P. *Rembrandt's Landscapes.* New Haven and London, 1990.

Slive, Seymour. *Rembrandt and His Critics, 1630–1730.* The Hague, 1953; New York, 1988.

_____. *Dutch Painting, 1600–1800.* New Haven, 1995.

Snow, Edward. *A Study of Vermeer.* Berkeley and Los Angeles, 1994.

Steinberg, Leo. "Velázquez's *Las Meninas.*" *October* 19 (1981): 45–54.

Summerson, John. *Architecture in Britain, 1530–1830.* New Haven and London, 1993.

Vergara, Lisa. *Rubens and the Poetics of Landscape.* New Haven and London, 1982.

Wheelock, Arthur K., Jr., ed. *Still Lifes of the Golden Age: Northern European Paintings from The Heinz Family Collection.* Washington, D.C.: National Gallery of Art, 1989.

_____, ed. *Johannes Vermeer.* Washington, D.C.: National Gallery of Art, 1995.

Wittkower, Rudolf. *Bernini.* London, 1966.

Index